THE LANDSCAPE PHOTOGRAPHY BIBLE

THE LANDSCAPE PHOTOGRAPHY BIBLE

THE COMPLETE GUIDE TO TAKING STUNNING SCENIC IMAGES

TONY WOROBIEC

D&C
David and Charles

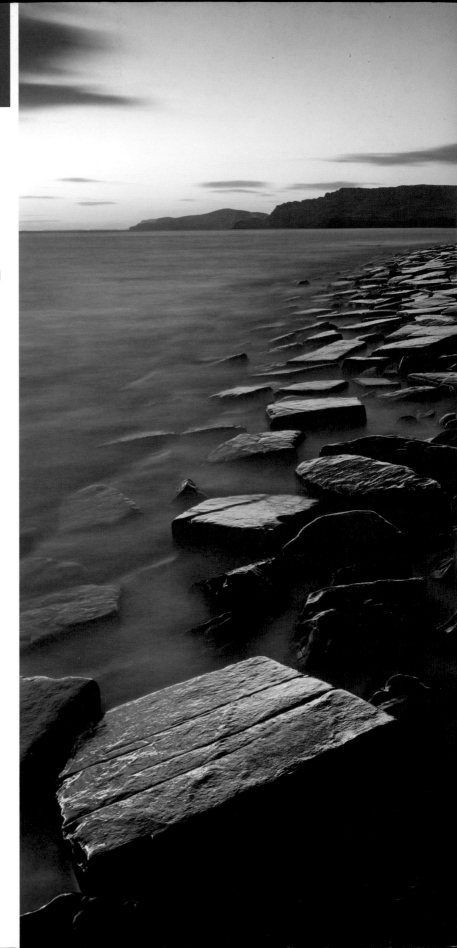

Contents

Introduction

Part of the appeal of landscape photography is that it can be done at any time of the day, at any time of the year and in virtually any lighting conditions; it also encourages us to explore the great outdoors. Being in the open invigorates us and, if we walk or cycle, the exercise helps to stimulate a chemical release of endorphins, which produces a feeling of wellbeing. I make this point because when we are relaxed we are more receptive to our immediate surroundings.

It is important to make a distinction between 'landscape' and 'travel' photography. One can easily feel intimidated by those who travel to the far corners of the world shooting in extremely impressive locations, but it is important to appreciate that it is not a matter of where, but rather how you photograph your subject. The best shots are those that communicate mood, which can just as easily be conveyed by a picture you have taken close to home. A capacity to see interesting landscapes in their own, immediate environment is a skill that is sadly overlooked by too many

photographers. It's my belief that if you have not developed this, you will be tempted to photograph clichés when you travel further afield. Photographing landscape is largely about responding to the moment and this is best achieved in familiar locations.

Getting to know your camera is an important first step, and the more you use it, the more familiar you become with its many options. Be curious, and if there are features that you do not understand, experiment. Ideally, your camera should become an extension to your hand and operating it should come as second nature, so that when you need to you can perform the task almost unthinkingly, while capturing great shots time after time. Sometimes we burden ourselves with too much equipment, so occasionally take along just the one lens. If you restrict yourself in this way, it is often easier to see photographs.

Planning is essential to good photography. The landscape is constantly changing and the secret is to be in the right place at the right time. You may well have

visited a particular spot and realized that, had you been there two weeks earlier, you could have exploited its potential far more effectively; by keeping a photographic diary, you can schedule it in for the following year. Get into the habit of looking at maps; one of the great pleasures of landscape photography is tracking down new locations and capturing great photographs when you find them. But not everything can be planned; no matter how resourceful you are, there will be occasions when the totally unexpected occurs and learning to respond to this encourages creative photography.

If you read about the great landscape photographers, one skill they all have in common is the ability to pre-visualize. Being able to imagine what the image will look like before they press the shutter, or understand how it will respond in different lighting conditions, allows them to make the best use of their camera's many functions. The lesson, of course, is that if you arrive at a location and you are initially disappointed, consider all the technical options that

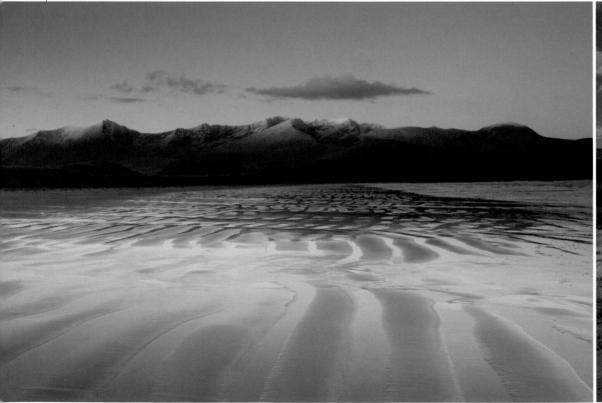

are available to you and never write off a potentially interesting landscape.

It is easy to pigeonhole the perfect landscape as some fantastic idyll, but it should be something more meaningful than that. Not all landscapes should conform to the 'chocolate box' stereotype and sometimes the unpromising or even the ugly can make worthy subjects. It is easy to be seduced by the 'lipstick' sunset, but varying lighting conditions promote different responses and this should be reflected in our photography. It helps to have photographic heroes who not only set us high standards, but also provide us with inspiring exemplars that are both challenging and possibly controversial. Step outside your comfort zone once in a while.

Unquestionably, one of the most important new skills users of digital cameras should acquire is how to create an HDR file. While they are improving, sensors still lack the latitude of traditional film; consequently, in high contrast situations, your camera may not be able to cope with the full dynamic range for the ambient lighting conditions. Although I sense that an entire book could be dedicated to this subject, I have included a short section that aims to highlight the issues. I would, however, add a cautionary note that, when producing a HDR file, you can so easily over-do the process and as a consequence lose all contact with reality.

A similar argument can also be made when using editing software. When photographing a landscape you are making a statement about what you saw and not what you wished you had seen. Some of the facilities in Photoshop are so powerful that they can turn a sow's ear into a silk purse, but one then needs to question whether this is honest landscape photography.

Defining what we mean by 'landscape photography' certainly raises one or two interesting issues, and while some will adopt a romantic view, deciding to exclude the presence of man, others prefer a more contemporary approach. Should we restrict our photography to rural areas or can the urban environment play a part? Is it legitimate to take photographs at night and call them landscapes? These are questions only you can answer, but what I have attempted to present in this book is a comprehensive coverage of the main issues. Essentially, 'landscape' should cover a variety of approaches and my aim is to illustrate this.

Without doubt, landscape is the most popular area of photography, largely because it is so accessible. Unlike other more specialized areas, which frequently require buying additional equipment, all you need is a camera and a willingness to step outside. You do not necessarily need to use a very expensive camera and acceptable results can be achieved even when using a mobile phone. Judging by the many popular photographic websites, people of all ages are enthusiastically embracing landscape photography as they appreciate that it makes travelling, or just a simple walk in the park, a much more enjoyable experience.

SECTION 1 Technical Issues

Equipment

YOUR CAMERA

The range of cameras currently available is bewildering and it is easy to get confused, but thankfully they are largely similar on the truly important points. If you have upgraded from a compact to a digital SLR (DSLR), or have recently given up film to go digital, then there will be many features that you will recognize, but possibly one or two that you will not. While individual marques vary slightly, most DSLRs conform to a generic type and the quality of capture from them has improved enormously. While the earliest cameras featured modest sensors, even fairly basic ones now use sensors of 12 megapixels or more, although it is important not to see this as the only criterion regarding quality.

LENS QUALITY

The quality of the lens is absolutely critical. It is sometimes quite tempting when comparing lenses offering the same focal specifications to buy the cheaper option but, as with most things in life, you get what you pay for. Cheaper lenses can suffer from chromatic aberration, pin-cushion and barrel distortion. Often DSLRs are sold as a package including an inferior single zoom lens. If it is possible, buy the camera body separately, and then get the best and most suitable lens you can afford. Pay particular attention to the colour saturation, contrast, colour accuracy and sharpness of the lens. These comparative specifications are often objectively reviewed in photographic magazines. Unlike a compact, lenses for a DSLR are interchangeable, consequently you can add to your equipment as finances allow.

FULL-FRAME CAMERAS

The majority of DSLRs and all compact cameras use a sensor that is the size equivalent to APS-C film as it is easier and cheaper to manufacture. Despite the fact that the image quality of these cameras is very good, an increasing number of serious amateur and professional photographers are now opting for a full-frame DSLR, which offers even better resolution. The size of the sensor parallels a traditional 35mm film camera (36 x 24mm), which gives a full-frame camera several advantages:

- You are able to fit selected lenses designed for traditional 35mm film cameras and use the same focal length. In contrast, cameras with a smaller sensor need a shorter focal length for the same angle of view. As a simple rule of thumb, multiply the DSLR magnification by 1.6.
- For a given number of pixels, the larger sensor offers a better dynamic range and lower noise when using high ISO ratings, therefore a full-frame DSLR produces better resolution in high contrast or low light situations.

THE FOUR THIRDS SYSTEM

There is now a new generation of cameras that have the convenience of compacts and the advantages of DSLRs and these are known as Four Thirds cameras. Unlike SLRs, the lens design has been adapted specifically to accommodate the digital sensor. While featuring interchangeable lenses, Four Thirds cameras use the same APS-C sensors

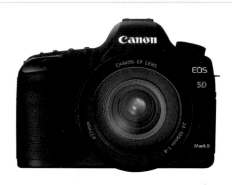

Canon EOS 5D Mark II
Full-frame cameras, such as the Canon EOS 5D Mark II, feature a full-frame sensor, which provides a better dynamic range, performance and overall image quality.

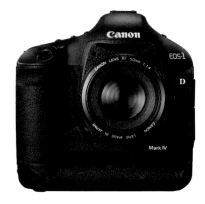

Canon EOS 1D Mark IV
Because of its reliability and robust weatherproof construction, this has been the camera of choice for many top professional photographers.

Olympus Pen
This model represents a new generation of Four Thirds cameras, which have the advantages of a DSLR, but the convenience of a compact.

Nash Point
While aperture priority tends to be a popular mode for most landscape situations, shutter priority is useful when you wish to control the speed of the exposure. In this example, I wanted to capture the effects of the water flowing back, which required an exposure time of 4 seconds.
Canon EOS 5D Mark II, 17mm lens, 4 seconds at f.20.

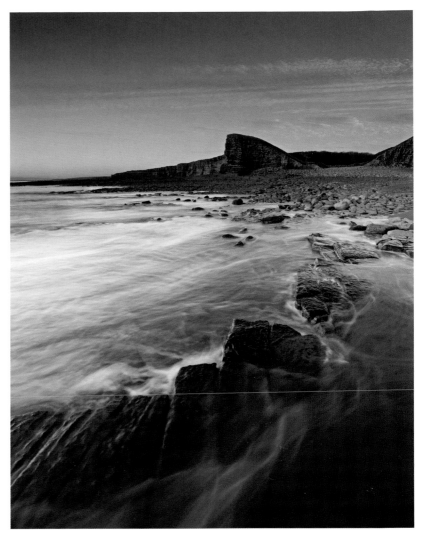

as most DSLRs, yet retain the smaller size of a compact, consequently the size of the lenses tends to be smaller as well. If you want the flexibility of a DSLR system but the convenience of a compact, this is an excellent option.

EXPOSURE MODES

Most DSLRs will offer a minimum of five exposure modes, Program Mode, Av Mode, Tv Mode, Manual and Bulb.

Program mode (P) – when using this mode the camera automatically sets the shutter speed and aperture for the ambient lighting. The exposure will be accurate, but as aperture plays such an important part in landscape photography, this is not a mode I would wish to use regularly, as that critical decision is removed from your control. It is perhaps ideal when you need to respond quickly, but for most landscape situations there are better options.

Shutter priority (Tv) – a semi automatic mode that allows you to select the shutter speed while the camera works out the correct aperture relative to the available light. This mode is best suited only when capturing movement is the priority and the depth of field is of secondary importance. For example, if you want to photograph the blurring of trees in the wind and have worked out that 1/8 second is the best shutter speed to capture this, using this mode would then be your best option.

Aperture priority (Av) – so-called because it allows you to select the aperture but then automatically works out the shutter speed you need for the available light. This mode is usually favoured by landscape photographers, who want to retain full control over the depth of field. Whether you are using a wide-angle or long angle lens, many landscape situations require a small aperture to ensure that the foreground and background are uniformly sharp. Alternatively, you may wish to select a very wide aperture so that just a very small part of the landscape is in focus; using aperture priority puts you in control.

Manual mode (M) – often ignored by inexperienced photographers, but in tricky lighting conditions, making a light reading independent of the camera and then manually selecting the correct aperture and shutter speed is often the best solution. There may be aesthetic reasons why you want to deliberately under- or over-expose; manual mode allows you to do this.

Bulb (B) – used when you wish to make very long exposures, as it allows you to keep the shutter open for as long as you want. These long exposures will be required when taking landscape shots in low light or night-time but you will need to use a cable release in order to avoid camera shake.

Subject modes – compact cameras, Four Thirds and some DSLRs also offer subject modes. These are usually presented as a selection of pictograms and they work out the best average settings for when you wish to photograph a landscape, a portrait, a close-up or use flash. This is not an option I would recommend if you wish to seriously master landscape photography.

UNDERSTANDING METERING SYSTEMS

Understanding how your metering system works is vital if you are to achieve consistently well-exposed images. Most cameras will feature evaluative, partial or centre-weighted metering and some will also provide a spot-metering facility. It pays to understand what these various options offer, particularly in relation to landscape photography.

Evaluative metering mode – considered by many photographers as their standard metering mode. It works well in most lighting situations but it is important to appreciate that your metering system is designed to achieve a notional 18% grey and can easily be fooled by very bright or very dark situations. Essentially there are three exposure values, black, white and 'middle-grey', which we term 18% reflective grey. That is the mean average tonal value between black and white. As the metering system is always trying to achieve 18% grey, there will be occasions when the metering system is fooled.

The classic error occurs when photographing snow – as the meter is trying to achieve 18% grey, this often leads to underexposure. Similarly, when trying to photograph a subject much darker than average, let's use the proverbial black cat in a cellar, your light meter will show a tendency to over-expose. This is where using the exposure compensation facility of the camera really helps. Exposure compensation is used to change the standard exposure set by your camera, usually by up to + or – 2 stops, set in 1/3 stop increments.

Centre-weighted metering mode – copes particularly well with tricky backlighting situations, typically when you have a bright sky over a darker landscape.

Partial or spot metering mode – best used when the subject is backlit but the surrounding light is strong. This can fool the centre-weighted metering mode. These two modes give you possibly more control than any of the other options, although it is important that you understand just when to use them. As the name would suggest, partial or spot metering allows you to meter just a small part of the scene, so if you want a backlit tree to stand out from the background, for example, you can ensure that it remains perfectly exposed and that no part of it appears burned out.

tip

Take into account that a hand-held meter cannot factor in any filters you may have on the lens at the time.

Lake Powell
The evaluative metering mode works well in most situations, even in relatively low light, providing the landscape is not excessively bright or too dark.
Canon EOS 5D Mark II, 70–200mm zoom, 6 seconds at f.14, ISO 100.

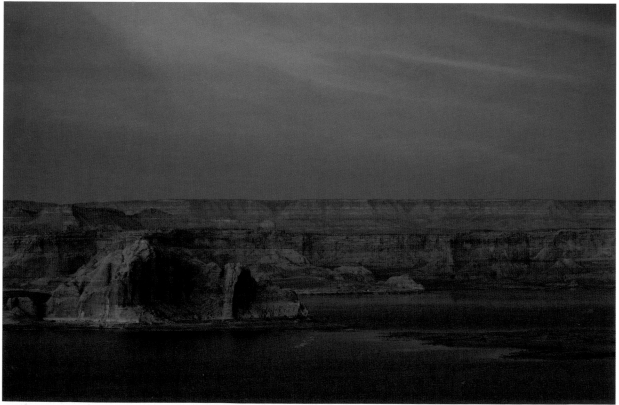

USING A HAND-HELD LIGHT METER

The quality of the built-in metering system in your camera will invariably depend on its cost; it stands to reason that the more you pay, the more precise the metering system will be. Accurate exposure is at the heart of all good photography and by using the best metering system you can get, the more successful your landscape shots will be. Because hand-held light meters operate separately from the camera, they are more flexible than the camera's built-in metering system, allowing you to take readings away from the camera.

When using a hand-held meter, you have the option of taking either a 'reflected' light reading (the light reflected from the area you wish to photograph), or an 'incident' light reading (a measurement of the source of the light). To take an incident light reading, it is necessary to fit a translucent cone over the light cell and point the meter towards the camera. In many situations the camera's own metering system will prove more than adequate, but in some particularly difficult lighting a hand-held meter will prove very useful. If there is a significant disparity between the sky and the foreground, use your hand-held meter to take a duplex light reading. A duplex reading is also helpful when photographing in contrasty or back-lit situations. If you use a reflected light reading, the meter is likely to under-expose, but an incident light reading is likely to over-expose the highlights. The solution is to take both an incident and a reflected light reading, and then average out the two. This is known as a duplex reading.

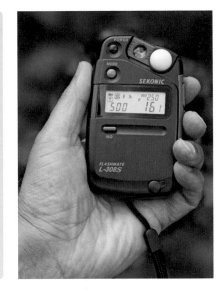

Hand-held meter
Because hand-held light meters operate separately from the camera, they are more flexible than the camera's built-in metering system.

THE ISO RATING

Undoubtedly one of the biggest advantages of using a DSLR is that you can easily change your ISO rating frame by frame. It is surprising just how many photographers fail to utilize this. There will be times when you want your landscape to reveal maximum resolution in which every nuance of detail is captured; if you intend to use a tripod, select the lowest available ISO rating. On the other hand, you may wish to photograph a speeding horse galloping across a dimly lit plain. By upgrading your ISO to 1600 or 3200, you should be able to achieve this while still hand-holding the camera. It is simply a matter of matching the ISO rating for the task in hand.

Most DSLRs operate between ISO 100 and ISO 3200, but some full-frame DSLRs have an ISO range of between 50 and 6400 (or even higher), which offers enormous flexibility. Remember, the lower the ISO rating the finer the detail. When using higher ISO ratings, theoretically you should expect to see reduced image fidelity and evidence of 'noise', although with ever improving sensors, it is possible to use an ISO rating of up to 4000 before noise becomes an issue.

Andalusian meadow
For most landscape work, set your camera on a tripod and use the lowest ISO rating to maximize quality. Canon EOS 5D Mark II, 200mm lens, 1/32th second at f.32, ISO 100.

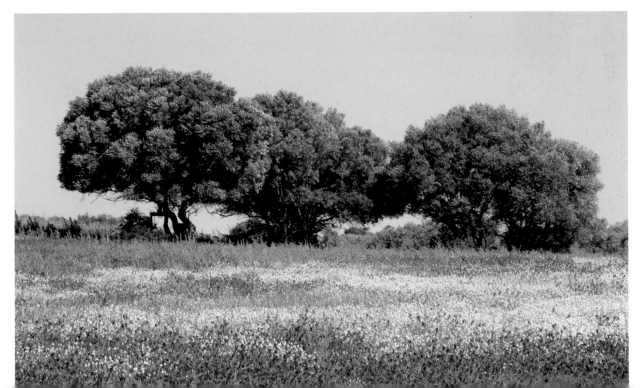

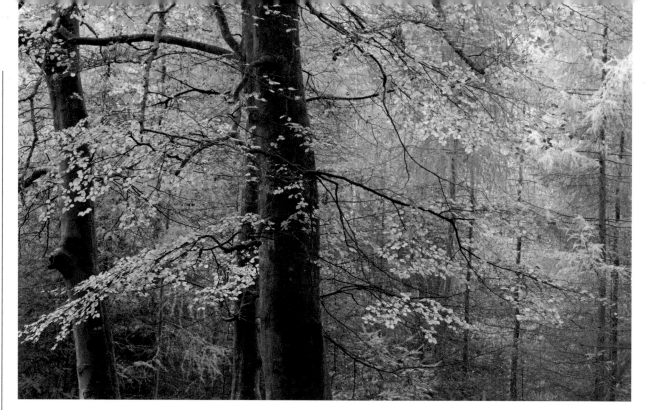

WHEN TO USE AUTO-FOCUS

There are numerous occasions when an auto-focus facility is helpful, although if you have attached your camera to a tripod, selected a small aperture and are using a wide-angle lens, its value is considerably reduced. In fact, sometimes auto-focus can prove troublesome, particularly in low light. The lens has difficultly establishing a suitable point of focus and consequently it goes into 'hunt' mode, which prevents you taking your shot. In those situations, it is best to switch it off and focus manually. Get into the habit of pre-focusing in low light.

MEMORY CARDS

If you are shooting RAW, then you will need a memory card of at least 4Gb. The largest cards go up to 16Gb, which can store a considerable number of images, although, when on a photographic shoot, you should always have a spare card in case one fills up or fails. It may seem sensible to take the largest card available on a trip but that can be risky as you will lose all your prized shots if anything should go wrong with it. Far better to spread your capture over several smaller cards and check they are all functioning before you depart.

If you are planning a long trip, you may also wish to take along some means of back-up. A laptop is ideal, particularly if you want to process your images while you are away. Another solution is to use a personal storage device, which has slots for your memory cards, allowing you to download your files. Ideally get one with a large LCD monitor, which will let you review and edit your work.

COLOR SPACE

The Color Space within the camera can best be understood by imagining all the reproducible colours that can be created by mixing red, green and blue light. The wider the gamut-display, the more accurate the colour will be. All DSLRs and most compacts offer a choice of sRGB and RGB in their sub menus and, as they both give the same number of colours, selecting one or the other can be confusing. If you are shooting RAW then it does not matter which one you choose because the processing software can override it. Although camera manufacturers often suggest that you shoot sRGB, if you intend to do some post-production work with software such as Photoshop, use Adobe RGB instead.

The New Forest
The great advantage of using auto-focus is that it allows you to concentrate on what really matters, capturing well composed and interesting landscapes. Canon EOS 5D Mark II, 200mm lens, 1/8th second at f.20, ISO 100.

Memory cards
It is far better to spread your capture over several smaller cards rather than storing all your images on a single one and risk it failing in some way.

THE LCD MONITOR

One of the great advantages of using a DSLR camera is that you can instantaneously review your shots, although they are difficult to assess in very bright or contrasty lighting conditions. They can also be unreliable regarding the accuracy of the exposure, so you should refer to the histogram for this. Where the LCD is useful is first by letting you know whether your image is sharp, and this can easily be established by using the zoom facility, and second whether your image is well composed. The LCD is also used to display the menu options

USING THE HISTOGRAM

Having taken our shot, we instinctively refer to the monitor to see whether it has been a success but, while it is useful up to a point, the monitor cannot tell you everything. In very bright conditions, the image in the monitor can often appear burnt out when in actual fact it has been well exposed. Similarly in very low light situations, some under-exposed images will appear to be well exposed until you check the histogram. The histogram should become the ultimate arbiter regarding the accuracy of your exposure. It is presented as a graph, which shows the exposure level distribution, overall brightness and gradation. As well as the brightness display, your histogram should also have an RGB display which shows you the saturation and gradation of each of the colour channels.

The horizontal axis indicates the brightness level, with the darker values appearing on the left and the lighter ones on the right. The vertical axis indicates how many pixels there are for each of the brightness levels. Generally there will be a spread across the entire histogram, although this will not necessarily be evenly spread. If you have taken a low-key image, then the histogram

will appear biased slightly to the left; conversely if you have just taken a high-key shot, then the bias will be to the right. If, however, pixels are appearing to bunch at either of the extremes then you are losing shadow or highlight detail.

This histogram is a bit more specific as it shows the distribution level for each of the colour channels, namely red, blue and green. It operates in a similar way to the brightness display, except that you are able to assess the colour saturation and gradation of each of the channels.

Dawn over Badlands
It can be reassuring to check the monitor just to see whether your image is sharp and well composed, although it does also pay to view your histogram as well in order to ensure that your exposure is spot on.
Canon EOS 5D Mark II, 24–105mm zoom, 1/100th second at f.18, ISO 400.

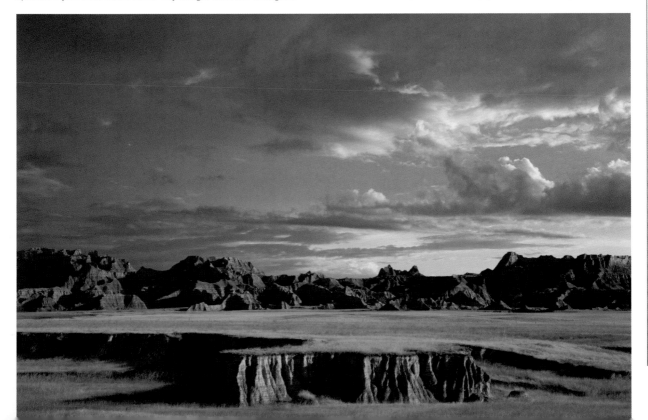

THE WHITE BALANCE FACILITY

The White Balance (WB) facility is a useful means of ensuring that when taking a photograph, your image does not have an *unwanted* colour cast. I will come back to that point of 'unwanted' shortly but what is a colour cast? If you are photographing a landscape featuring a white building, naturally you would expect that building to appear white in your image. If it has a bias towards one colour or another, then this is termed a colour cast.

But as the sun rises and falls through the course of the day, its relative strength changes. Moreover, one can encounter days when the sun is shining, and others when it is cloudy and overcast. These changing conditions will have a bearing on the colour temperature of the image and unless this is redressed, the white building might appear to have a colour bias. Sometimes this is a good thing. For example, if you photograph the building in the late afternoon, it will appear to have a golden glow, which adds to the appeal of the image.

There will be extreme circumstances, particularly when photographing at night, when urban areas are illuminated by either tungsten or white fluorescent light, when you will certainly experience a strong colour cast. Being able to counter this by adjusting the white balance setting is clearly helpful. If you are in doubt, most DSLRs feature a white balance auto-bracketing facility; when selected, with each shot taken three images will be recorded simultaneously showing varying colour temperatures. For example, in addition to the preset white balance, it will record one with either a blue or amber bias and one with a green or magenta bias.

I find that the Auto White Balance (AWB) copes well with most daylight situations. In any case, if you shot RAW, then the white balance decision can be deferred until later, when you have more time to review the images you have taken.

Factory Butte

Judging when and when not to accept a colour cast will always be debatable point. The late evening light creates a natural warm cast and by removing it the sense of atmosphere would be lost. You should find that the AWB option copes with most lighting situations, but if it does not, make any required changes in The RAW converter after you have taken your shot.
Canon EOS 5D Mark II, 70–200mm lens, 1/25th second at f.22, ISO 400.

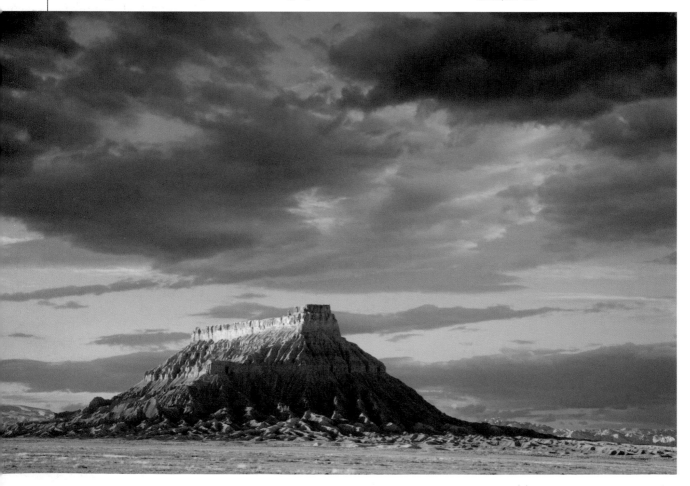

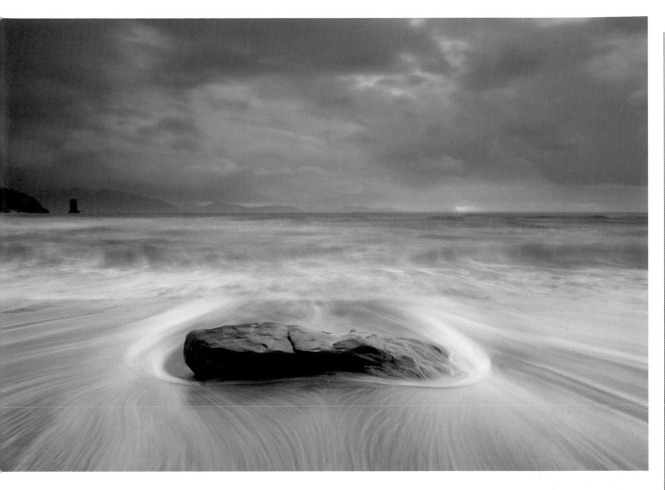

SHOOTING JPEG OR RAW?

The major advantage of shooting JPEG is that it takes up far less space on your memory card. Certainly, if you are the kind of photographer who wishes to shoot fast action, then JPEG is unquestionably the better option. It is sometimes assumed that the quality of RAW files is superior to JPEGs but many people would have difficulty distinguishing between an image taken on a large JPEG and one taken RAW unless you are printing bigger than A4. Also, RAW requires dedicated software in order to read it, which can be an annoyance, and it is difficult to share with others unless they have the same software. One wonders why anyone would want to shoot RAW?

The advantages of RAW

- RAW offers the best quality possible and when you are shooting landscape, this is a great advantage, particularly if you want to exhibit your work. Essentially, if you are shooting JPEG, some of the data will be lost but when you shoot RAW you are utilizing the full capacity of the sensor.

- While you do need dedicated software to read a RAW file, this comes with an editing package, which allows you to make quite sophisticated changes to your file non-destructively. Some of these packages are so good that they virtually remove the need to edit your work in either Photoshop or Lightbox. Different cameras require different RAW converter packages so check this before you buy.

- One of the decisions I often defer when shooting in the field is which white light balance to use. I generally opt for AWB, which proves to be accurate 99 per cent of the time, but by using the RAW converter I am still able to make changes if required.

Swirling tide
Shooting RAW has many advantages over JPEG for serious landscape photography.
Canon EOS 5D Mark II, 24mm lens, 1 second at f.16, ISO 100.

EFUL FILTERS

oblem you will certainly encounter from time to time, which exposes a weakness of most digital cameras, is the restricted dynamic range. This can be most obviously seen when photographing landscapes as the sky can appear too bright or the land too dark. There are several useful filters that help to overcome these issues.

FILTER TYPES

A filter is simply a glass or plastic screen that you put in front of your lens in order to reduce or control the light reaching the sensor. They come in many shapes and sizes, but there are two generic designs. Firstly there are the screw-on types, typically manufactured by *Hoya* and *B&W*. Secondly there are the modular types that require placing a rectangular filter in an adapter and holder, made by *Lee Filters* and *Cokin*.

UV FILTER

The general advice with filters is only to buy on a needs must basis; some are particularly expensive and should only be considered if they positively help your style of photography. However, there is one filter I would strongly recommend you buy with each new lens you get, and that is the simple UV filter.

This filter is designed to remove the bluish haze caused by particles in the atmosphere. By introducing a very gentle pinkish tint, the sky will appear cleaner, so in terms of improving clarity, it serves a useful purpose. But the main reason I would recommend using one is because it guards your lens. Remember that without a filter you are exposing the front element to dust and possible scratch damage. These filters are relatively cheap and, while they have only a minimal effect on the image, they protect your very much more expensive lens. If you want to add another filter such as a polarizer, you will need to remove the UV filter or vignetting may arise. Otherwise always keep this filter firmly secured to your lens.

GRADUATED NEUTRAL DENSITY FILTER (ND GRAD)

As I have already suggested, one of the key problems when photographing landscape is excessive contrast, particularly when the sky is included, which is where a graduated neutral density filter can prove so useful as it helps to balance out the disparities of exposure. When making a light reading there might often be a three or four stop difference between the foreground and the sky. If you expose for the sky, the foreground will appear too dark, but if you meter for the foreground, the sky will appear burnt out. The graduated filter corrects this disparity without changing the colour balance. It is possible to buy a screw-on graduated filter but they are more commonly part of a modular system such as Lee or Cokin. In essence, it is a half grey and half clear sheet of acetate, which is positioned in front of the lens. By ensuring that the darker part filters out the lighter part of the scene, an exposure balance is restored.

UV filter
While UV filters remove the bluish haze in the atmosphere, they also serve as protection for the lens.

Graduated filters come in different strengths, commonly, a 0.3, which equates to a one stop reduction of light, a 0.6, which equates to two stops and a 0.9, which reduces the light by three stops. These filters also come as 'hard' or 'soft'. This describes the transition between the grey and the clear areas, which can be gentle or harsh. It is also possible to use two filters in combination so that the overall exposure is reduced, which is useful when you wish to achieve a low light effect in normal light. In this way they become, in effect, a neutral density filter. They can also be 'stacked' in order to increase the strength of the filtration, but it is best not to overdo this as the sky should normally appear marginally lighter than the foreground.

ND Grad
These are among the most useful filters for landscape work as they help to balance out the sky and foreground. They come as 'hard' or 'soft'.

Metering with a graduated filter

This can prove problematic, as the metering system on the standard DSLR can easily be fooled, resulting in the foreground appearing too light. There are ways to overcome this.

- Take two independent light readings, one of the sky and one of the foreground, set the camera to expose for the foreground, then select the appropriate ND grad filter in order to achieve an overall balanced exposure. It should also be noted that while the effect of the filter can be seen through the viewfinder, it is being viewed with its maximum aperture. By using the depth of field preview facility you can see the effect the filter is having with the aperture you have selected, particularly when using a hard grad filter. If the effect is too harsh, then you may wish to use a larger aperture.
- Meter the subject first without the filter, use the camera's auto-exposure facility to memorise the reading, then add the filter and expose.
- Meter manually without the filter, make the necessary camera adjustments, and then put the filter over the lens.
- Bracket your shots. Working digitally, this is easy to do.

tip

It is essential to keep filters clean. Check them regulary to ensure that no droplets of water or other particles have got onto them as this could affect image quality.

Pier

Generally when using a graduated filter, the idea is to balance the sky with the foreground, but in this example, the sun had set to my left which meant that the image was unevenly illuminated. By adjusting the filter so that it was rotated on its side, this imbalance was easily addressed.
Canon EOS 5D Mark II, 24–105mm lens, 142 seconds at f.22, ISO 100.

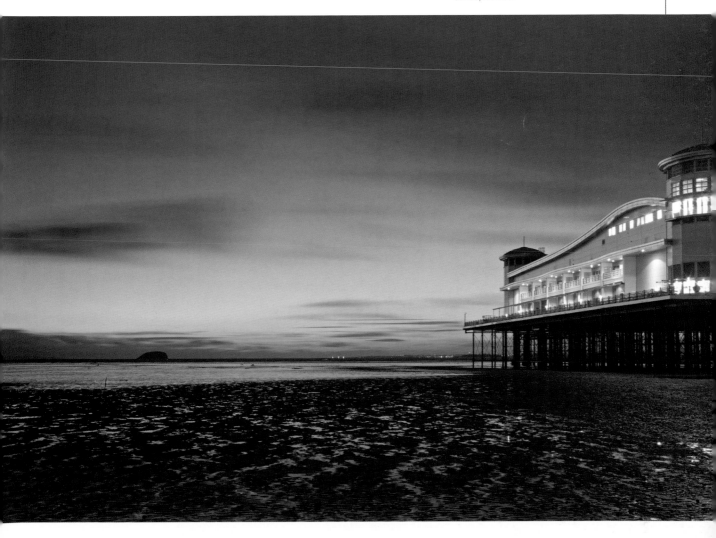

NEUTRAL DENSITY (ND) FILTER

These are like graduated filters except that they reduce the light evenly across the entire frame. They are most commonly manufactured as screw-on filters and act rather like a pair of sunglasses. A neutral density filter is used to reduce the amount of light reaching the sensor by absorbing the same amount of all the wavelengths, therefore it does not alter the colour in any way. As it effectively reduces the ISO rating, it is often used to simulate the effects of low-light photography when there is still plenty of available light.

One slight problem you will encounter when using some of the stronger ND filters is that, because of the almost opaque nature of the glass, it is impossible to see through them. The only way round this is to compose and focus with the filter off, and then carefully place it on the lens once you want to take your shot.

Neutral density filter
Plain, dull and grey, neutral density filters don't look very exciting but they are one of the most creative options in the toolbox.

ND FILTER DENSITIES

- ND 2 allows 50% of the light to reach the sensor, reducing your speed by one stop.
- ND 4 allows 25% of the light to reach the sensor, reducing your speed by two stops.
- ND 8 allows 12.5% of the light to reach the sensor, reducing your speed by four stops.

Palm trees
By using a strong neutral density filter, it is possible to illustrate the wind moving through the palms. Without a filter, I needed to use a shutter speed of 1/125th second, but with it, I was able to increase this to 25 seconds.
Canon EOS 5D Mark II, 50mm lens, 25 seconds at f.16, ISO 100.

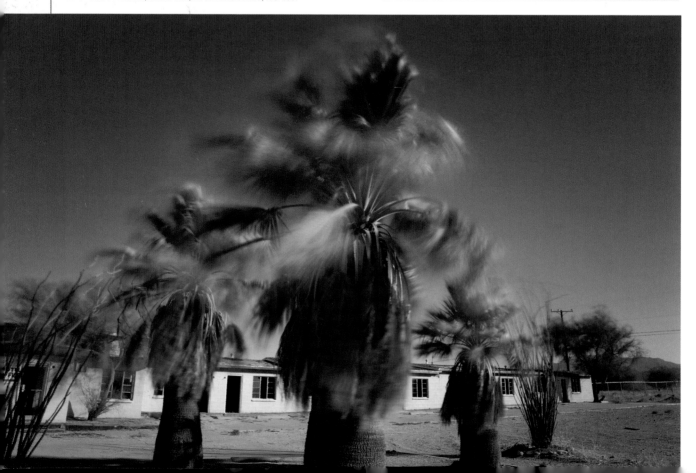

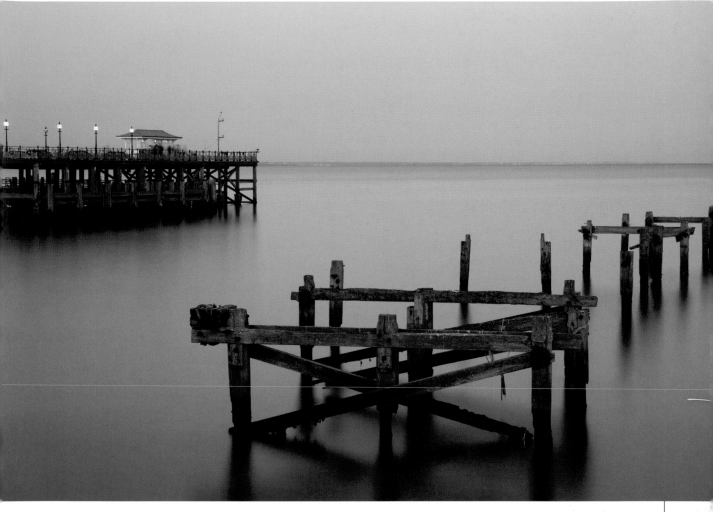

When to use an ND filter

- You may decide that you want to use a very wide aperture, but you are unable to do this because the available light is too bright.
- You are photographing a location and people keep getting in the way. By considerably reducing the shutter speed, they will appear in the image as a blur, or disappear entirely.
- When photographing waterfalls, many photographers wish to capture the silky, gossamer effect that one achieves when using a slow shutter speed. If the lighting is too bright, using this filter will counter it.
- Typically they are used to photograph coastal locations in daylight, but where you want to capture the moving sea to create the ethereal effects of very low light.
- Alternatively, you may wish to photograph a landscape, but capture the moving clouds as an interesting blur. This kind of photography certainly creates a wonderful contemporary feel. So if your camera's metering system tells you that for a given aperture a shutter speed of 1/60 second is required, by applying a neutral density filter this could change to seconds or even minutes, depending on the strength of the filter. Obviously you will then need to re-set your camera accordingly, using it either in manual or bulb mode.

Swanage
Taken in rich, evening light, I greatly extended the exposure time by using a strong neutral density filter in order to render the moving sea as a featureless glassy surface, which contrasts with the textured structures in the water.
Canon EOS 5D Mark II, 24–105mm lens, 70 seconds at f.11, ISO 400.

tip

A strong ND filter can often create an unwelcome colour cast but this can be countered in Photoshop by using a cooling filter.

POLARIZING FILTER

This is possibly one of the most useful filters for landscape photography, as it helps in three ways. First, it eliminates unwanted reflections making water and other reflective surfaces appear more transparent. The effect varies considerably depending on the angle to the water so, for example, if you take your shot at an oblique angle, the results will be minimal, but if you are able to take your photograph directly over it, the results can be dramatic. Second, it reduces the reflection from plants and leaves, increasing saturation and so making colours look more intense. Third, a polarizing filter can be used to improve saturation or just to increase contrast, particularly if a sky is included in the shot.

This filter is most widely used by landscape photographers to intensify a blue sky, but it only works to its full potential when the lens is pointing 90 degrees to the sun. The effects can be dramatic, particularly if there are some white clouds present. By removing the reflection of light from the minute water droplets present in the atmosphere, the polarizing filter produces more saturated and slightly darker skies.

There are two types of polarizing filters, linear and circular. The linear versions were cheaper to manufacture and worked well on older SLR cameras. They can, however, create problems with the metering and focusing of modern DSLRs. For these you need a circular polarizer that is designed to work with the camera's exposure and auto-focus systems.

While a polarizing filter has benefits, there are some drawbacks. The purpose of this filter is to reduce the amount of light reaching the sensor, therefore expect to lose between two and three stops when using one. This could mean the difference between hand-holding your camera and putting it onto a tripod. They can be over-used, resulting in an unnaturally dark blue within the sky. Polarizing filters are notoriously tricky to use with wide-angle lenses, sometimes resulting in an uneven effect across the frame.

tip

Rotate the polarizer in its holder to see the affect it is having on the image. Use with care or the effect can appear unnatural.

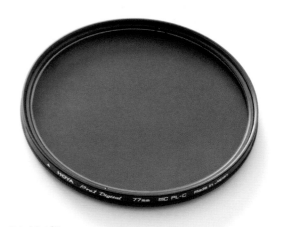

Polarizing filter
A polarizing filter can be used to improve saturation or just to increase contrast, particularly if a sky is included in the shot.

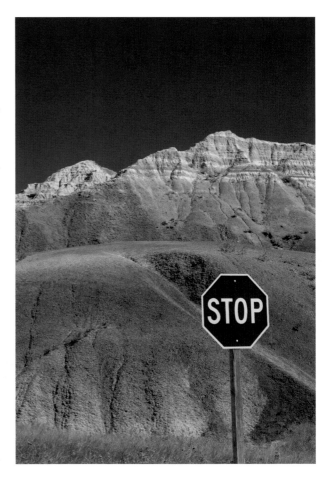

Stop sign
One of the advantages of using a polarizing filter is that it serves to intensify colours, although this can sometimes cause the sky to appear unnaturally dark. Canon EOS 5D Mark II, 24–105 zoom, 1/200th second at f.11, ISO 400.

Field near Granada

Polarizing filters work best when taken at 90 degrees to the sun. Because of the minimal nature of this landscape, it was important to reveal every last detail in the sky. Using a polarizing filter has helped to achieve this.

Canon EOS 5D Mark II, 24–105 zoom, 1/180th second at f.16, ISO 400.

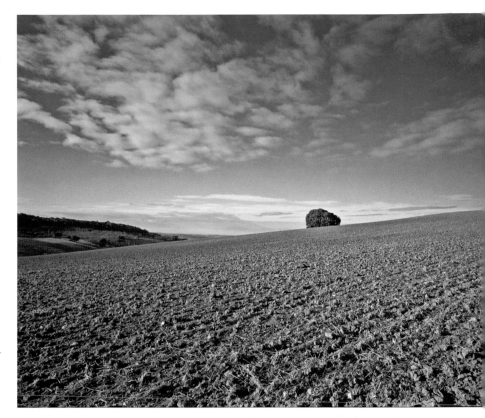

Dunes

Great care needs to be taken when using a polarizing filter that the sky does not appear unevenly polarized. This can be particularly evident when using very wide angle lenses.

Canon EOS 5D Mark II, 20mm lens, 1/64th second at f.16, ISO 250.

THE TRIPOD

Photographing landscape is one of those disciplines that generally requires using a tripod and it is almost inconceivable that anyone specializing in this area of photography would not own and use one. Some will no doubt complain that carrying a tripod, particularly across difficult terrain, can prove inconvenient, but the merits of taking one greatly outnumber this single disadvantage.

WHY USE A TRIPOD?

- Unlike other aspects of photography, shooting landscape is about capturing detail. We expect to see sharpness from the foreground through to the horizon, a tradition established by Ansel Adams and the other great American photographers of the 20th century. This kind of work can only be achieved when using a small aperture, which frequently requires using a tripod because of the corresponding slow shutter speed.
- While the landscape is relatively static, it is nevertheless difficult to keep a straight horizon unless you are using one. But more importantly, it allows you to compose far more purposefully. Many landscape photographers now use zoom lenses and by placing the camera on a tripod, you can work on the finer points of composition.
- Undoubtedly some of the best landscapes are taken early in the morning or late in the day when the sun is low in the sky. This of course means that the strength of the light is reduced and if you want to use a small aperture, this requires using a relatively slow shutter speed.
- When using a tripod, you are no longer a hostage to fortune. You can select the ISO rating and aperture that best suits the lighting conditions.
- Using a tripod allows you to extend the dynamic range of your shot. Digital capture lacks the latitude of film and one often needs to make a HDR file in order to overcome the problem (see the HDR technique [p54]). This is achieved by taking several shots of the location while the camera is mounted on a tripod.
- Even on a bright day, one frequently discovers 'intimate landscapes' hidden away in shaded areas. These are usually best taken when the camera is set on a tripod.

TRIPOD WEIGHT

I hope the argument is clear that a tripod is an essential part of your equipment. The best advice I ever received was to buy the heaviest tripod I could carry and the most expensive one I could afford – it is advice I have never regretted taking. As some of your exposures may be lengthy, you are likely to encounter gusts of wind, and so will need a tripod capable of withstanding them. Most tripods are made of aluminium, which is both light and sturdy, but some are now constructed from carbon fibre, which is even lighter. This makes them easier to carry, but possibly more vulnerable to wind.

In the field there are things that you can do to alleviate this problem: select a spot sheltered from the wind and if that is not possible, use your body as a shield. Some tripods come equipped with a hook on the central column, which allows you to attach your camera bag to weigh it down.

There are various mini-tripods on the market that are small enough to be carried in a camera bag. They can be used in an emergency, providing you can find a suitable surface to place one on, although they do need to be strong enough to be able to support your camera and lens.

THE TRIPOD HEAD

The tripod head needs to be sufficiently robust to support your camera and lens, especially if you plan to use a weighty zoom lens or a motordrive. Flexibility is another important issue, because when you are working in the field you need to be able to manoeuvre your camera quickly. There are two principle types of

SPIRIT LEVELS

A small feature that I personally find indispensable is a spirit level. These are sometimes integrated into the head, but if not, you can buy them independently and attach them to the camera's hot-shoe. Either way, it is important to retain straight horizons, and using a spirit level helps.

Carbon fibre tripod

Most tripods are made of aluminium, which is both light and sturdy, but some manufacturers are now constructing them from carbon fibre which is even lighter. This makes it more convenient when trekking long distances.

tripod heads – ball and socket and pan and tilt.

Pan and tilt heads - allow vertical tilt (forward and backward), together with lateral and swivel movement. They are well suited to panning and ideal if you wish to construct panoramics, but when you are working under pressure, the ball and socket design is far more adaptable.

Ball and socket heads - favoured by most professional photographers, but they do tend to be more expensive. Their big advantage is their speed and flexibility. With just one turn of the control release you are able to lock your camera in any position. A feature of most ball heads is a 'drag' facility, which is designed to give the head sufficient grip even with the heaviest of cameras. You may also consider buying a quick release tripod head, particularly if you anticipate making continuous camera changes.

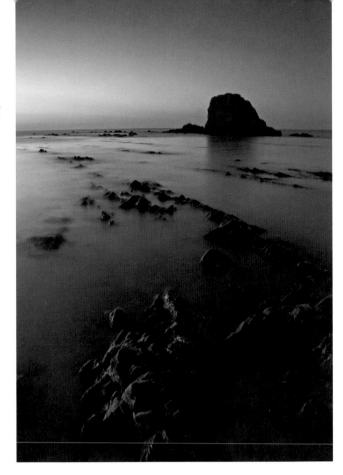

Rocky shoreline
By using a tripod, you can continue to take landscape shots even in very low light. This was taken 50 minutes after the sun had set.
Canon EOS 5D Mark II, 20mm lens, 187 seconds at f.16, ISO 100.

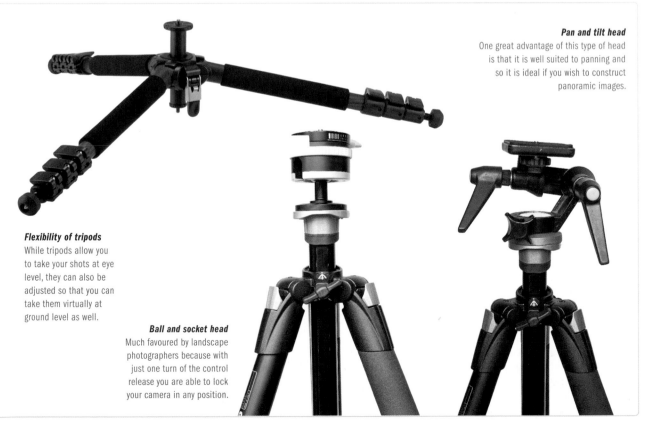

Pan and tilt head
One great advantage of this type of head is that it is well suited to panning and so it is ideal if you wish to construct panoramic images.

Flexibility of tripods
While tripods allow you to take your shots at eye level, they can also be adjusted so that you can take them virtually at ground level as well.

Ball and socket head
Much favoured by landscape photographers because with just one turn of the control release you are able to lock your camera in any position.

TRIPOD ALTERNATIVES

There are several other pieces of equipment or camera functions that can be used either instead of a tripod or in addition to one as an additional security against camera shake.

MONOPOD

Like the mini-tripod, this is a quick and lightweight way to stabilize the camera. Monopods are useful in certain situations and are generally used to prevent vertical movement, although I certainly would not advise using one for exposures of one second or more. They are best used to stabilize long angle lenses when shooting at moderate speeds.

GORILLAPOD

If carrying a tripod is too much of a nuisance, an innovative option you may wish to consider is a gorillapod. This is a compact, cheap, lightweight alternative that can easily be carried in your bag. Having fixed your camera to the gorillapod, you can then attach the entire unit to any available elevated structure such as a branch of a tree or a lamppost by using its bendable arms, although, because of their size, they are not suited to heavy, professional equipment. If you are using a compact, a lightweight DSLR or a Four Thirds camera, this might prove to be an excellent alternative.

CABLE RELEASE

This is a simple mechanism that allows the photographer to take a shot without touching, and therefore disturbing, the camera. Once again I would urge that you buy the best that you can afford, and certainly you should have one with a locking device. Rather irritatingly, some cameras can only take a cable release designed by the camera manufacturer, which simply adds to the cost, but it is a piece of equipment you cannot afford to be without. It is also possible to use an infrared operated wireless remote release. These are ideal, particularly if you wish to use fill-in flash, because they allow you to operate away from your camera.

SELF-TIMER

If you don't have a cable release, try using the camera's self-timer. This usually offers an option of either two seconds or ten, although in my experience two seconds is too short as you can still experience camera shake. Having selected the self-timer from the menu, simply press the shutter button and a bleeper will warn you that your camera is on standby and will then fire. Do not stand in front of the camera when setting off the shutter, otherwise your camera will auto-focus on you.

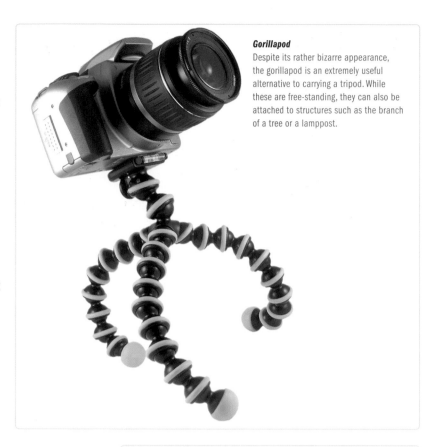

Gorillapod
Despite its rather bizarre appearance, the gorillapod is an extremely useful alternative to carrying a tripod. While these are free-standing, they can also be attached to structures such as the branch of a tree or a lamppost.

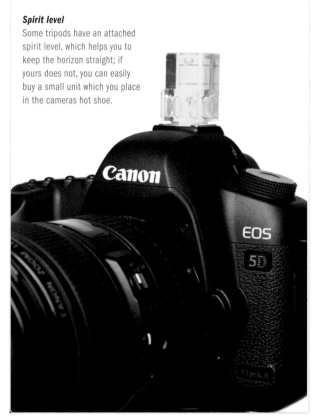

Spirit level
Some tripods have an attached spirit level, which helps you to keep the horizon straight; if yours does not, you can easily buy a small unit which you place in the cameras hot shoe.

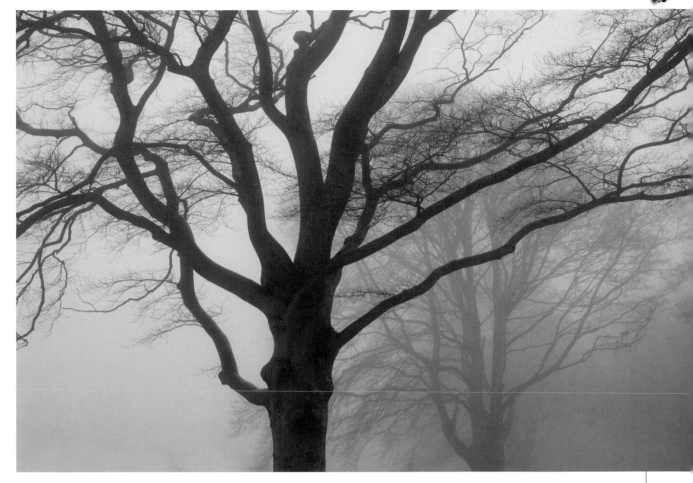

MIRROR LOCK

Although using a self-timer or cable release can prevent camera shake, selecting the camera's mirror lock-up facility in order to reduce vibration can also help, particularly when using a macro or extreme long angle lens. This option can be found in the camera's menu. The problems of camera shake caused by the movement of the mirror are particularly noticeable when using a shutter speed between ¼ second to 2 seconds, even if the camera has been securely attached to the tripod.

LENS STABILIZERS

There will be occasions when it just isn't appropriate to use a tripod, which is where lens stabilizers can prove so useful. Often referred to as IS (image stabilization), VR (vibration reduction) or OS (optical stabilization), these lenses have a mechanism built in that detects hand movements and are able to compensate for this. Each lens manufacturer uses different technology, but essentially the lens uses a movement detector coupled to an electronically driven optical device, which cancels out the camera shake. It depends on the lens, but you should be able to hand-hold your camera at three shutter speeds slower than you would normally. So, if you could hand-hold your camera at 1/60 second without a stabilizer, it should be possible to hand-hold at just 1/8 of a second with one. Some camera manufacturers have built the stabilizer directly into the camera body, obviating the need to buy expensive lenses with stabilizers.

Trees in mist
A tripod is an essential piece of equipment in any low light situation, but particularly dense fog. As I was using a relatively long angle lens and needed to use a small aperture, hand-holding my camera really was not an option.
Canon EOS 5D Mark II, 70–200mm lens, 1/15th second at f.22, ISO 100.

YOUR CHOICE OF LENS

Your choice of lens and how you use it can have an enormous impact on the final image and so it is worthwhile trying to find out what their specific characteristics are and which lenses are best suited to landscape work. Bear in mind that the range of lenses available for a full frame DSLR is different from those with a smaller APS-C sensor. Lenses vary in price and specifications and it is sometimes quite confusing, although reading the latest magazine reviews can help. Generally, the advice is that you should buy the best lens you can afford and do not consider getting another until you really need it.

THE STANDARD LENS

Before DSLRs become the norm, the 50mm lens was seen as the 'standard' lens and would be part of the initial purchase package. With the increasing popularity of zoom lenses, the standard lens is being used less, which is a pity, because it does have certain optical characteristics that are well suited to landscape photography. A standard lens is one that creates a perspective nearest to what the eye can see and probably reflects the landscape you are photographing more accurately than any other. However, things are slightly complicated by whether you are working with a full-frame DSLR camera or not. If you are using one with an APS-C sensor, then a 35mm lens will be your standard, and with a Four Thirds, 25mm.

Irrespective of the camera you are using, these standard lenses are easier and therefore cheaper to manufacture, so it is possible to make them with a larger maximum aperture: f.2.8 is the norm, but some of the more expensive standard lenses go down to f.1.4. This not only means that you are able to hand-hold your camera in poorer light conditions, but that the optics are improved, particularly when using a smaller aperture.

WIDE-ANGLE LENSES

This is often the lens of choice for many landscape workers, largely because the wide-angle lens has the capacity to condense a broad view into a smaller format. It can handle the panoramic view offered by a landscape far more effectively than any other lens. A wide-angle lens embraces anything from a 35mm lens down to 6mm but, of course, at this extreme, the images will appear distinctly fish-eye. If you have never used a wide-angle lens before, a 24mm would be an ideal first step. With any lens other than a standard you will experience some distortion, but that goes with the territory. With an increased angle of view (94 degrees) you will just begin to detect a slight curvature of the horizon; this will be most evident when photographing simple seascapes. With a 15mm lens or wider, you will start to see a fish-eye effect.

On the plus side, a wide-angle lens has a broader angle of view and a much deeper depth of field than the standard lens. Even at f.8 everything should appear in focus. Because of their short focal length, it is possible to hand-hold the camera at speeds as low as 1/30 second even without a stabilizer, which might obviate the need to use a tripod. With a wide-angle lens on the camera, one is much more inclined to use it in the portrait format in order to utilize the incredible sense of depth these lenses cover. It is very difficult to avoid including the sky when using a wide-angle lens, so it is best used when the sky appears interesting.

Red rock
The standard lens is often overlooked, but can be useful as it creates a perspective nearest to what the eye can see.
Canon EOS 5D Mark II, 50mm lens, 1/180th second at f.8, ISO 100.

tip

Lens quality is crucial to the outcome of your photographs so aim to buy the best you can afford.

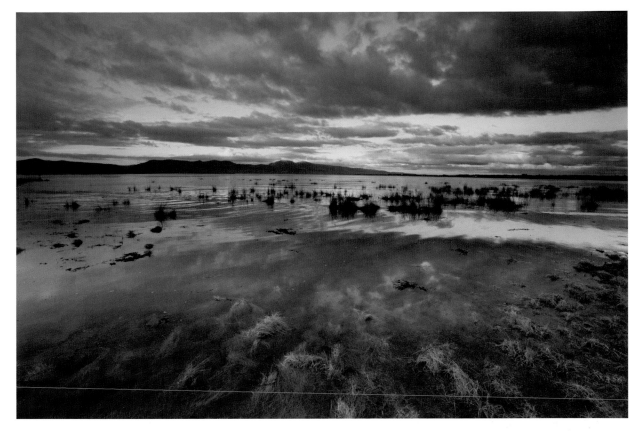

Flooded estuary
Wide-angle lenses are particularly well suited for landscape because they allow you
to capture an almost panoramic view of the location.
Canon EOS 5D Mark II, 17mm lens, 1/200th second at f.14, ISO 250.

Field with silos
One of the great advantages of using a wide-angle lens is that you can ensure than
everything is sharp, even when using a moderately large aperture.
Canon EOS 5D Mark II, 20mm lens, 1/8th second at f.11, ISO 400.

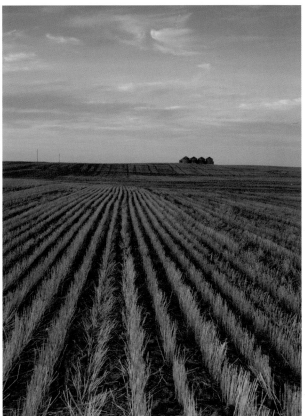

TELEPHOTO LENSES

This is another range of lenses much valued by landscape workers,
largely because they compress the perspective by reducing the
apparent distance between the foreground and background. The
results can be particularly graphic and sometimes quite abstract.
For landscapes, the best focal lengths to use are between 100mm
and 300mm; certainly at the extreme end one rarely includes the
sky. The main characteristics of telephoto lenses are that they have a
considerably reduced depth of field, and generally tend to be slower
than the standard lens. When photographing landscape select either
a very small or a large aperture. When the aperture is wide open, only
a narrow part of the image will be in focus, which in a landscape can
create a rather pleasing, almost abstract picture; this can be enhanced
by an effect called 'circles of confusion'. If, however, you want every
part of the picture to be sharp, you will need to use the smallest
aperture and focus extremely carefully, ideally one third of the way into
the landscape.

Because any hand movement tends to be amplified when

using a telephoto lens, a tripod is recommended. If the lens has an optical stabilization system, use it. Telephotos are also particularly useful when you wish to isolate a part of the landscape such as a tree or building from the background by using a narrow depth of field; the results can be stunning.

ZOOM LENSES

Good landscape work generally involves walking, and carrying too much heavy equipment can prove quite discouraging. If you are able to rationalize, all the better and one way of doing this is to use zoom lenses. Essentially all you need is a moderately wide-angle zoom and a long-angle zoom to cover most situations. Until recently, there was a concern that the quality of zooms did not match those of prime (fixed focal length) lenses, but lens technology has greatly improved, and the quality of images you can get from a top end zoom should compare with anything taken using a prime lens. Moreover, they

have got considerably smaller which makes carrying them much easier. But possibly the greatest advantage of zooms is that they encourage the user to compose creatively. Having identified a potentially interesting landscape, it is worth checking out every possible compositional viewpoint and zoom lenses allow you to do this. The variation of zooms is now so great that they are classified as follows:

Standard zoom – is one that spans a moderate wide angle to a short telephoto. Often referred to as 'kit' lenses because they are offered as part of the camera package, they do vary in quality, and the more you pay, the better the lens. If you do not have a particular project in mind, this is an excellent all-rounder for landscape work.

Wide-angle zoom – possibly most photographers' favourite lens, largely because of the drama it can add to

a landscape shot. Typically a wide-angle zoom will cover a range between 10–24mm, although you will experience some distortion at the super-wide end. This becomes most noticeable when photographing horizons; expect to see a slight curvature.

Telephoto zoom – often overlooked by some landscape photographers, these lenses are superb for capturing distant features. As you scan a landscape, the area is vast, and what can appear to be reasonably within the scope of a normal lens often proves not to be. I personally value the telephoto zoom as highly as my wide-angle, although it is very rare that I can use it without the support of a tripod.

Super-zooms – typically spanning a focal length of 18–200mm, super-zooms are designed as a one lens solution, and while they are amazingly flexible, in terms of quality they rarely compete with other zooms. If you are in

Tree in field of sunflowers
From a creative standpoint, one of the great virtues of the telephoto lens is its capacity to reduce the apparent distance between the foreground and background, producing graphic and sometimes abstract results.
Canon EOS 5D Mark II, 300mm lens, 1/140 second at f/32, ISO 100.

KEEPING YOUR LENS CLEAN
If you want to get the best possible optical results from your lens, it is important to keep it clean. The easiest way to achieve this is always to always to use a UV filter (see the filter section [p16]). If it gets dirty, it is a simple task to take it off and clean it. This might require just a wipe with a soft cloth but if the filter becomes particularly greasy, then try washing it in warm soapy water. When removing your filters ensure that you leave no finger-marks on the front element; if you do, it is important that they are removed as quickly as possible. Only use a high quality lens cloth or lens-cleaning tissues to do this. You will undoubtedly get dust on the lens from time to time; this should also be removed by holding the lens upside down and blowing away the dust using a blower brush. Take particular care of the rear element as any dust or loose debris on this can substantially degrade the quality of the image.

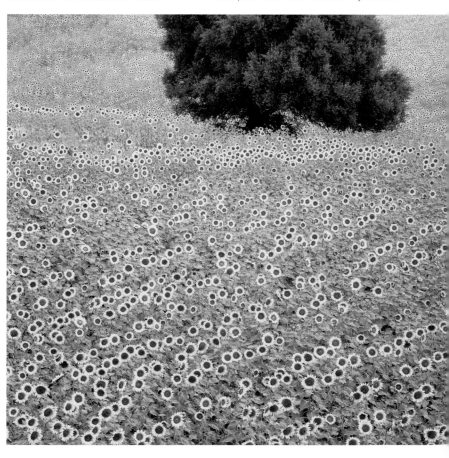

a difficult mountainous environment and you are greatly restricted by what you can carry, then this lens certainly would serve a purpose. One other advantage with a super-zoom is that, because you hardly ever need to change lenses, the incidence of dust on the sensor is kept to a minimum.

MACRO LENSES

As many zoom lenses now have a macro setting, fewer photographers are buying prime macro lenses, but there still is a role for macro lenses in landscape photography. A macro lens will have a minimum ratio of 1:1, which means that it can produce a sharp image of a subject the size of the camera's sensor. Some macro lenses will have a magnification capacity of 5:1, but really this is going beyond the realms of landscape photography. Where they do have their uses is when you wish to capture 'intimate' landscapes. While many landscape photographers concentrate on vast panoramas, there is a place for shooting tiny elements within the landscape as well.

LENS HOODS

Lens hoods can sometimes appear a bit cumbersome, but more good landscape shots are lost by not using one than for any other reason. Fortunately most lenses now come with a lens hood attached; they are necessary in order to reduce flare. Attaching a lens hood to prime lenses tends not to create problems, however you do need to pay a little more attention when attaching one to a zoom, particularly a wide-angle zoom, which requires a customized petal lens hood, because if it is not properly attached, you will encounter vignetting. Essentially I would ensure that a lens hood is attached at all times except when using an on-camera flash; then you will need to remove it otherwise you could end up with a strange shadow in the image.

tip

Super-zoom lenses are a good option if you need to do a lot of travelling by foot. They are incredibly flexible and cut down the need to carry lots of different lenses.

Barnacle
A macro lens, or the macro facility of your zoom, encourages you to look for 'intimate landscapes', which may prove to be your most original images. Canon EOS 5D Mark II, 60mm lens, 1/10th second at f.22, ISO 400.

Ploughed field and tree
Telephoto zooms are superb for capturing distant detail. Our eyes are very selective but as soon as we look through the viewfinder, very often more is included than initially caught our attention. Using a telephoto lens helps us to focus on just that part of the landscape we want to include.
Canon EOS 5D Mark II, 200mm lens, 1/400th second at f/5.6, ISO 100.

LENS CONVERTORS
A lens converter is an accessory that allows you to change the focal length of a lens. It may allow you to convert your wide-angle lens to a fish-eye, without having to buy an additional and potentially expensive lens. At the other extreme, you can alter your 300mm lens to a 600mm lens, simply by adding a converter. Lens converters are cheaper than conventional lenses, but of course they do not achieve the same standard of quality. On the positive side, they allow you to experiment with extreme focal lengths, which might suit your style of photography.

CHOOSING A BACKPACK

Unless you have the good fortune to be able to take a shot from a convenient lay-by, the likelihood is that you will need to walk, sometimes great distances, in order to get to your chosen location, which means carrying your photographic equipment with you. This is where a gadget bag or, better still, a backpack, becomes so important.

POINTS TO CONSIDER

Like a rucksack, the photographers' backpack is designed to allow you to distribute the weight of your equipment over your shoulders and back. A balance has to be struck between providing protection for the camera, offering flexible storage for a range of equipment and yet be comfortable to wear. The array of products currently available is impressive, each offering slightly different specifications, and it is important to match those to your own personal requirements.

Is it comfortable?

It doesn't matter how flexible you backpack is, or how many impressive design features it has, it needs to be comfortable. Moreover, a product favoured by an athletic, six-foot male might not suit a petite female. Almost the first thing you ought to do is to strap it on and, even unloaded, you can immediately sense whether it fits your needs. You should be able to adjust it in such a way that it sits comfortably in the centre of your back; if it is too low, you are likely to experience spinal problems.

Other details to consider are how well padded are the shoulder harnesses, can they be easily adjusted to fit you, is there sufficient padding in the lumbar region and is it breathable? Also, you do need to ask yourself whether it is likely to prove too heavy over a longer period.

Construction quality

In addition to checking out the ergonomics of your backpack, you should also consider how well it has been constructed. After all, you want it to last for years. Most backpacks open and close using a zip, so check that it is sufficiently durable. Mindful of how important the zip is to the overall design, some manufacturers are constructing flaps over the zip in order to protect it from possible damage. While some of the older designs looked rather like a rambler's rucksack, some modern designs are rectangular in shape, more rigid in construction and are better suited to carrying photographic equipment.

It is also worth checking out the durability of the stitching, as you do not want you backpack coming loose at the seams. But most importantly, your backpack needs to protect your valuable camera equipment from possible knocks, so check whether it is sufficiently padded.

What is the storage capacity?

In addition to our camera (or cameras), we also need to take various lenses, light meters, memory cards and cable releases, all of which have to be organized for easy access. Bearing in mind that we each have specific needs, it is important that your backpack has well padded, flexible, modular compartments which allow you to fit it all in. It should be designed to ensure that equipment does not move around when you are walking. Increasingly backpacks are being manufactured with small pockets, which are useful for things like maps, mobile phones, wallets, purses and so-on, which means that when you do go out trekking, your backpack is all you need to take.

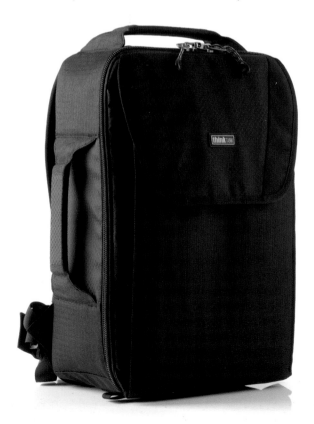

Backpack
A backpack is an important long-term investment so consider carefully how it should suit your needs.

Carrying a tripod

A tripod is an essential piece of equipment but is one further item you need to carry. With this in mind, manufacturers are designing products that allow your strap you tripod to your backpack. You need to give this aspect of the design some serious thought. The most popular, although possibly the least successful, of these designs, have straps at the bottom of the bag. Your tripod is likely to be the heaviest piece of equipment, and having it swinging from the bottom of your backpack really isn't ideal. Some backpacks are now designed so that the tripod is strapped on the top, or is stored comfortably within the heavy lumbar padding on the reverse of the backpack.

Will it hold a laptop?

Increasingly photographers wish to take a laptop with them, particularly if they intend being away for long periods. It allows them to edit their work while they are away, or possibly even email images to clients if they are working professionally. Several backpack manufacturers now design a compartment for your laptop.

Is it waterproof?

All photographic equipment is vulnerable when wet, so it is important that your backpack is impervious to rain. Most are made from a water-resistant, but breathable material, but if it has been poorly designed, water can still seep in through seams. Some backpacks come with purpose-made raincovers, which will not just protect the backpack during a shower, but is also a useful way of protecting your equipment from blowing sand.

Is it airport friendly?

Many landscape photographers opt to travel abroad, but with very demanding restrictions on the dimensions of hand luggage, it is important that your backpack does not go over these limits. Where one can sometimes get caught out is when the outer pockets are fully loaded, as they can exceed the maximum allowed width. Mindful of how often many photographers travel, several manufacturers now produce rolling photo bags which you can carry on your back like a conventional backpack, but which also have wheels and a handle allowing you to pull your gear through the airport terminal.

When travelling abroad, we sometimes need to rationalize and think carefully about what is essential for our trip. I cannot imagine being without my battery charger, so I always ensure that it comes with me in my backpack, rather in a suitcase where it might get lost. However, I might be prepared to pack my flashgun in a suitcase if I do not anticipate doing much flash work. Instead of taking all your prime lenses, just pack one or two zooms instead.

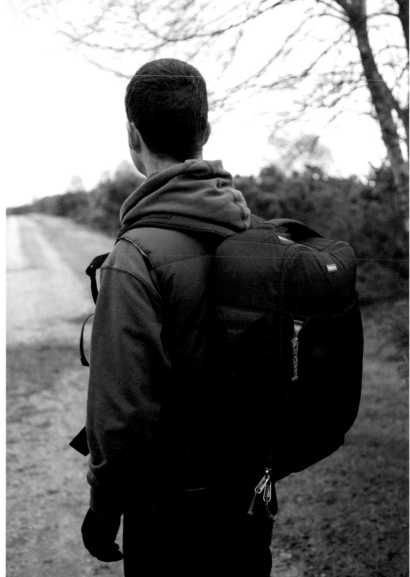

Backpack in use
The latest backpack designs are extremely comfortable and practical – a big improvement on the old, unwieldy camera bags.

TAKING CARE

The appeal of photographing landscapes is that it often encourages us to venture into the wilderness and experience the great outdoors. We purposely set out when the weather is likely to be interesting (which non-photographers might term 'bad') because that is when we are likely to bag our best shots. In these conditions and in harsh environments, there is the potential for damaging our expensive equipment, not to mention harming ourselves, so it is important to remain aware of possible hazards.

PROTECTING YOUR CAMERA

- Always use a UV filter (see the section on filters [p16]). When you are out on location, this is when you are at your most vulnerable, and most tired. It is so easy to drop an expensive camera or lens. Increasingly cameras are being constructed within titanium frames and can withstand a certain measure of mishandling, however lenses are always more vulnerable. Ensuring that you always replace your lens-cap and that a UV filter is constantly fitted will go some way to protect it. A lens hood helps as well.
- In bad weather make sure that you don't let moisture get inside your camera as this can do serious damage to the delicate electronic parts. In heavy rain, water can seep into your camera from outside, so ensure that it remains sheltered from the elements and, should you wish to take shots, make sure that you and your camera are under cover. Various companies manufacture purpose-made rain covers that allow you to operate your camera even in the heaviest downpour.
- Few things are quite as corrosive as salt water, so when you are photographing by the coast, keep your equipment clear of sea spray. If you do get any onto your equipment, have a clean microfibre cloth available to immediately soak up any moisture. Take extra care when working on slippery rocks as it is so easy to drop equipment into pools, which really would spell disaster.
- When working in deserts, or on beaches, be aware of sudden gusts of wind as even the smallest amount of grit can do untold damage. Change your lenses as infrequently as possible, and if you do need to, try to find a sheltered spot to work from. There are many good arguments for using a zoom lens, and this is one of them.
- If you are working with a tripod in a high wind, don't underestimate its capacity to send your tripod and camera crashing. In these situations, never leave your equipment unattended and try to use your body as a shield. If your tripod has a camera bag hook, use it.

Colorado river
If you are exploring canyons, let someone know where you're going and what time you expect to return.
Canon EOS 5D Mark II, 70–200mm lens, 1/30th second at f.16, ISO 100.

- In areas of very high humidity, both the lenses and the viewfinder will fog up, so remember to carry a clean microfibre towel. When you finally pack away your equipment, make sure that it is as dry as possible.

BE PREPARED

While it is desirable that your camera and lenses are not damaged, it is essential that no harm comes to you. Trekking into the wildernesses can be great fun, but it is important that you respect the terrain.

- Think about your footwear. When trekking, you are likely to encounter uneven terrain, wet or slippery rocks or shallow streams and pools. Your footwear should be able to deal with all of this. If your feet are uncomfortable, it is difficult to concentrate on photography, so wear ankle boots lined with Gore-Tex. If you anticipate doing quite a lot of work near water, wear wellingtons.

- If you are working near or by water, particularly in the colder months, it isn't worth taking needless risks; sudden immersion into cold water is the second biggest accidental killer, so be aware of slipping on ice.

- Other than in the summer months, make sure you dress warmly. This can often mean wearing a waterproof. The best light for landscapes is usually before dawn or just as the sun is setting but, of course, this can be the coldest time of the day. Often we need to wait around just to see if the lighting improves, leaving us ever more vulnerable. I always make it standard practice to take more clothes than I need on the principle that if I get too warm, I can always remove a layer. A range of comfortable, lightweight, waterproof clothing favoured by many professional photographers, as well as hill-walkers is made by Paramo. For further details go to www.paramo.co.uk.

- When working by the coast, be aware of the tides. Often the best time to photograph the sea is when the tide is going out. An in-coming tide can also offer wonderful shooting opportunities, but you do need to be aware that you can get cut-off. Always check your escape route.

- When working in large bays and estuaries, be aware of the hazards of sinking mud and quicksand – surprisingly, it is a common problem along many coasts. It is worth consulting the coastguard, checking a local map, or just asking the locals.

- I always ensure that I have a towel and a dry pair of socks in the car. Having experienced several accidents in sea water over recent years, I have come to appreciate the joys of driving home with dry feet.

- Make sure that you have a fully charged mobile phone with you. If you are mountaineering, felling-walking or exploring canyons, do let someone know where you are going and your estimated time of return.

- In hot and dry conditions take plenty of drinking water. Don't underestimate how quickly you can dehydrate. Make sure that you are well covered with sun-block and, of course, that your head is protected to avoid sun-stroke.

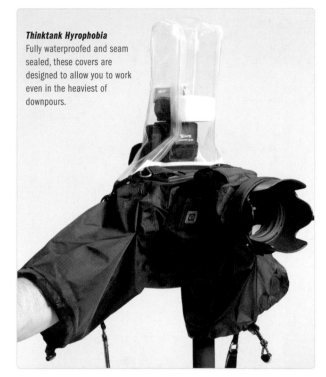

Thinktank Hyrophobia
Fully waterproofed and seam sealed, these covers are designed to allow you to work even in the heaviest of downpours.

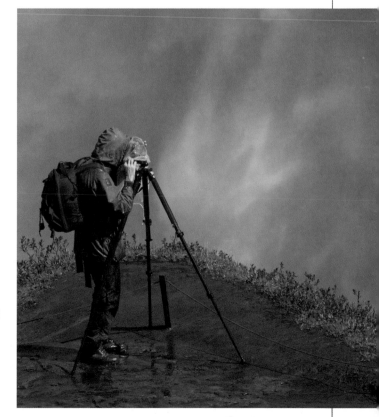

Paramo waterproofs
Lightweight, waterproof clothing will come into its own in adverse weather.

In-Camera Techniques

PLANNING A SHOOT

When I first started photographing landscapes, I would hop into my car, drive aimlessly and wonder why I had so little to show when I returned home. The reason was that I had no idea what I wanted to take in the first place. I had this optimistic belief that, as I drove, fabulous landscapes would magically materialize before my eyes; in reality that very rarely happens. It's far better to have a particular project in mind, whether it's photographing the patterns created by ploughed fields or exploring a particular technique, such as fill-in flash.

RECCE THE LOCATION

Whether you are photographing in a new location or perhaps closer to home, it is critical that you reconnoiter the area prior to taking your shots. The real art of landscape photography is being able to recognize the potential of a location, even if it does not appear particularly exciting at the time. The question you need to ask yourself is 'what if…' What would this landscape look like if I returned later this evening, or would this be a suitable location to take in foggy weather? Understanding how the position of the sun, weather conditions or the passing of the seasons affects the landscape is critical and trying to anticipate how this will work is crucial to successful landscape photography.

USING A SUN COMPASS

Taking the first of those issues, one small tool that I have found invaluable is the *Dubois Sun Compass*. This cheap little device allows me to accurately establish the sunrise or sunset positions of any location throughout the year. By taking a simple reading, I can quickly assess whether it is worth returning to a particular scene later in the day, or perhaps early the next. For it to work, simply line the compass with the north; the months of the year are printed on the base, which allows you to make accurate readings month by month. It also lets you plot the course of the sun throughout the day, which will give you some idea of how shadows will affect your landscape. For further information go to www.flight-logistics.co.uk.

HAND-HELD GPS

Instead of a map, many photographers now use a hand-held GPS tracker to help them get to and from their location. These devices work just like your car sat-nav except that they are loaded with ordnance survey mapping instead. They also provide valuable sunrise and sunset times.

CREATE A PLANNER

Whether you are working close to home or not, it is a good idea to keep a planner. This could simply take the form of a photographer's diary in which you log potentially interesting places, or you could take some snapshots with a compact camera or mobile phone as a visual record. The landscape is in a continuum, forever changing, and even the most unpromising areas will have their moments. The skill is to anticipate when. For example, you might regularly pass an interesting group of trees as you drive to work, but you are aware of an unsightly housing estate in the far distance. However, if you were to pass the same trees in misty conditions, the unattractive background would cease to be a problem. Landscapes can be amazingly seasonal. Fields that appear uninteresting in winter can easily be transformed in spring and it is just a matter of anticipating possible changes and recording this.

This is most easily done with respect to your own immediate environment, although when travelling further afield, I make sure that I have at least a few days in the same location, giving me the opportunity to do some meaningful reconnoitering. It is only then that I am able to plan the best use of my time.

Dubois Sun Compass
A sun compass is a handy tool to establish sunrise and sunset positions of any location at any time of year.

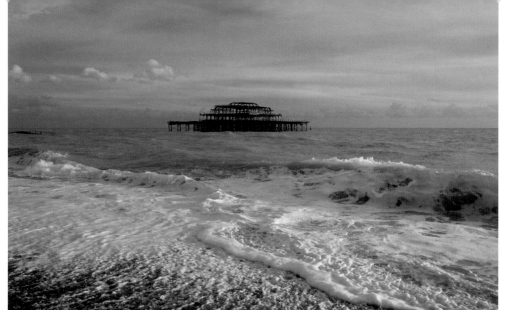

West Pier, Brighton, 1
This was photographed in the middle of the afternoon when there was just a scattering of clouds in the sky; I decided to select a moment just as the sun came out. Using a relatively fast shutter speed, I was able to make a feature of the breaking waves.
Canon EOS 1Ds Mark II, 17–40mm lens, 1/250th second at f.16, ISO 100.

West Pier, Brighton, 2
While this was not a particularly dramatic location, I recognized that with better lighting, it had more photographic potential. I returned several hours later and caught it just as the sun was setting to my right. As the evening sky proved to be the most interesting feature, I pointed my camera upwards in order to include more of it.
Canon EOS 1Ds Mark II, 17–40mm lens, 1/4 second at f.16, ISO 100.

West Pier, Brighton, 3
I finally decided to return to the same location at night-time and obviously needed to give this a much longer exposure. This image assumes an almost mystical atmosphere, which contrasts with the stark realism of the previous two shots.
Canon EOS 1Ds Mark II, 17–40mm lens, 400 seconds at f.11, ISO 100.

THE ROLE OF THE CAR

It is all too easy to see landscape photography as some Spartan endeavour, believing that we should trek to all our locations, but that of course is simply unpractical. I have already made clear how important reconnoitering is to the process of identifying locations, and obviously we need to use our car to do this.

It should be noted that Ansel Adams (the doyen of all landscape photographers) would often use the roof of his station wagon as a platform for taking his shots, so we should not be afraid of using our vehicles either. They are useful for getting us to where we need to be, although we do need to be aware of their limitations. It is unlikely that you will capture a truly great landscape from the roadside; having parked, you will undoubtedly need to walk, sometimes considerable distances to get the shot you are after. If you do see a good location from the road, it is important that you park responsibly, particularly if you anticipate working on it for a while. Also, once parked, try crossing the road just to see if there is anything worthwhile on the other side. Use it as a chance to explore a little wider.

DO YOUR RESEARCH

It really is worth investing the time in researching a new area prior to travelling. This could be important in all sorts of ways, if only to ensure that you take the right equipment along. While I would never encourage plagiarism, it does help to see how others have photographed the area. Obviously landscape books help, but local postcards can also be very useful. The Internet is proving to be a valuable and accessible resource, particularly with websites such as *Flickr*. while many of the images may not be quite to your liking, you will invariably find examples that illustrate the potential of a particular area. It is important, however, not to become over-seduced by certain pictures and not to copy them. Not only is it unethical, but in the long term it will do nothing to develop your own confidence as a landscape photographer.

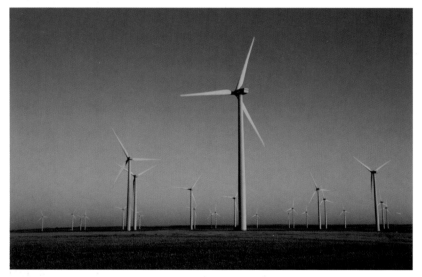

Wind turbines, 1
With the setting sun directly behind me, there was still sufficient light to freeze the movement of the blades. The warmth of the light is particularly apparent in the uprights of the wind turbines.
Canon EOS 5D Mark II, 50mm lens, 1/60 second at f.11, ISO 100.

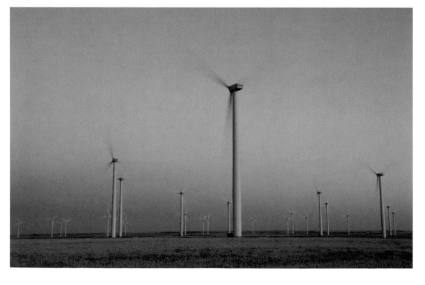

Wind turbines, 2
Only moments after the sun has set, the quality of the light dramatically changes. Not only has its intensity diminished, allowing me to use a slower shutter speed, but the hues have changed as well. Photographing just before and after sun-down always offers excellent photographic opportunities.
Canon EOS 5D Mark II, 50mm lens, 1 second at f.16, ISO 100.

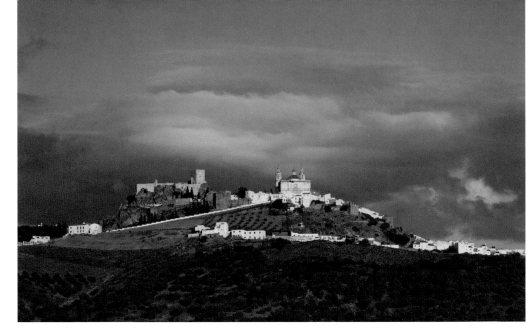

Passing storm, 1
Floating clouds can appear immensely theatrical as they drift across the sky, although in this example I felt the sky appeared to overwhelm the foreground.
Canon EOS 5D Mark II, 70–200mm lens, 1/50th second at f.22, ISO 100.

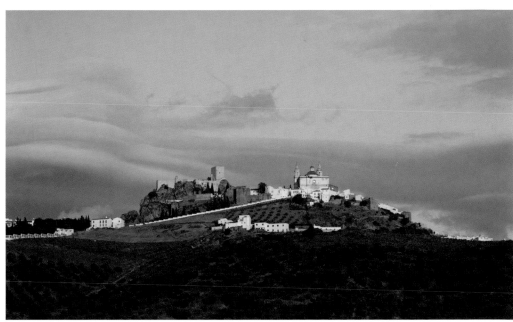

Passing storm, 2
By waiting just a couple of minutes, the relationship between the clouds and the foreground changes. The wonderfully arabesque lines these clouds create appear to echo features in the foreground.
Canon EOS 5D Mark II, 70–200mm lens, 1/30th second at f.22, ISO 100.

WHEN TO TAKE YOUR SHOT

The most important issue when planning to take photographs is judging precisely when to press the shutter. It could be a matter of just waiting seconds or minutes but you may need to delay taking your shot for hours, days or even months. The landscape is rather like a stage, which is in one way static, but in another constantly changing. There are often occasions, particularly when there is a mixture of sunshine and moving clouds, when the success of the image will be determined by which part of the landscape is illuminated at any precise moment.

Taking a slightly longer view, there will be times when you sense that the shot should be taken in the middle of the day, or perhaps it might be improved if it were captured pre-dawn; it is a matter of using your judgment. As a landscape photographer, one thing you must appreciate is just how dramatically a given scenario can change and being able to anticipate this is part of the skill.

If you are not quite sure of what you wish to achieve, be prepared to experiment with varying lighting conditions at different times of the day. The great thing about shooting digitally is that it allows you to

immediately review your work, giving you a useful guide for further photography.

Finally, if you find yourself in a potentially interesting location, but feel that it still doesn't offer what you are after, establish in your own mind what you feel is missing. It might well be that it needs to be photographed in better weather conditions, or perhaps at a different time of the year. If you believe that a particular location has good photographic potential, be prepared to return.

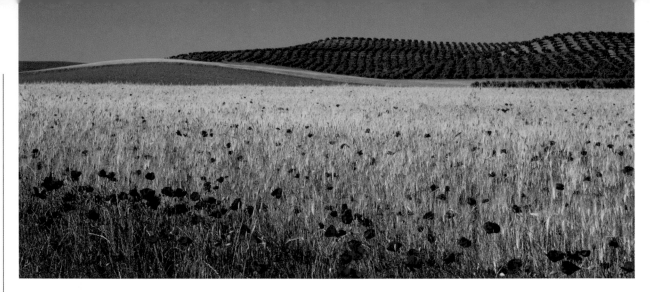

FORMAT AND ORIENTATION

As cameras with a rectangular format are most common, we face a choice about the camera's orientation – whether to use either the 'landscape' or 'portrait' format. The idea that when photographing a figure we unthinkingly hold our camera vertically but opt for a horizontal format for landscapes is unhelpful. We might fill the frame more effectively in landscape format but it might not be the best option aesthetically.

THE EFFECT OF THE LENS

The choice of lens can have a bearing on the best orientation of the camera. For example, when using an ultra wide-angle lens, the portrait format often adds an exciting dimension, enhancing that dramatic sense of depth these lenses are capable of creating. This certainly applies if you are able to identify an interesting feature in the near foreground. In contrast, long lenses seem generally to work well in landscape format, particularly if you wish to compress the image.

But when it comes to photography you should never impose rules. If you think a subject ought to be photographed in the horizontal format, try turning the camera vertically just to see if it can be improved in any way. The important point is to be prepared to experiment. Choosing the right format certainly will help your composition, but it is not always clear-cut.

SQUARE FORMAT

In the days of film, the square format of cameras such as the Hasselblad was popular with landscape photographers. One can still

Andalusian field
Using a panoramic format is rather like photographing a narrative as it encourages the viewer to 'read' the image from left to right. The gently undulating horizon emphasizes the overall tranquility of this landscape. This was constructed from two images stitched together using Photomerge. Photograph by Eva Worobiec.
Canon EOS 5D Mark II, 17–40mm, 1/50th second at f.16, ISO 200.

Undulating fields
This has been cropped to a square, which is viewed as a static shape that helps to suggest stability and wholeness.
Canon EOS 5D Mark II, 70–200mm, 1/25th second at f.22, ISO 100.

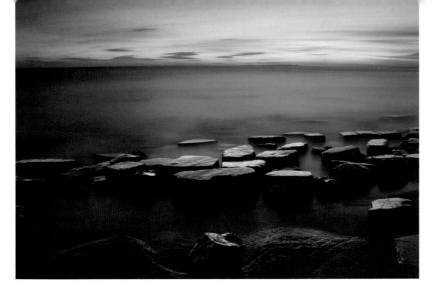

Kimmeridge 1.
By using the landscape format, one is able to achieve a gentle, almost lyrical relationship between the rocks in the foreground and the distant sky.
Canon EOS 5D Mark II, 17—40mm, 66 seconds at f.22, ISO 100.

Kimmeridge 2
By choosing to shoot in the portrait format, the dynamics of the composition completely changes, particularly when using a wide-angle lens, as the sense of depth is greatly exaggerated.
Canon EOS 5D Mark II, 17—40mm, 85 seconds at f.16, ISO 100.

tip

For creating a stitched panorama, it helps if your tripod has a spirit level.

buy digital square-format cameras but they are far less common than rectangular DSLRs, which is a pity because the square has qualities that are well suited to landscape. However, as sensors are become ever larger, it should be possible to crop your image to a square format without unduly compromising quality.

Square format cameras had initially been designed to allow the photographer to shoot either portrait or landscape without having to adjust the orientation of the camera, working on the principle that the image could be cropped later on, but it quickly became apparent that photographers composed for the square and consequently there was no need to crop. More fundamentally, the nature of the image changes as a consequence of using this format. Looking for parallels in other areas of the visual arts, the square is viewed as a static shape, which helps to suggest stability and wholeness. It also has a strong contemporary appeal.

PANORAMIC FORMAT
An increasing numbers of photographers are using the panoramic format. If you do not own a panoramic camera, one option that is becoming increasingly popular is to 'stitch' various files together. In order to achieve this, it is important to plan out your work in advance. Capture all the required shots using a tripod with a panning head. It helps if it has a built—in spirit level to ensure that your camera remains consistently horizontal. As you take each shot, make sure that you build in an overlap of 30 per cent. This allows the process of stitching greater latitude.

Stitching can be achieved by using Photoshop, although many camera manufacturers offer stitching software as part of their introductory package. Alternatively, several manufacturers have created compact cameras that allow you to literally sweep your camera over the scene, without using a tripod, and the camera's software will stitch together the multiple shots automatically to create a wide panoramic image. The results can be stunning.

In landscape images, an extended horizontal format gives rise to a sense of calm, particularly if the horizon starts and finishes at the same level. Using a panoramic format is rather like photographing a narrative as it encourages the viewer to 'read' the image from left to right. Used in this way, you can create beautifully flowing images; typically, the foreground elements weave in and out while the horizon provides a fixed frame of reference.

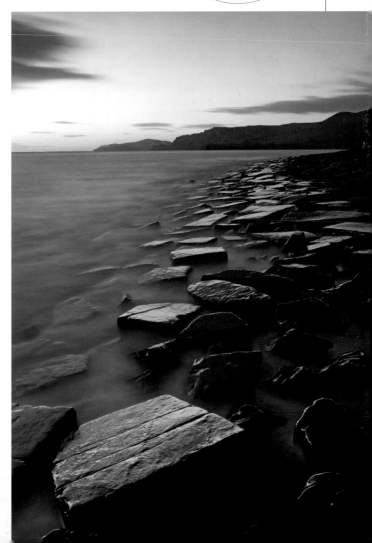

CREATING A PANORAMA

The panoramic format suits landscape possibly more than any other genre because our eyes naturally scan the horizon. Capturing this in photography is just a little more difficult as we are normally restricted by the format of the camera, but by using either a specialized panoramic camera, or by stitching various files together, we are able to capture the sense of grandeur that initially caught our attention.

USING PHOTOMERGE

Most DSLR cameras come with software that allows you to stitch various files together in order to create a panorama, but if yours does not, this can easily be achieved in Photoshop instead. It has been possible to create panoramas in Photoshop for some while, but the introduction of Photomerge has certainly made the task considerably easier.

1. Access your images using Abode Bridge. This allows you to use your RAW files.

2. Go to File > Automate > Photomerge. Select Browse within the Photomerge dialog and select the images you wish to work with. On the left side of the dialog are the Layout options, which allow you to align the files together in different ways. The Auto option usually works well in most situations, but if you find that your results are not quite what you expected, you may need to experiment with either the Perspective, Cylindrical or Spherical options to see what works best for you. You are also able to create sophisticated collages or deal with files that require repositioning by selecting the relevant option.

3. Make sure that the Blend Images Together and the Vignette Removal boxes are ticked. The Blend Image Together

option is selected by default and ensures that the colours and tones remain consistent throughout the new file. It helps to use the Vignette Removal option, particularly if the corners have darkened slightly. It is unlikely you to need to select the last option, Geometric Distortion Correction. Once you have made all the required selections, click OK.

4. When the stitching process is complete, there will inevitably be some irregularities at the edges, which will require cropping. Remember that the file size of your panorama will have increased considerably, therefore a crop will not unduly affect the overall quality of your image. If you feel that cropping might prove to be too severe, consider cloning parts of the missing area.

tip

You should be impressed by what you can achieve using Photomerge, but there are bound to be one or two very small imperfections that might need to be addressed.

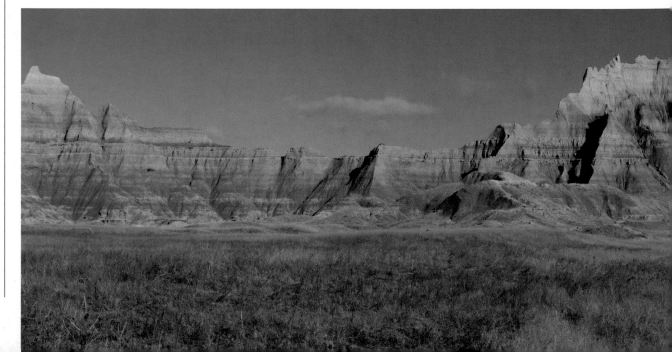

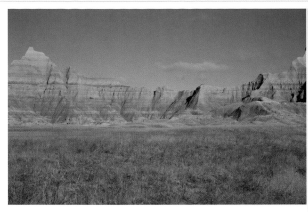

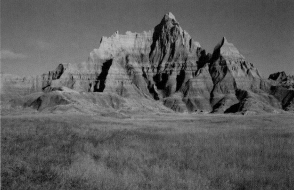

When the stitching process is complete, there will inevitably be some irregularities at the edges, which will require cropping.

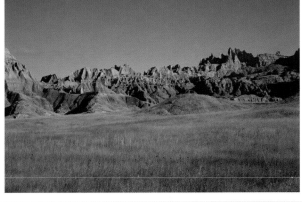

SHOOTING FOR A PANORAMA

While software is becoming increasingly more sophisticated and is able to identify the relevant overlaps, it is better if you can give it a helping hand. If you are able to use a tripod and ensure that the position of the horizon is consistent with each frame, this will decrease the likelihood of a disjointed composite. Make sure that each image overlaps by at least 25 per cent so that the software can make a valid comparison when trying to stitch the various files together. If you are using a wide-angle lens, then expect the distortion to appear more exaggerated; ideally use a short telephoto lens instead. It also helps if each frame has been taken at about the same time. If you take two of your shots in the morning but one in the afternoon, for example, you might experience problems with the consistency of the lighting.

Panorama in the Badlands

Panoramas are exciting because they capture the awe-inspiring experience of viewing a wonderful landscape. In this example, the foreground was only of limited interest, which contrasted with the spectacularly jagged nature of the distant peaks. By presenting this as a panorama, I have been able to feature only the interesting parts of the landscape.

Canon EOS 5D Mark II, 24–105mm lens, 1/200th second at f.22, ISO 400.

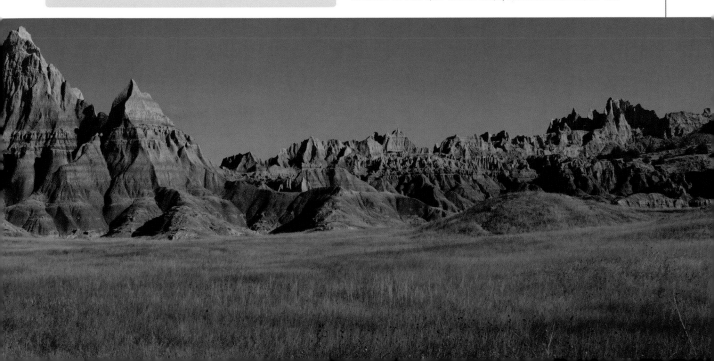

EXPLORING THE VANTAGE POINTS

When photographing landscape, it is all too easy to point the camera towards the horizon, usually with the sky featuring in either the top third or, if it is especially dramatic, the top two-thirds of the picture. This is an understandable reaction due to the panoramic nature of landscape, but it is sometimes worth considering a different vantage point as well.

HOW MUCH SKY?

Most photographers take their shots from their standing position, about five or six feet above the ground. By simply kneeling, you are immediately exploring a different viewpoint. Instead of pointing the camera towards the horizon, why not point it downwards, so that only a tiny strip of sky appears in the frame; or cut out the sky completely? By doing this, the dynamics of the composition completely changes, often with stunning results.

LYING LOW

When you are in a potentially exciting landscape, but cannot immediately see an interesting vantage point, why not consider lying on your back? This can be especially successful when you are surrounded by towering natural features such as trees or canyons. Try this technique with the widest lens you have and you will be amazed by how this worm's eye view causes the verticals to dramatically converge. I permanently have a weather cover packed in my camera bag, which of course is designed to keep the camera bag dry in wet weather, but it does also act as a superb ground-sheet on those occasions when I wish to lie on my back.

YOUR SHOOTING POSITION

Of course, it isn't just the direction you point the camera that is important but also the place from where you decide to take your photograph. For example, when you are travelling through a

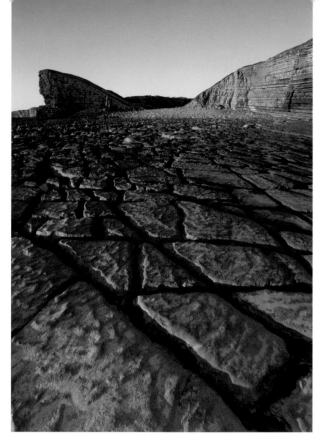

Rocky headland
Kneeling, with my wide-angle lens almost touching the ground, I was able to transform a relatively unpromising location into something more exciting. Canon EOS 5D Mark II, 20mm lens, 1/200th second at f.11, ISO 100.

valley, the natural inclination is to look upwards to include the sky. Imagine what it would look like if you were shooting from a much higher position looking across. By changing your vantage point, are you able to improve the image?

Think also about access. As you travel along the valley floor, look for roads or small tracks that allow you to get onto higher

River bed
By gaining a higher vantage point and looking downwards, you can capture an image from a birds-eye view. In this example, I was standing on a bridge overlooking a dried river bed, which presented a rather interesting abstract. Canon EOS 5D Mark II, 50mm lens, 1/320th second at f.5.6, ISO 100.

Field of poppies
The overwhelming majority of landscape shots are taking while standing up but by lying on the ground, you can start to investigate the landscape from an entirely new perspective. By using a very wide aperture, large parts of this image have been thrown out of focus. Canon EOS 5D Mark II, 50mm lens, 1/320th second at f.2.8, ISO 100.

ground. Similarly, if you find yourself looking down a mountain or canyon, try to imagine what it would look like if you opted to shoot from a lower position. The key is to identify the features you particularly want to photograph and then to consider what might be the best vantage point.

USING YOUR TRIPOD

Your tripod plays an important part in determining the right angle of view. Remember that it is a particularly flexible tool, which allows you to extend it to a height often higher than you or, alternatively, it can be splayed so that your camera is virtually at ground level. Many photographers are understandably reluctant to extend their tripods above their height because they cannot see through the viewfinder, nor are they able to read the data on the cameras top-plate. This is why I would suggest taking a set of stepladders. Often these are made of a light aluminium alloy, and can easily fold to fit behind the driver's seat, or even in the boot. While they may only give you three or four feet of additional height, you will be surprised by how frequently this can make the difference. Think how often your viewpoint is spoiled by a hedgerow? By using a set of stepladders you will easily overcome the problem.

Aspen trees
Some wonderful and unusual shots can be achieved by lying on your back looking upwards. The strong converging verticals create an almost abstract effect. Canon EOS 5D Mark II, 20mm lens, 2 seconds at f.22, ISO 100.

CONTROLLING DEPTH OF FIELD

Depth of field is the amount of the image that is acceptably sharp and is largely governed by the aperture you have selected. With a large aperture (typically f.2.8 on a standard lens when using a DSLR camera) less of the image will be in focus so the depth of field will be smaller. If you choose a smaller aperture (typically f.22 on a standard lens) more of the image will be in focus and the depth of field will be wider. Understanding this simple principle is essential to photographing landscape.

THE ROLE OF THE CAMERA AND LENS

Matters are slightly complicated because your choice of camera can also have a bearing. A large format camera requires a much smaller aperture to ensure that everything is acceptably sharp, so, typically, a standard lens on a large format camera will need to close down to f.64. Your choice of lens will also have a bearing. For example, everything will appear in focus if you close the aperture to just f.11 or even f.8 when you are using a wide-angle lens, but if you have opted for a long angle lens, you will need to use an aperture of f.32 in order to maximize the depth of field.

APERTURE PRIORITY MODE

As selecting the correct aperture is a fundamental part of determining the success of your landscape, it is important that you use the correct exposure mode. It is all too easy to select Program and allow the camera to decide the best shutter speed and aperture for the lighting conditions. While it has been designed to give you an accurate balance, it has many options and its choice is largely random so by selecting this mode you are letting the camera make the decisions you should be making. With virtually all landscape work select either the aperture priority (Av mode), in which you select the aperture and the camera selects the corresponding shutter speed, or manual, where you select both.

Cholla
Despite its appealing appearance, this species of cactus can prove particularly painful to touch as the microscopic barbs can easily penetrate your clothing if you have the bad luck to brush against them. I have chosen to use a very narrow depth of field in order to highlight the numerous small spines.
Canon EOS 5D Mark II, 24–105mm lens, 1/200th second at f.4, ISO 100.

Poppies
Try photographing a landscape from a worm's viewpoint and then select a very wide aperture. By focusing on only one very small part in the middle of the image, a rather interesting, slightly abstract affect can be achieved.
Canon EOS 5D Mark II, 24–105mm lens, 1/500th second at f.5.6, ISO 100.

Hanksville
Maximum depth of field is when everything from the foreground to the background is in focus. This is achieved by selecting the smallest available aperture. Canon EOS 1Ds Mark II, 20mm lens, 1/100th second at f.22, ISO 400.

distance. This can prove disconcerting because when you look through the viewfinder, important parts of the image will appear not to be in focus, but that is because the aperture is wide open — when you press the shutter button, the aperture automatically closes down to your selected aperture. Many inexperienced photographers select the smallest available aperture and focus on infinity, but then the two-thirds of sharpness beyond the focusing point goes to waste, while areas in the immediate foreground might still remain out of focus.

You can be just a little more scientific about this and calculate the hyperfocal distance using markings on the barrel of your lens. These appear on prime lenses although they rarely appear on zooms. Essentially the depth of field scale has two markers on either side of the focusing point, so if for example you have chosen an aperture of f.11, set the infinity symbol to f.11. In this way you are maximizing the depth of field for the selected aperture.

SELECTING THE RIGHT APERTURE

When you select an aperture, you are making a statement. You either want to ensure that the entire image is sharp or you may wish to isolate a particular feature by throwing everything else out of focus. It stands to reason that in order to achieve the maximum depth of field, you should select the smallest available aperture, but this is complicated by the fact that, optically, most lenses perform best when using an aperture of f.8 or f.11. This will not be obvious on a high quality lens, but some distortions might just be noticeable on cheaper ones.

HYPERFOCAL DISTANCE

When using a moderate wide-angle or a standard lens, if you carefully focus one third of the way into the image, everything will be sharp even if you are using an aperture of just f.11. This is known as the *hyperfocal*

Barbed wire fence
By setting the hyperfocal distance on the lens, it was possible to use a slightly wider aperture, but still get everything in focus, thus allowing the camera to be hand-held. Photograph by Eva Worobiec. Canon EOS 5D Mark II, 20mm lens, 1/50th second at f.11, ISO 100.

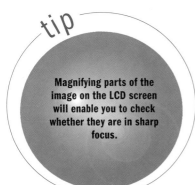

tip

Magnifying parts of the image on the LCD screen will enable you to check whether they are in sharp focus.

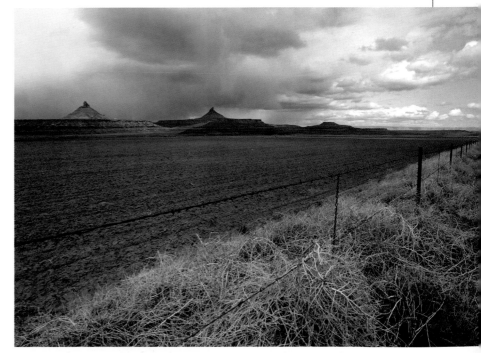

COMPOSING LANDSCAPES

You have found a great location, the light is perfect, you have worked out the ideal exposure but now comes the really important bit: how to compose your image to best share with others the experience of seeing a wonderful landscape. To do this, first you need to consider the elements in the landscape you find exciting, then you should structure the image in such a way that the viewer can fully understand why it caught your interest.

THE RULE OF THIRDS

There are numerous compositional strategies one can use in photography but possibly the best known and the most useful of these is one that is extravagantly known as the 'golden section'. Adopted from Renaissance art, the basic principle is simple, but if it is strictly applied it can prove challenging. It argues that in order to achieve the ideal proportion, you take a line and divide it so that the proportion of the large piece to the whole is the same as the ratio of the small piece to the large piece. In order to achieve this, the coordinates of the composition should precisely meet 61.8 per cent along any given line.

Now if you are starting with a painting, it is easier to structure your image just by introducing a grid, but when taking a photograph, which is a more spontaneous activity, something much simpler needs to be applied which is where the 'rule of the thirds' comes in. Instead of dividing your coordinates precisely 61.8 per cent along a given line, many photographers recognize that almost equates to two-thirds and therefore structure their landscapes so that key elements appear on the one-third or two-thirds coordinate. This certainly makes matters much easier.

 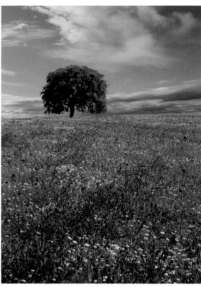

Rule of thirds
By dividing the frame into thirds, horizontally and vertically, four focal points are created. Placing your main subject on one of these coordinates helps to create an asymmetrically balanced picture. However, it becomes increasingly more difficult to apply when you wish to highlight two or more key features.
Canon EOS 5D Mark II, 24–105mm lens, 1/40th second at f.18. ISO 200.

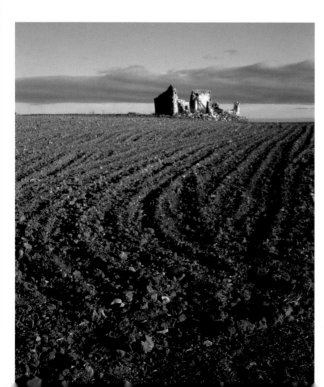

ESTABLISH A FOCAL POINT

Whether you choose to use the rule of the thirds or not, establishing a key focal point introduces clarity. Essentially, photography is about communication and the viewer should be able to quickly establish what it was that excited you when you took the shot. It may well prove that the focal point is only of secondary importance, but it helps to give the image structure. Some may feel that a picture that uses just one focal point looks too simple, but providing that all the other elements within the composition appear to support it, the image will retain interest.

Ploughed field
By using a viewpoint that avoids all other distractions, I have been able to condense this image to just the ploughed field and the ruin in the distance. The furrows lead the eye to the building on the horizon, while the light cloud serves to frame it. Nothing has been included which is extraneous to the overall design.
Canon EOS 1Ds, 24mm lens, 1/80th second at f.16, ISO 100.

BALANCE AND COUNTERBALANCE

All the elements within the picture frame
have a visual weight. For example, a
large tree on the left of a picture might
be counterbalanced by something much
smaller on the right, but because of
its unique visual qualities it assumes a
more dominant role. The easiest way to
understand this is to imagine two children
on either side of a see-saw. They are, of
course, in perfect balance when each child
is suspended mid-air, although visually
that might not appear interesting. There
are numerous other permutations that will
still suggest order: when one child is on
the ground and the other in the air, then
balance is retained.

Where it gets interesting is when you
have two children on one side of the see-
saw, but only one on the other. As you are
all aware, equilibrium can only be achieved
if the two children on the first side move
inwards. The position of the fulcrum will
also have a bearing. While we normally
imagine it being in the middle, it can just
as easily be to either side, so establishing a
balance becomes more challenging. Being
aware of how the various elements within
the image interact is important.

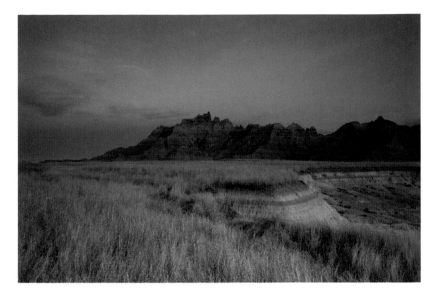

Badlands
Balancing and counterbalancing elements is a fundamental compositional skill. In this example, the pink clouds
in the extreme left are countered by the pale bank in the bottom right of the picture.
Canon EOS 5D Mark II, 24–105mm lens, 2 seconds at f.22, ISO 100.

THE LEAD-IN LINE

This is a compositional strategy much
used by landscape photographers. Having
decided on your main point of focus, try
and find a natural line that leads the eye to
it. Typically this could to a fence, a track or
possibly something more natural such as
a stream or a hedgerow. The lead-in does
not necessarily need to go directly to the
point of focus; often a meandering line has
the capacity to link important elements of
the picture together.

Telegraph poles
Very often it is man-
made features that
provide the most
effective lead-ins, be
it a path, a fence or,
as in this example,
telegraph poles.
Canon EOS 5D Mark
II, 24–105mm lens,
1/100th second at f.18
ISO 400.

THE 'S' CURVE

This compositional strategy seems particularly well suited to landscape – imagine a backlit river snaking its way through the image, starting at the base and working its way through the picture to the top. If you can design it so that the river starts in the bottom left corner and disappears in the top right, the composition will look much stronger. But of course, this technique does not just work with rivers; it could be a road, undulating sandbanks or just the way a farmer has ploughed a field. This technique seems to work particularly well when using a long-angle lens, as it has the effect of compressing the image and exaggerating the 'S' shape.

THE FRAME

Framing a key feature using a bending tree, a broken fence or natural stone arch is a particularly effective way of drawing attention to an area of the picture you wish to highlight. Be imaginative about what you can use as a frame; I have even seen this technique wonderfully applied using an open car window, for example. One of the advantages of framing is that it helps to put the picture into context. By photographing a landscape through an arch, for example, it could tell us that the landscape is part of an historic estate. It also helps to introduce

Field in snow
This 'S curve' technique appears to work particularly well when the S shape starts in the bottom left and disappears in the top right corners. Using a long angle lens helps to condense the S.
Canon EOS 5D Mark II, 200mm lens, 1/60th second at f.32, ISO 100.

an added sense of depth. But from a compositional standpoint, the greatest advantage of using a frame is that it leads the eye to the main focal point.

THE CENTRAL MERIDIAN

This is a personal favourite and is a technique that runs counter to the rule of thirds, but it can be very successfully applied to most landscapes. To use it, imagine an invisible line through the middle of your composition, then aim to balance your key elements on either side of it. Many photographers are reluctant to use the central meridian for fear of producing a tightly symmetrical picture, but when you are photographing a landscape, that is almost impossible to do. The trick is always to introduce an element that is just off-centre; sometimes imperfection can be a wonderful compositional asset. The problems of composition relate not just to photography but to all aspects of the visual arts and while this particular technique is not widely used by photographers, it is by graphic designers.

Chateau
From a compositional standpoint, the greatest advantage of using a frame is that it leads the eye to the main focal point. In this example, the two pollarded trees help to direct our attention to the building in the distance.
Canon EOS 5D Mark II, 24–105mm lens, 1/160th second at f.14, ISO 200.

IDENTIFYING PATTERNS

One of the best compositional ploys, and one that is frequently overlooked by photographers, is to identify patterns in the landscape. Sometimes these occur naturally, but more often they appear as a result of man's intervention. Patterns help to create a unity within the image. Finding them is easy as they frequently exist in areas of agriculture, on beaches, in woodlands and in canyons. While initially these images can look rather superficial, when you examine them more closely, you will start to notice subtle variations, which help to sustain the viewer's interest.

FOLLOW YOUR INSTINCT

Finally, it is important not to become a slave to the 'rules.' These are, at best, just a useful guide to good composition. The more you become practiced at taking photographs, the more likely you are to develop an inner aesthetic sense which should serve as your guide. Think carefully about what you are trying to say with your photograph and then organize the visual elements into a clear and simple structure.

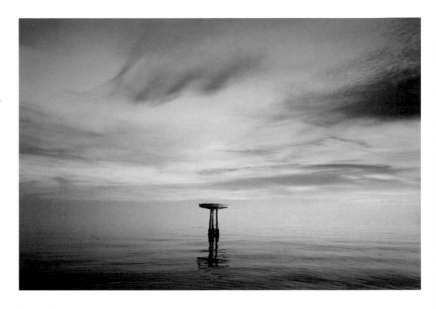

Calm waters
While walking along the beach, I was struck by this strange structure in the water. As the composition was so simple, my initial instinct was to place it on the thirds, but then I noticed the pink clouds directly above. In this situation placing everything centrally proved a far better option.
Canon EOS 5D Mark II, 24–105mm lens, 1/40th second at f.16, ISO 400.

Winter trees
Often some of the best patterns in landscape can be found during extreme weather conditions. In this example, the wintry weather has highlighted the delicate tracery of the defoliated trees.
Canon EOS 5D Mark II, 200mm lens, 1/13th second at f.25, ISO 200.

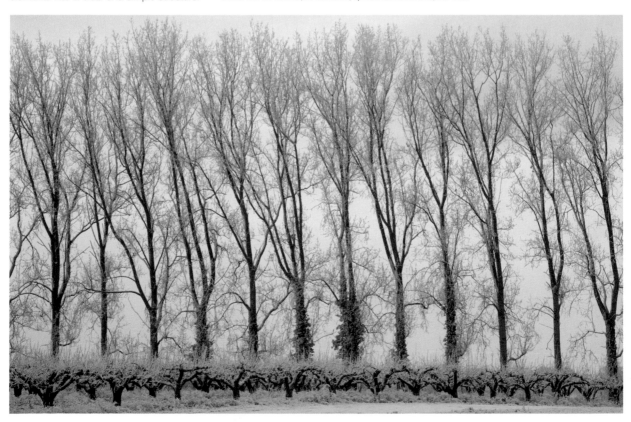

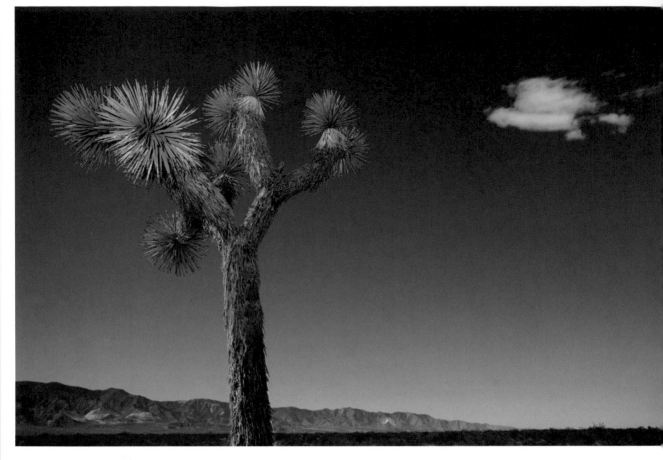

USING FLASH

The idea of using flash when photographing landscape might strike some as bizarre, particularly as the operational range of a flashgun is somewhat restricted, but there are occasions when using flash can prove useful, especially when you want to highlight a key feature within the landscape.

FILL-IN FLASH

Whether you are using the camera's built-in flash, or an independent unit attached to the hot-shoe, it can be used to illuminate dark areas within the foreground. This can be done either in daylight or at night.

To achieve this, take a light reading and set the camera for the ambient light, but then set the flashgun so that it will give a burst of light which will under-expose by one or two stops. How much you under-expose depends on the results you are after; you may need to experiment. By

deliberately under-exposing, you are able to balance the dark part of the foreground with the rest of the image without the effects appearing too obvious. If, however, the flash is used at full strength, you risk blown-out highlights.

If you can use your flashgun off-camera, position it so that its direction matches that of the natural light; so, if the sun is to the left of the subject, position the flashgun to the left as well. The results will appear plausible, and the modelling it introduces will match the rest of the image. If your flashgun has a diffuser, another alternative is to set both the camera and flashgun for the ambient light, but using the diffuser to subdue the harshness of the light created by the flash.

When to use fill-in flash

- A bit of a generalization, but when photographing landscapes, the extreme foreground is often darker than both the middle distance and background. While we normally overcome this by using a soft ND grad (see Using Filters [p16]), some

Joshua tree
Ironically, one often needs to use fill-in flash in strong but contrasty lighting. In this example I used a polarizing filter and underexposed by one third of a stop in order to separate the main subject from the background.
Canon EOS 5D Mark II, 24–105mm lens, 1/400th second at f.8, ISO 125.

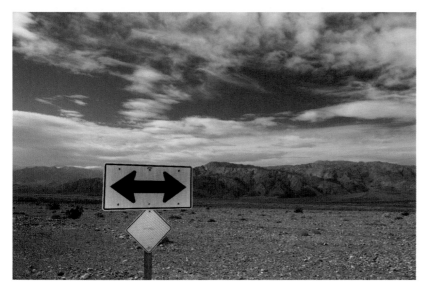

Road sign
As with the Joshua tree, while there was plenty of available light, it did not shine directly onto the yellow sign in the foreground. By using a small amount of fill-in flash, this problem has been resolved. Canon EOS 5D Mark II, 24–105mm lens, 1/125th second at f.13, ISO 200.

details in the foreground can still remain stubbornly under-exposed. By using fill-in flash this problem can be overcome. Normally, this technique is best applied when using a wide-angle lens and with the camera in portrait format.

- When you wish to specifically highlight a feature in the foreground, be it a small bush, a rock or gnarled piece of wood.
- To make a daytime shot look as if it has been taken later in the evening. Instead of setting the flash-gun to underexpose, try setting the camera so that it under-exposes by one stop: to achieve this you may need to set it to manual mode. The overall effect will be to darken the landscape, while the fill-in flash will dramatically highlight key features in the

foreground. This effect seems to work particularly well when you have a dark or threatening sky.

PAINTING WITH FLASH
A technique you may wish to consider that works particularly well in landscape is to 'paint' with flash. This can only be effectively done when the lighting levels are low (ideally it should be done at night), but the results can be spectacularly beautiful. In order to achieve this, your calculated exposure time should be a least 30 seconds, so if you are trying this when there is more natural light around you may need to use a neutral density filter to reduce it. Make sure that the camera is on a tripod, that you have chosen the lowest

ISO rating and that you have selected Bulb (B). If you are working at night, turn off the auto-focus as well.

It is very likely that you will appear in frame, so make sure that you are wearing dark clothing. With exposures of 30 seconds or more, providing you keep moving, then you should not appear in the finished image. If you are trying to light-up a large object at night, it might require several bursts of light, each illuminating a different part of the object. Clearly you will need to be organized and remember which parts have already been lit. As well as keeping moving, it is important that you shield the flash-gun from the camera, so that the source of the flash cannot be seen in the final result. You do not, of course, need to limit yourself to illuminating just one object; depending on the time you have available, you could try several.

When doing this kind of work, you might well appreciate a remote cable release as it offers the great advantage of allowing you to operate many yards away from the camera. This requires placing a receiver on the camera, (usually on the camera's hot-shoe), and then using a transmitter, which you point in the direction of the camera to trigger the shutter.

FLASH AND WHITE BALANCE
When using flash, the quality of light closely replicates daylight, therefore you can continue to use a white light balance that best suits the sky. If you are shooting RAW, when you come to edit your shoots and think that you have selected the wrong WB option, this can easily be corrected in the RAW converter.

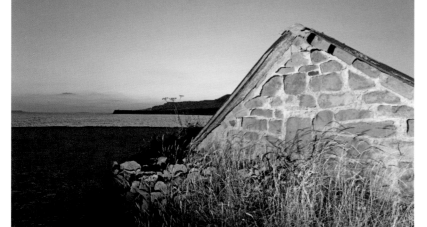

Boathouse
In normal light the boathouse is truly inconsequential, but by deliberately under-exposing the background and using fill-in flash just to highlight the foreground, it is made to appear more interesting. Canon EOS 5D Mark II, 24–105mm lens, 1/125th second at f.13, ISO 200.

OTHER LIGHT SOURCES

USING A TORCH

Compared to a sophisticated flashgun, a torch seems a rather primitive tool, but it is amazing how many highly respected landscape photographers use this technique. One disadvantage of using a flashgun is that it blankets the entire foreground area in light, which is not always required. Using a torch, you are able to selectively pick out the detail you wish to highlight; as the light is applied cumulatively, considerable control is possible. Try to imagine that your torch is like a large brush and that you are painting in the detail. The best time to use this technique is at late dusk or pre-dawn, when you need lengthy exposures, but when there is still sufficient light to illuminate other parts of the landscape as well.

Torches vary in strength and some have an illumination capacity of up to 1,000,000 candles, which can light up quite a sizable structure. Using one of these more powerful torches at night can be particularly interesting, with the resulting landscape assuming an almost theatrical quality. With your camera fixed to a tripod, you should be able to walk up to your subject and start 'painting-in' the required detail. The great advantage of this technique is that you do not need to restrict yourself just to highlighting foreground detail; you can literally wander into the landscape and pick out features in the middle distance instead.

COLOURED GELS

As so many photographers now use DSLRs, filter gels are less common than they once were, but before

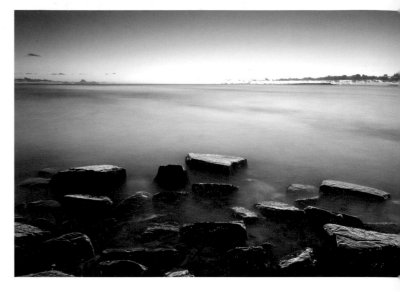

Jellied rocks
It is possible to create very unusual visual effects when attaching coloured gels over the flash head. In this example, the rocks in the foreground appear like huge blocks of red jelly. Canon EOS 5D Mark II, 24–105mm lens, 74 seconds at f.18, ISO 200.

digital cameras were the norm, they were sold together with a flashgun kit as a means of overcoming casts created by fluorescent and tungsten lighting. We now use the camera's white balance facility to resolve this (see the section on white balance [p14]). If you are unable to get hold of any filter gels try attaching customized theatrical lighting gels instead.

This technique works best at night, first because it

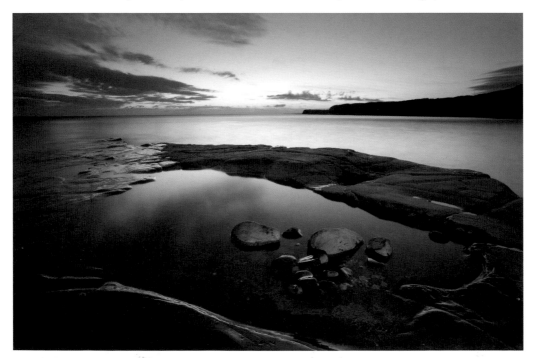

Stones in pool
At first glance, the algae on the rocks in the foreground appears quite convincing, however this effect has been achieved by fixing a green gel over the flashgun head, prior to giving this a short burst of light. As one would normally expect to see green slime on stones within the inter-tidal zone, this visual deception could quite easily go unnoticed. Canon EOS 5D Mark II, 17mm lens, 20 seconds at f.16, ISO 100.

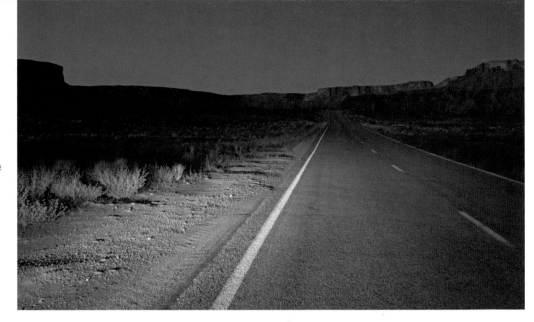

allows you sufficient time to change and apply the different coloured gels and second because the colours it creates are at their most dramatic at that time. Using your flashgun off-camera, and with your camera set to Bulb, select a coloured gel, place it over the flash-head and give the subject a burst of light from just one side. Remove the gel, replace it with another one and then give the subject a second burst. Depending on the mixture of colours you have applied, the results can prove wonderfully surreal. If you are photographing a subject that allows you to get inside (such as an abandoned car or an old shed), try using a burst of flash from within; once again, the results can be stunning.

CAR HEADLIGHTS

Using car headlights is certainly an unconventional method for illuminating a landscape, but it does work surprisingly well. I discovered this technique largely by accident when, after taking some shots at a particular location, I got into my car, switched on the headlights and immediately saw the landscape in front of me fabulously illuminated. The light you get from your headlights closely resembles daylight so it does not pose problems with the white light balance. The car headlight beam is quite penetrating, offering an alternative to a flashgun. Don't feel that you will not have any control over the quality of lighting; where you park your car relative to the area you wish to photograph will have a bearing, so it should be possible to use side and not just directional lighting. If you are photographing at night and need an exposure of several minutes, then you can move the vehicle during the exposure to balance out the illumination.

You need to be careful where you put your tripod. Obviously if you place it behind the vehicle it will appear in view, but if you place it in front of your car it is very likely that the shadow of your tripod will appear in the image; ideally place it to the side of your car.

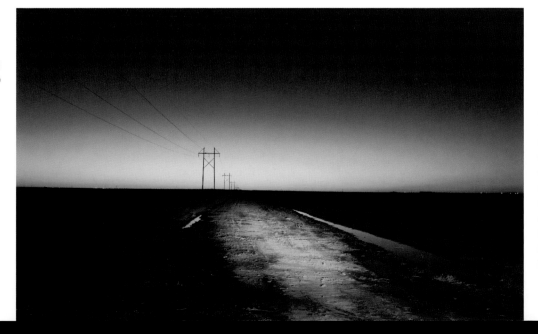

Post-Camera Techniques

HDR (HIGH DYNAMIC RANGE) METHODS

The advantages of using digital cameras are innumerable, however they do have one pronounced weakness and that is, when compared to traditional film, they have a restricted dynamic range. What does that mean? With film, and particularly colour negative, if you photographed a landscape, even in contrasty conditions, you could expect to see discernible detail in both the highlights and shadows. When using a digital camera in similar lighting the results can be disappointing unless you use a corrective filter. This is especially a problem on an overcast day when the diffused light in the sky is substantially brighter than the foreground. Either the photograph will have a correctly exposed sky but an underexposed foreground or, more often, a well-exposed foreground, but a poorly exposed sky. There are now several HDR techniques designed to overcome this.

PHOTOMATIX PRO

The most popular HDR technique involves using Photomatix Pro. This is immensely useful software that allows you to blend files of different exposures together. It can be downloaded from www.hdrsoft.com. Typically, you might decide to produce three or four separate exposures of the same landscape, making each of your exposures specifically for different tonal values (see Shooting for HDR).

Tone Mapping

1. Call up Photomatix Pro and select Generate HDR Image, then go to Browse and bring up the files you wish to blend. In this example I have chosen three, but I could have selected four or five images if I had needed them.

2. Select OK and the Generate HDR-Options dialog will appear. With the Align Source Images box ticked I needed to ensure that the By Matching Features option was highlighted to ensure that my three hand-held shots were perfectly aligned. Once this is done, click OK.

3. Photomatix now merges the variously exposed images into a single HDR file, which should contain a full tonal range. Your image will appear quite disappointing at this stage because it still requires processing; to achieve this click the Tone Mapping button. The Preview and the Tone Mapping Settings palette will appear in separate windows, together with the histogram, which you should constantly check if you are to remain in control. It is worth noting that the Preview is only an approximation.

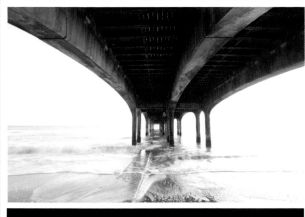

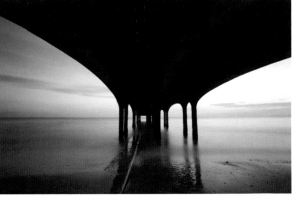

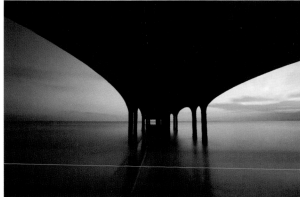

Above left

If using conventional photographic methods, this would be an impossible image to capture, as the dynamic range is far too great. In this example, I have exposed for the bottom of the pier at the expense of the sea and sky.

Above right

In this example I have concentrated on getting the exposure for the water correct, but this has resulted in the structure appearing underexposed; I have also lost some detail in the sky.

Left

Aware that detail in the sky was missing, I specifically exposed this one in order to capture important highlight detail.

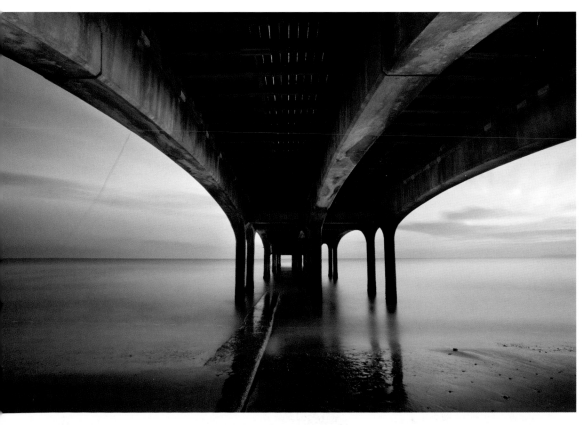

Pier after HDR
Even the most intractable exposure issues can be overcome by creating a HDR file.

The Tone Mapping Settings

- The Tone Mapping Settings will determine the tonal range of your final image, and it is worth experimenting just to see what can be achieved. You can elect to use the Details Enhancer, which increases local contrast and boosts shadow detail. The effects can appear 'painterly'.

- Alternatively try using the Tone Compressor, which is designed to give a more photographic look. To access either of these facilities simply toggle between the two. When using the Tone Compressor, you will have a Brightness slider, Tonal Range Compression and a Contrast Adaptation adjuster, which are means of altering the overall tonal values of the image. When using any of these, you do need to keep a careful eye on the histogram; in order to achieve a true landscape, try to ensure that you retain a balance across the full tonal range.

- The Details Enhancer gives you more options, but remember that also offers more opportunities to make mistakes. The ideal place to start is with the Tone Setting; while looking at the histogram, use the White Point to establish the maximum highlight, the Black Point for the deepest black and then use the Gamma slider to establish overall tonality of the image. Color Setting has some very useful options.

- While the Temperature slider lets you determine the relative warmth of the hues, the Saturation Highlights and Saturation Shadows sliders allow you to independently boost the colours in either the light or dark areas. The Presets are tempting, but they can leave your image looking rather contrived;

I would not opt for anything other than Natural. If you want to heighten the tones but in a controlled way, try experimenting with both the Smoothing and Strength sliders; it is a method for introducing drama without losing contact with the original landscape.

Exposure Fusion

This is a simpler method for creating a HDR file and has the additional advantages that the results appear more natural, and it is a method least likely to incur noise. When the Workflow Shortcuts appear select Exposure Fusion and send your files to the Exposure Fusion – Selecting box, making sure that Align Source Images and by matching features are highlighted. Click OK and a picture of the blended image will appear in the Preview. The controls on the left allow you to subtly change the blend. Select the Highlights and Shadows – Adjust, which will then allow you to make further tonal changes.

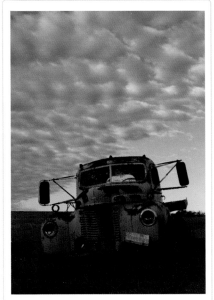

Pick-up 1.
In this example I specifically metered for the sky, but as a consequence the foreground appears too dark.

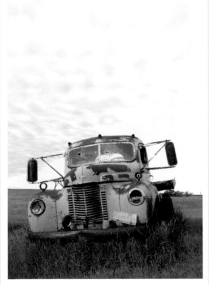

Pick-up 2.
Taking a light reading just of the foreground, has resulted in a much lighter image, but of course this has been done at the expense of the sky.

After HDR
Photomatix and other tone-mapping software can create some awesome effects, but I feel it is important to retain some link with reality, consequently my approach has been restrained.

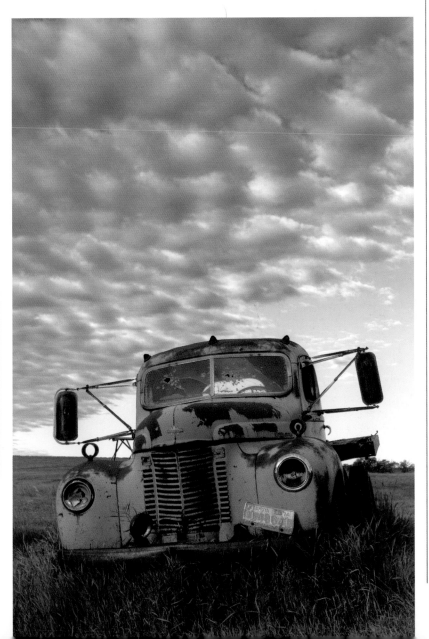

HDR WITH PHOTOSHOP

Recent versions of Photoshop CS also provide a tone-mapping option, which, while not quite as comprehensive as Photomatix, offers a very useful alternative: the one available in Photoshop CS5 is particularly effective.

1. In order to access this go to File > Automate > Merge to HDR Pro. When the HDR Pro Dialog appears. select Browse > My Documents and select the folder containing the images you want to work with. It is far better to retain the images as RAW files as they offer a far better dynamic range. You might also find it more convenient if you store all the required files in the same folder. Make sure that the Attempt to Automatically Align Source Images is ticked and then select OK.

2. The Merge to HDR Pro dialog will appear with the images already fused together and usually the results are close to satisfactory. The Source files appear at the bottom of the dialog. At this stage, your HDR file merely requires a bit of tweaking.

3. To achieve this use the various sliders to the right of the dialog. The most useful of these appears under the heading Tone and Detail.

Tone and Detail

As with with Photomatix, it is important to establish the maximum lightest and darkest points and this is achieved by using the Shadow and Highlight Sliders. Once that has been completed, use the Gamma slider to establish the mid-tone; if this has been accurately done, the Exposure slider should prove largely redundant as it governs the overall tonality. The Detail slider is interesting, because it can be used to heighten the sense of texture; slide it to the right and the apparent textural qualities are increased, but by dragging it to the left, the textures are smoothed out. However, if you wish to retain a sense of naturalism, this option should be applied with caution.

The textural qualities of the image can also be changed by using Edge Glow, but unless you have a specific need to change them, leave those in the default settings. On a similar note, ignore the Presets as they offer very little that cannot be done using the various Tone and Detail sliders.

Finally, the colours can be adjusted by using Vibrance and the Saturation sliders at the bottom of the dialog, and if you prefer, the tonality of image can be adjusted by using Curves instead. In all, it offers a very comprehensive and flexible package.

While tone-mapping is an excellent technique and can offer a range of tones far in excess of what could have been achieved when using traditional film, it should only be seen as a means to an end. It is very easy to overdo the HDR effect and lose contact with the landscape as a consequence.

Abandoned school, Colorado
Often the most difficult landscapes to photograph are those featuring large, overcast skies. Retaining detail in both the shadows and highlights is especially difficult unless you decide to create a HDR file. This has been done using the HDR Pro facility in Photoshop CS5.

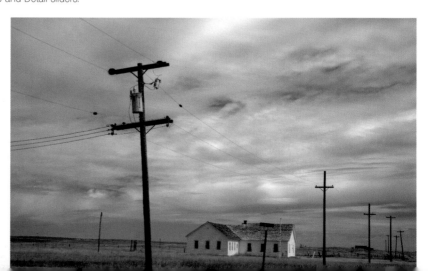

Urban backstreets 1

This is typical of the problems most photographers encounter when using a digital camera. Because of its relatively restricted latitude, you are faced with the choice of a well-exposed foreground or a burnt out sky. In this example, I metered for the foreground.

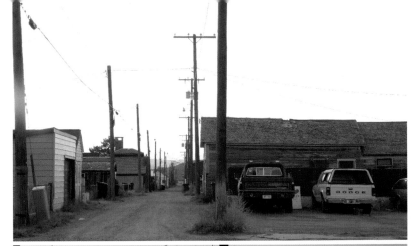

Urban backstreets 2

By metering for the sky, the foreground appears unacceptably under-exposed.

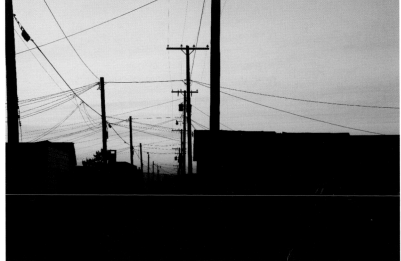

WHEN TO USE HDR

It is often remarked that one of the best times to shoot a landscape is when the sky is overcast, but that assumes that when composing your picture, the sky will be excluded. That is because the detail in an overcast sky is weak, but also because the contrast between the sky and foreground is too great. Using HDR is an excellent method for countering this problem. HDR can also prove helpful with night photography, particularly if some of the illuminated buildings are excessively bright relative to the landscape. It is, however, always better if you can resolve a contrast problem in-camera, and if it is just a matter of using a ND grad filter, then that would always be my preferred option.

Urban backstreets final

By merging the two files using Photomatix, a much more successful outcome is achieved.

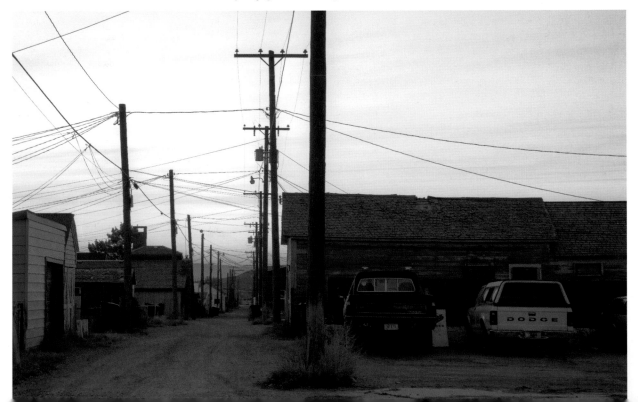

IMPROVING THE SKY

If you decide to include the sky in your composition, it is important that you show it to its best advantage. As I have previously indicated, one of the main problems you are likely to encounter when photographing a landscape that includes a sky is the exposure disparity — because of the restricted dynamic range of most DSLRs, either the sky will appear pallid or the foreground will be underexposed. The usual way to overcome this is to use either a soft or hard grad filter, but sometimes that is not convenient. The problem then needs to be resolved post-camera using Photoshop. There are two ways of doing this, described here.

METHOD 1: USING CURVES

1. Go to Quick Mask (the small circle inside a pink rectangle at the bottom of the tool box), and then select the Gradient tool; make sure that the linear option is selected. Using the Gradient tool cursor, drag a line from the bottom of the image upwards. The area that will not be affected by any subsequent changes will be covered by an apparent translucent red layer.

2. To convert this to a selection, select the Quick Mask Mode, which now should appear white. This will create the graduated selection, which is indicated by the usual 'marching ants'.

3. Make an adjustment layer and select Curves and then carefully pull the curve downwards in order to darken the sky. This image is also unevenly illuminated horizontally so that it appears slightly lighter on the right side than it does on the left. By making another graduated selection, but this time across the image, this can also be resolved.

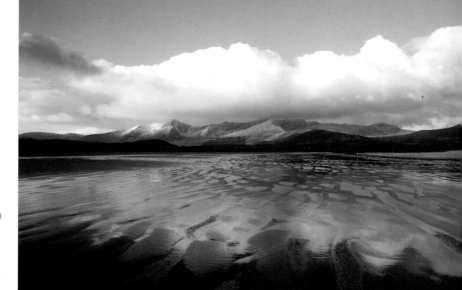

Exposing for the foreground

This is a common problem one often encounters when shooting landscape. If I expose for the sky, then the foreground will appear too dark, however as I have exposed for the foreground, detail in the clouds has been lost.

Canon EOS 5D Mark II, 24mm lens, 1/30th second at f.13, ISO 100.

METHOD 2: CREATE A PSUEDO HDR

The general principle of a HDR image is to produce several exposures of the same image, so that the entire exposure range is covered, although generally all that is required is one for the sky and another for the foreground. With my camera still attached to a tripod, I took a second shot, but this time I exposed specifically for the sky. When doing multiple exposures like this, it is often far better to use the Manual mode, but make sure that you change only the speed settings and not the apertures, otherwise you risk having inconsistent depths of field.

1. In Photoshop call up both the dark and lighter images, but then just briefly minimize the lighter image, which will become the Background layer. With only the darker image on screen, make a gradient selection using Quick Mask and the Gradient tool, but do not necessarily drag the cursor right to the top of the image; sometimes it is advantageous to drag it just part of the way up depending on the position of the horizon.

2. When you have done this, call up the lighter image, and with both on the screen, use the Move tool to drag the selection from the darker image over the lighter image while at the same time depressing the Shift key; this ensures that the two images are perfectly aligned. It helps at the photographic stage to ensure that both images are taken in fairly quick sequence, particularly if the clouds are moving, otherwise an accurate registration will always prove difficult. Finally after making a Layer Mask, use the Eraser tool to reveal detail in the background layer, although aim not to use an Opacity much greater than 30%.

Exposing for the sky
With the camera still attached to the tripod, I took a second shot, except this time I specifically exposed for the sky, but as a consequence the foreground appears unacceptably dark.
Canon EOS 5D Mark II, 24mm lens, 1/80th second at f.13, ISO 100.

Finished image
Ideally I should have used a graduated filter when taking this shot, but at the time that simply was not practical. Blending together two separate files in Photoshop proved a perfect solution to the problem.

DROPPING IN A NEW SKY

Often when shooting landscape, we identify a wonderful location, but it lacks is an attractive sky. Similarly, we often encounter fabulous skies, but finding a suitably impressive foreground alludes us. Wouldn't be wonderful if we could bring these two elements together? Well of course you can, by creating a composite in Photoshop.

CREATING A SKY BANK

One of the great advantages of shooting digitally is that it encourages spontaneity and so, if I see an impressive sky, I take it and then 'bank' it – I have set aside a folder especially for interesting skies that I might be able to use at a later date. If you do this it is important to categorize each one carefully. I have allocated sections for 'early morning', 'day-time', 'evening' and 'night skies' and have methodically logged all the relevant details concerning the lens used, the direction of the sun and apparent colour temperature. This is important, because if you do intend to import a new sky into a landscape, they must be completely compatible; if you get this wrong, it really shows.

When shooting skies, try and find a location with a very simple horizon; there is no point in taking one with distracting telegraph poles for example. Living near the coast, I often take mine looking out to sea, but an area of flat land serves this purpose just as well.

USING PHOTOSHOP

1. When replacing a sky, the first task is to make a selection. Use the Magic Wand tool to select the area nearest to the horizon. If the colours or tones of the landscape below the horizon are quite similar to those in the sky, select a low tolerance – try 15. Once you have completed an accurate selection of the sky just above the horizon, you are then free to use other much quicker selection tools such as the Lasso. Having made a reasonably accurate selection, go to Select > Modify > Expand and increase the selection by 3 pixels. This prevents the tell-tale white line appearing along the join. It also helps to Feather your selection by 2 pixels.

2. If you find that the horizon has tricky elements such as trees or bushes, which the Magic tool cannot handle, consider using Refine Edge – this allows you to sharpen up your selection even further. Set the Edge Detection tool to a relatively large radius and then drag it over those areas that require further modification.

3. Bring both files onto the screen. Activate the sky screen and go to Select All > Edit Copy, then, while the landscape file is still active go to Edit > Paste Special > Paste Into. The new sky, which now becomes Layer 1, will have replaced the old sky. Often the match at this stage is not perfect and further slight adjustments are still needed. It is important to adjust the imported sky so that its horizon is consistent with the old sky. Select the Move tool, and make further adjustments as required. If the fit is not perfect, with Layer 1 still active, go to Edit > Transform > Scale and, with the Shift key depressed, scale up the new sky. Finally, by activating each of the layers in turn further tonal colour changes can be made.

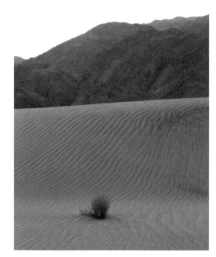

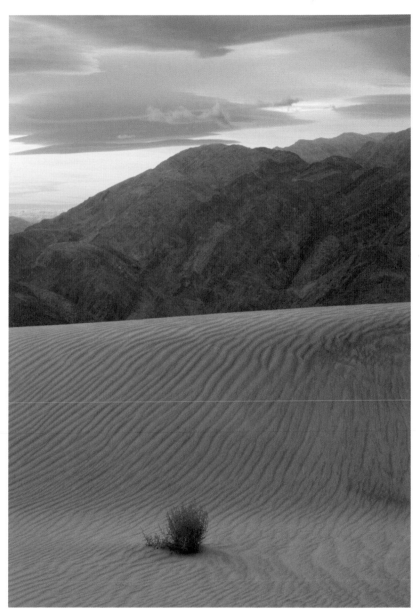

Before

Photographed at dawn while facing the emerging sun I had very little chance of securing the detail in the mountains and the sky. I therefore metered for the darkest parts of the image, secure in the knowledge that I could drop in a new sky later on.
Canon EOS 1Ds Mark II, 24–105mm lens, 1/100th second at f.14, ISO 400.

New sky

When importing a new sky, it is important to consider the direction of the lighting, the lens used and the relative colour temperature if it is to appear plausible.
Canon EOS 1Ds Mark II, 24–105mm lens, 1/125th second at f.9, ISO 100.

Final image

It is often so tempting to add the best, most dramatic sky in your folder, but it is important to ensure that the two elements match. In this example I needed to select a moderately quiet file. Not only does this sky add much needed detail, but the subtle yellow on the horizon complements the purple hues of the mountains.

GROUPING IMAGES TOGETHER

There are occasions when we produce a sequence of photographs illustrating small parts of a landscape, but when we review our work we lose confidence about presenting the images individually, fearing, perhaps, that they are just too minimal. If so, try grouping the images together because you will quickly discover that one serves to strengthen the other. Another creative advantage of sequencing pictures is that it is an incentive to capture aspects of the landscape that we may otherwise regard as too inconsequential.

EDITING AND ORGANIZING

Editing is clearly a very important part of the exercise. You may have taken dozens of very similar images, and deciding which ones you wish to use may be difficult; certainly exploring various permutations on the computer screen helps. Think carefully about how you wish to structure your composite and the variations you wish to introduce, while making sure that the planned composite retains its holistic character.

By their very nature, sequences need to be planned, therefore it is sensible to store all the images in the same folder. It usually helps if you ensure that all the images are roughly the same size. Also, it is pointless using images that are too large for the intended target, so some resizing might be required.

Create a background layer

When grouping related images together, a white background is often used, although you might wish to use a black or even a coloured background instead: it is easy to experiment and try out different options. To make your background layer in Photoshop, go to File > New. The New File dialog box will appear; type in the preferred height and width and set the required resolution. It helps if this is consistent with the images you wish to import.

Positioning your images

Where you place each image and the space you allow around each one clearly is important to the success of the design of your composite. The order in which each image is selected and placed should already have been sorted out in advance, although changes can always be made right up until you decide to flatten the file. To ensure that the imported image is accurately positioned, introduce a grid to the background layer, (go to View > Show > Grid), and then use the Rectangular Marquee tool to select the area the first file should be imported into. Activate the file you wish to import, then go to Select All; activate the background layer and then apply Paste Into. The imported image may not be positioned precisely where you want it to be, but changes can be made using the Move tool. If you still need to change the scale of the imported image, go to Edit > Transform > Scale. Repeat this process for each of the other files you wish to add.

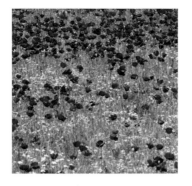

tip

Why not try using a theme such a colour in the landscape, rather than the same subject, to group your images together?

Completed floral composite

Often when photographing landscapes we can become particularly fascinated by related details. When presented individually, the images might appear to lack substance, but when grouped together each of the images serves to support the other.

Rocks

Knowing that I can group pictures together encourages me to photograph very small elements of detail. Sometimes I can even visualize how I will finally put all the related images together.

SECTION 2 Approaches to Landscape Photography

The Time of Day

Within the course of a day, the landscape will constantly be changing, so deciding when to take your photograph is clearly important. As I suggested in the section on Planning a Shoot [p34], assessing the quality of the light is very important and while one location might suit the morning, with another it might prove more profitable to take your photograph in the evening.

DAWN

Arguably, photographing at dawn is the most inconvenient time of day, as it often requires getting up in the middle of the night and then making a car journey. It is likely to be the coldest time of the day and even in summer I would recommend taking along a jacket. It is also well worth checking the weather forecast as there is little point in getting up early only to find that you are rained off. Your window of opportunity at dawn is relatively short, just 20 minutes before the sun rises and 10 minutes afterwards, so it really is important that you get to your location well on time; but get it right and the rewards can make all your efforts worthwhile.

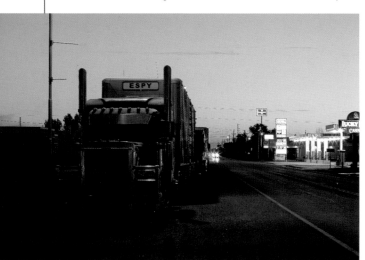

IT PAYS TO PLAN

It is essential to reconnoiter all possible locations the previous day and establish where and when the sun will rise. Checking out possible viewing points also helps, because this can be very difficult to do when arriving in the dark. Simple, practical things need to be considered such as how long it will take you to get to your location, and where can you park your car. After having gone to the trouble of getting up early, and during the summers months that could easily be 3 or 4am, there is little point arriving half an hour after the sun has risen.

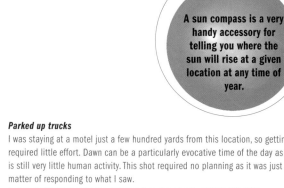

tip

A sun compass is a very handy accessory for telling you where the sun will rise at a given location at any time of year.

Parked up trucks
I was staying at a motel just a few hundred yards from this location, so getting up required little effort. Dawn can be a particularly evocative time of the day as there is still very little human activity. This shot required no planning as it was just a matter of responding to what I saw.
Canon EOS 1Ds Mark II, 24–105mm lens, 5 seconds at f.16, ISO 400.

Field with telegraph poles
At dawn the most attractive part of the sky is that area at precisely 180 degrees to where the sun is going to rise. Characteristically it assumes a beautiful gradation from blue to magenta, which makes even the most ordinary landscape look special.
Canon EOS 1Ds Mark II, 24–105mm lens, 1 second at f.18, ISO 320.

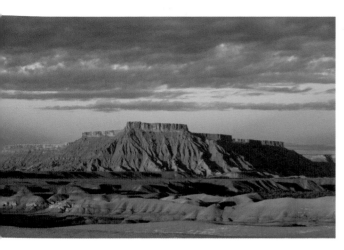

Hanksville at dawn
The few moments just after the sun has risen can provide some of the best lighting conditions for landscape photography. With the rising sun to my back, the butte was wonderfully illuminated by a warm, directional light.
Canon EOS 5D Mark II, 24–105mm lens, 1/50th second at f.22, ISO 400.

Dawn over Zabriske Point
Watching the emerging sun at dawn start to bathe the landscape in light is like viewing an unfolding drama. Selecting the precise moment to take your shot is part of the challenge.
Canon EOS 5D Mark II, 24–105mm lens, 1/13th second at f.18, ISO 800.

THE REWARDS

For all the hassle and possible disappointments, the lighting at this precious time of day truly can be awesome. I find that the lighting is at its most photogenic just moments before sunrise. The landscape seems to be bathed in a rich warm light, but because the sun has yet to emerge, the contrast is still containable. While it is very tempting to point your camera in the direction of the rising sun, try turning 180 degrees and look at what is happening in the opposite direction. The sky directly behind you has the capacity for bathing the landscape in a beautiful gentle light; it assumes a particularly pleasing cerulean-magenta blush, which is flattering to even the most prosaic of scenes.

Once the sun does appear, it will begin to illuminate, initially, only the highest features within the landscape. However, as it continues to rise, you will start to experience problems with contrast. Whenever you choose to take your dawn shots, expect to see an exposure difference of between three and four stops between the sky and the foreground so take along your ND grad filters. Always shoot RAW, just in case you need to increase illumination on the computer, and, of course, don't forget the obligatory tripod to prevent camera shake during long exposures.

Dawn over Badlands
Photographing the landscape pre-dawn can often prove profitable, particularly if you have some cloud cover in the sky as the emerging sun illuminates it from below, which provides a very dramatic backdrop for any landscape.
Canon EOS 5D Mark II, 24mm lens, 1 second at f.18, ISO 100.

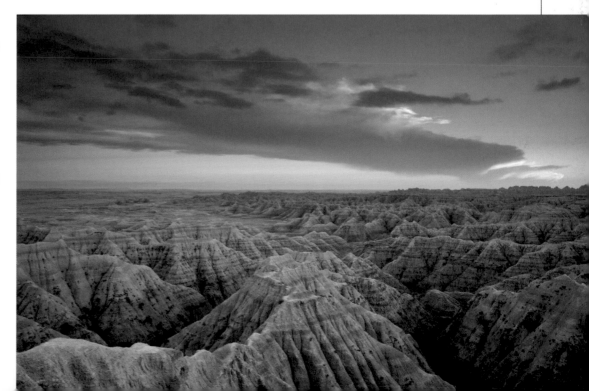

HIGH NOON

There is a belief among many landscape photographers that noon is the time to pack away your camera gear and retire for lunch, although I feel this is a rather negative attitude to adopt, as you should be able to get interesting photographs at any time of the day. Taking my cue from the countless movie-makers who, over the decades, regularly use the harsh midday light to create a particular mood, I often break with this convention. While you are unlikely to capture the same romantic qualities one sees at dawn or dusk, the practice of shooting at noon should not be altogether rejected.

OVERCAST LIGHT

Firstly, and stating the obvious, you are just as likely to experience overcast light as you are sunshine when shooting at noon. Overcast light in the middle of the day is easy to handle, particularly if you decide to cut out the sky; if you want to include it then you might need to consider making a HDR file (see Post-Camera Techniques [p54]).

SUNSHINE

If the sun is out, then matters are a little trickier; the nature of the landscape will also have a bearing. If you find yourself photographing a 'spaghetti western' type landscape where the searing sun at noon bleaches out all highlight detail and where shadows barely exist, then you will undoubtedly experience difficulties. With the sun directly overhead, contrast will be at its most severe, the colours will appear pale and the land will assume an uncomfortable glare. When photographing in the morning or during the late afternoon, the sun is nearer the horizon, consequently the contrast is not quite so extreme, but when you are shooting at high noon, particularly in a barren landscape, it is very easy to over-expose. Compensating for this will help to overcome the problem.

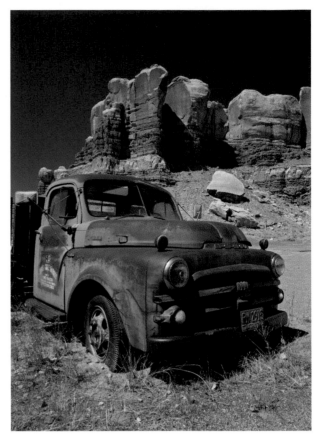

Abandoned truck
The landscape at noon can be virtually shadowless and quickly calls to mind the many movies that are photographed in strong lighting. In order to intensify the colours, I opted to use a polarizing filter.
Canon EOS 5D Mark II, 24–105mm lens, 1/80th second at f.22, ISO 500.

Sand dunes
I had originally taken this photograph as an aide memoire with the aim of returning later in the day, however, once I was able to compare the two, I realized that this particular subject benefited from being photographed with the sun high in the sky.
Canon EOS 5D Mark II, 200mm lens, 1/320th second at f.32, ISO 800.

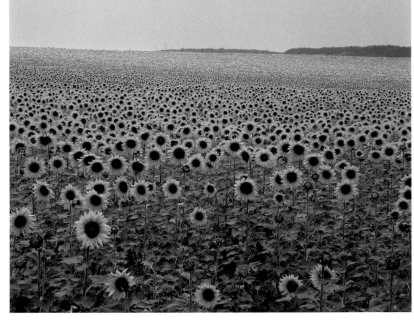

Sunflowers
Some subjects are greatly improved when photographed at midday. With the sun directly overhead, this field of sunflowers suffers none of the distracting shadows one is likely to see when photographing it at other times of the day.
Canon EOS 5D Mark II, 70–210mm lens, 1/160th second at f.32, ISO 400.

Abandoned elevator
Often the sky helps to define a landscape, and this is particularly evident in this example. The harsh lighting at midday creates a slightly unsettling scenario.
Canon EOS 1Ds Mark II, 24–105mm lens, 1/125th second at f.22, ISO 100.

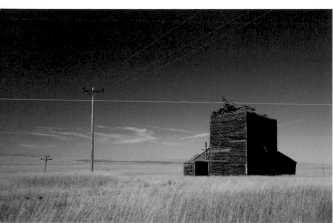

If you are photographing landscapes in more temperate zones, where the fields and pastures are verdant and green, photographing them should not pose any difficulties. In fact, the strong overhead light and the lack of shadow can sometimes prove an asset. As with most aspects of landscape photography, it is all about containing contrast. Look carefully from your chosen vantage point and judge whether some parts appear unacceptably bright; if so, redesign your composition to exclude them.

ISO CHOICE
It is important to select the right ISO for the task in hand. If you have been using an ISO of 400 earlier in the day and continue to use it at noon, then you are likely to experience burnt-out highlights. Select the lowest one available.

CONSIDER THE SKY
It is also worth asking whether the sky contributes to your landscape. If it does, then consider using a polarizing filter, or possibly a soft graduated filter, to give it more impact; if it does not, exclude it altogether. Be prepared to venture into areas of shadow and concentrate on picking out small elements of detail.

It is too easy to assume that photographing landscape in the middle of the day is a waste of time, but as long as you remain aware of the contrast you are likely to encounter and take measures to overcome it, shooting at noon can be as productive as at any other time of the day.

Olive tree
You can take photographs at midday, particularly when the sky is overcast, often with excellent results.
Canon EOS 1Ds Mark II, 24–105mm lens, 1/80th second at f.11, ISO 100.

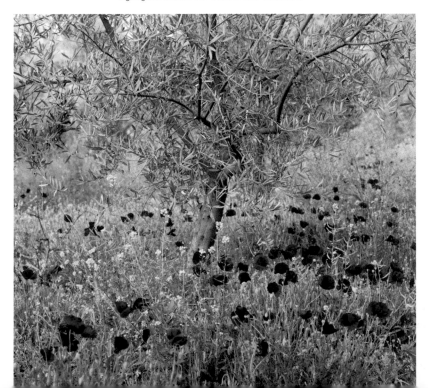

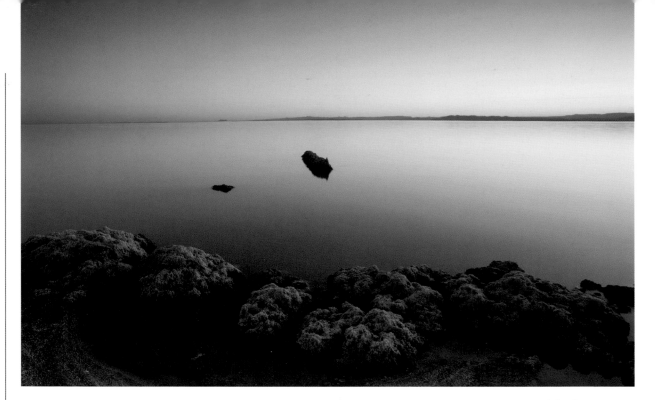

DUSK

For a variety of reasons, photographing in the early evening is possibly the most popular time to take landscape shots. First, it does tend to fit in more comfortably with one's daily routine. While the lighting at dawn can be equally as alluring, it frequently requires getting up in the dark. Second, it is usually possible to predict how the lighting will develop simply by watching how the light changes during the course of the afternoon; at dawn we tend to set off on a wing and a prayer. But ultimately, whether we take our photographs at dawn or dusk, we must be governed by how the lighting affects the subject.

ARRIVE EARLY

The transition from late afternoon to evening can often prove frustratingly slow, but it is sound practice to arrive at your location at least an hour before you anticipate taking your shots. Even if you are familiar with the area, you should still be prepared to check out various vantage points just to make sure that you are making best use of the lighting. Occasionally, the shots that you take prior to the evening light prove to be the most successful, so be prepared to approach the task with an open mind. But on a more practical note, there are few things more exasperating than getting stuck in traffic miles from your intended location, only to see the beautiful evening sky turning to night.

Salton Sea

I tried to photograph this location the previous evening but quickly abandoned it as the lighting was disappointing and there were strong gusts of wind. Returning, everything had changed, the water had becalmed and we experienced a wonderfully gentle sunset. Sometimes it pays to be patient. Canon EOS 1Ds Mark II, 24—105mm lens, 2 seconds at f.22, ISO 100.

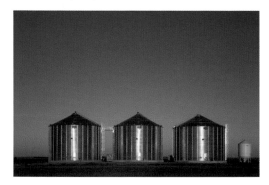

Silo 1
Judging whether to photograph a landscape just before or just after the sun has set will always prove difficult. In this example, I took my shot just before the sun disappeared and benefited from the warm directional light one typically encounters at this special time of day. It almost appears theatrical.
Canon EOS 5D Mark II, 24—105mm lens, 1/50th second at f.18, ISO 100.

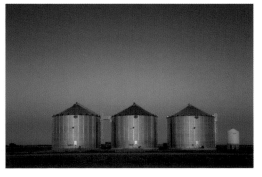

Silo 2
Just shortly after taking the first shot, the sun disappeared from the sky and the quality of light changed. Much of the contrast had gone, but I was also rewarded with the beautiful magenta blush that heralds the onset of night.
Canon EOS 5D Mark II, 24—105mm lens, 2 seconds at f.18, ISO 100.

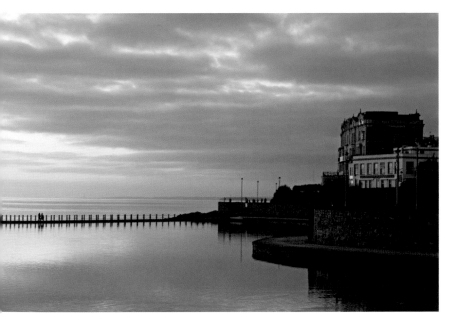

Dusk on the coast
Coastal locations make excellent subjects to photograph in evening light because the water has the capacity to reflect the sky, thus reducing the contrast problems that other locations can sometimes present.
Canon EOS 5D Mark II, 24–105mm lens, 1/30th second at f.9, ISO 100.

METERING

Metering can be quite challenging in these relatively low light conditions, particularly if you are using graduated ND filters. While in most cases the camera's metering system works well, a hand-held light meter can prove far more flexible. Taking two independent light readings, one from the sky and the second from the foreground is useful, as this will help you to decide what strength filters you require. Typically, expect the sky to be three to four stops lighter than the foreground. If you are spot metering, try taking a reading in an area between the horizon and the foreground, which tends to give an average result, although, of course, there will be exceptions to this. Alternatively, use the camera's metering system, but keep referring to the histogram after you have taken each of your shots. With your exposure mode set to manual, you should be able to make further subtle adjustments if your initial exposures are not satisfactory.

USE A FILTER

Visually, the setting sun is immensely seductive, but do be aware of the contrast you are likely to encounter. General advice is that you should never attempt to photograph the sun until you can comfortably look at it with the naked eye. Far better to wait for a bit of cloud cover to arrive, which will mask the sun: this not only helps to counter the contrast, but it also looks more pleasing.

Photographing at dusk is when I am most likely to use a graduated neutral density filter. If I am photographing landscape I use a soft ND, however if I am photographing coastal locations, I am more inclined to use a hard ND filter instead.

AFTER SUNSET

A good time to photograph dusk is during the period shortly after the sun has set as some of the problems of contrast will have disappeared. On a particularly clear evening, the afterglow in the sky can remain for up to 40 minutes, which offers a wonderful setting for the landscape. Some inexperienced photographers assume that once the sun has vanished, so have the opportunities for taking photographs, but providing you are prepared to use a tripod, you should be able to continue shooting for quite a while. It is amazing how flexible a DSLR can be, even in very poor lighting.

Zabriske Point
The lighting had been disappointing for most of the day and I really did not hold out too much hope that things would improve, but I decided nevertheless to visit this location aiming to capture some interesting evening light. These hunches often pay off as the clouds can sometimes begin to clear at the end of the day.
Canon EOS 5D Mark II, 24–105mm lens, 124 seconds at f.16, ISO 100.

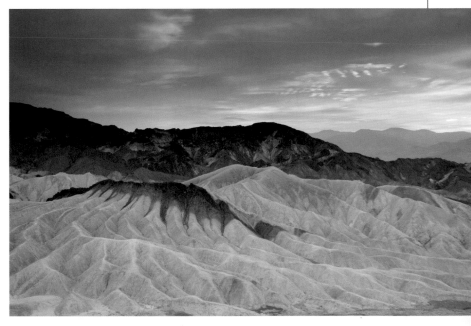

NIGHT

Not every photographer's cup of tea, but shooting landscape at night can offer some truly wonderful opportunities. It is all too easy to pack away your equipment the moment the sun drops below the horizon, but this is the time of day when the lighting become really interesting. Locations that we are accustomed to seeing in daytime are transformed, frequently assuming amazingly saturated colours when seen at night. There are, of course, several technical issues one needs to address, but if you are prepared to put up with the slight inconveniences of photographing at that time of the day, there are rich pickings to be had.

CAMERA SUPPORT

If you decide to follow this route, you will find that the majority of your images will be taken using a tripod. As I suggested in Section 1, a tripod is an almost indispensable tool when taking landscapes and none more so than when photographing at night. I would also urge you to use a good quality cable release; it is sometimes tempting to use the camera's self-timer, but this can cause camera shake, particularly at certain shutter speeds.

USE THE BULB SETTING

When taking landscapes, one usually tends to set a smaller aperture and a low ISO rating in order to maximize quality, but this inevitably means using long exposures; once the sun has set, you can measure these in seconds or even minutes. The shutter speed of most cameras goes down to 30 seconds (some up to a minute), but as day slips into night, you will need to use exposures considerably longer than this, which requires setting your shutter to Bulb. This allows you to take shots for as long as you want – hours if necessary.

KEEP YOUR BATTERY CHARGED

One obvious disadvantage of making long exposures is that it is a drain on the camera's battery, so make sure that it is fully charged before setting out. Avoid taking needless shots and try to be selective. It is also tempting to remove 'failures' from the memory card as you go along, but this can also prove to be an additional drain on the battery. It is far better to do this after you have taken your final picture.

It is also good practice to ensure that you have a fully charged spare for those really long night exposures that can take up to an hour or more.

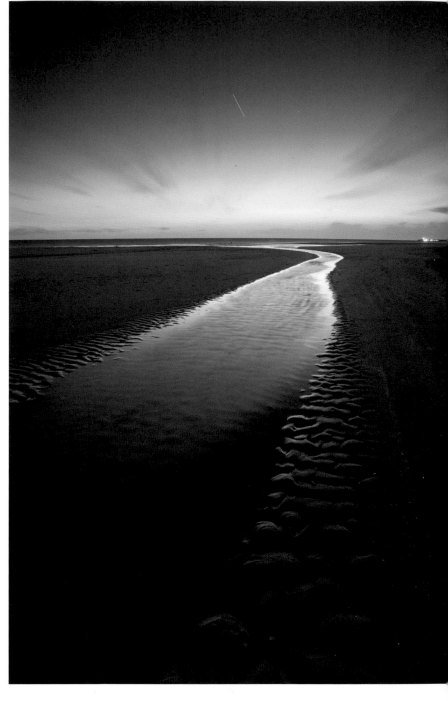

Cadiz, Spain
When seen in the daytime, this is an insignificant stream running down to the sea, but viewed at night, it assumes an entirely different character. Even the most prosaic of locations can dramatically change in these lighting conditions.
Canon EOS 5D Mark II, 17mm lens, 854 seconds at f.16, ISO 100.

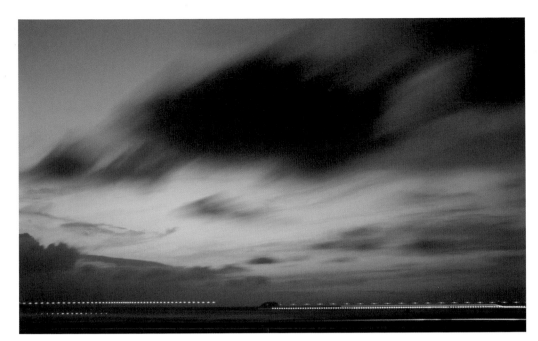

Lights above sea
Strange and beautiful images can be captured at night-time. As I was photographing this beach, two JCBs passed by with flashing lights, but because of the lengthy exposure, it looks like a string of unsupported lights hovering over the sea. Canon EOS 40D, 17–85mm lens, 36 seconds at f.22, ISO 100.

FOCUSING IN THE DARK

If the lens has an auto-focus facility, switch it off, otherwise your camera will go into 'hunt' mode, and prevent you from taking your shot – it is far better to focus manually. If you are photographing in the late evening, get to your location while there is still some light and pre-focus; as the light disappears, you should be safe in the knowledge that everything is sharp.

If you arrive in the dark, or you are working pre-dawn, then it is important to focus on any single light area you can see. If you are using a prime lens, this can be achieved by estimating the hyperfocal length but with a zoom this is more difficult to do. Selecting a small aperture is another way of ensuring that most of your image is sharp. I suspect that I am stating the obvious, but it really does help to carry a small torch whenever doing this kind of photography so that you are able to adjust the camera settings in the dark.

Getting horizons straight can sometimes prove problematic. While I regularly attach a spirit level to the camera, it can be hard to read, even with a torch. Generally you can see the horizon, even in the dead of night, and achieve a close approximation, which can then be tweaked in Photoshop.

Canyon near St George, Utah
If you have wondered how certain successful postcard photographers are able to capture a beautiful landscape under a rich blue sky, yet appear not to be troubled by excessive contrast, it is because they have probably photographed it at night. In this example, I ensured that my back was facing the lightest part of the sky. Canon EOS 5D Mark II, 24–105mm lens, 18 seconds at f.22, ISO 100.

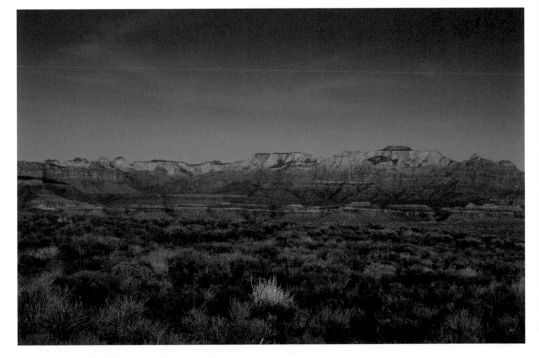

TAKING A LIGHT READING

One of the great advantages of using modern DSLRs is that they offer a variety of metering modes, which ensure that you achieve an accurate exposure time after time. They are not, however, designed for night photography. If you are going to do this kind of work, then I would suggest that you use a hand-held light meter; firstly because they are much more flexible, but also because they tend generally to be of better quality than the camera's own metering system. If you do opt to use the camera's metering system, then select the Evaluative mode.

Most light meters offer a light reading of up to one minute, (although some go up to 30 minutes); camera metering systems rarely go beyond 30 seconds. If your light meter only goes up to a minute then you can easily fool the system to give you the light readings you need. The first way of achieving this is to set the ISO rating higher than is required. For example, if you wish to use an ISO rating of 100, set your metering system to 800 (which is three stops faster than you intend to use), and then take a reading. If your metering system tells you that you need an exposure of 30 seconds when using an ISO rating of 800, it is also telling you that it requires an exposure of 4 minutes when using ISO 100.

On a similar tack, set the aperture on the light meter to just f.2.8, even if you intend to use f.16. If again your light meter gives you a reading of 30 seconds what you really require is a shutter speed of 16 minutes. If you intend to do a lot of night photography, why not prepare a chart rather like the one I have included below and take it with you?

f.2.8	30 seconds	15 seconds	8 seconds	4 seconds	2 seconds	1 second
f.4	1 minute	30 seconds	15 seconds	8 seconds	4 seconds	2 seconds
f.5.6	2 minutes	1 minute	30 seconds	15 seconds	8 seconds	4 seconds
f.8	4 minutes	2 minutes	1 minute	30 seconds	15 seconds	8 seconds
f.11	8 minutes	4 minutes	2 minutes	1 minute	30 seconds	15 seconds
f.16	16 minutes	8 minutes	4 minutes	2 minutes	1 minute	30 seconds
f.22	32 minutes	16 minutes	8 minutes	4 minutes	2 minutes	1 minute

Monument Valley
It is difficult to get a fresh angle on this particularly iconic viewpoint other than to try photographing it at night-time. Requiring an exposure of 7 seconds, the moving vehicles in the bottom right of the picture are evident only as a result of the light trails they leave. Canon EOS 5D Mark II, 24–105mm zoom, 7 seconds at f.22, ISO 100.

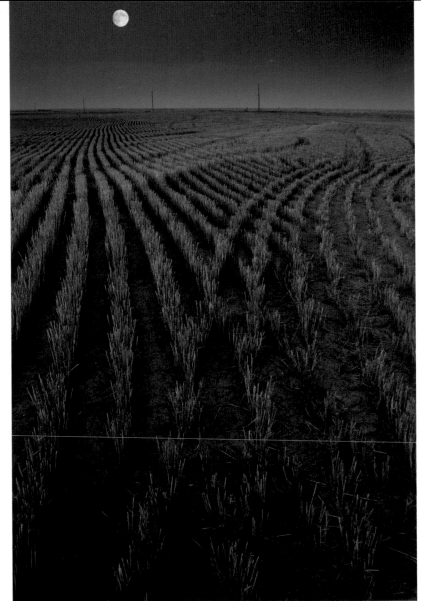

Harvested field
I had attempted to photograph this field just as the sun was setting, but encountered very strong contrast, but by waiting until the sun had disappeared, I was able to counter this problem. The strange colour shifts one experiences when photographing at night certainly adds a mystery to this landscape. Due to the rotation of the earth, the moon was shot independently of the landscape and added later using Photoshop.
Canon EOS 5D Mark II, 17mm lens, 13 seconds at f.16, ISO 100.

USING THE HISTOGRAM
The histogram is possibly the best feature of a digital camera, because it provides you with very accurate information regarding exposures you have just made. If you are experiencing difficulty making light readings, using the histogram is one way of getting round this. Having made an educated guess, make an exposure and then refer to the histogram to see how the pixels have distributed across the tonal range. It is important to ensure that there is not too much bunching to the left (indicating under-exposure), but also that there is no burn-out of highlight detail. Do not rely on the monitor, which can appear deceptively over-bright viewed at night.

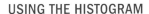

Goosenecks
Too many photographers assume that once the sun disappears, it is time to pack up and go home, but if you are prepared to wait 30 or 40 minutes, the lighting becomes increasingly more interesting. Photographing landscape on the edge of darkness can throw up some really intriguing results. Colours appear saturated yet less contrasty when shooting at night.
Canon EOS 5D Mark II, 24–105mm lens, 25 seconds at f.16, ISO 400.

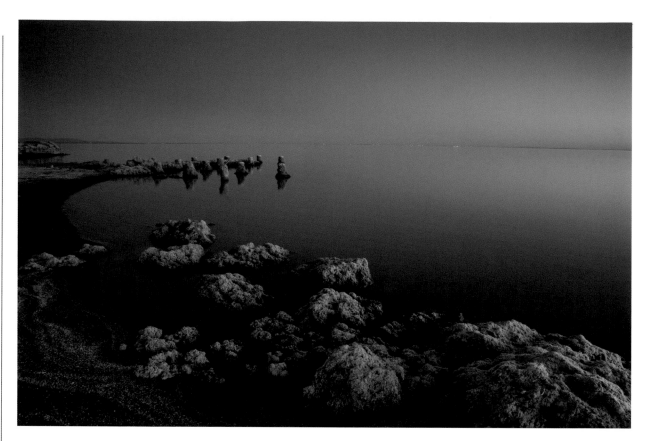

OVERCOMING NOISE

One of the drawbacks of photographing in low light is that you can encounter 'noise' (an increased appearance of graininess which can diminish the overall quality of the image). Fortunately most modern digital camera's now offer a NR (noise reduction) facility. It will be available within the cameras menu and should be selected when making exposures of one second or more.

However, all good things come at a price. After taking a picture, the camera requires a processing period equal to the exposure time. The camera cannot be used until this course is complete, so if you have just taken a two-minute exposure, your camera will require two minutes to reprocess this when the NR facility is switched on. Also, when using NR, the process actually softens the image ever so slightly, so it does need to be judiciously applied.

The quality of digital cameras has risen remarkably over recent years, particularly with regard to the size and quality of sensors. Certainly, if you are using a

modern full-frame DSLR, you should be able to use an ISO rating of 3500 or more, without seeing any noticeable noise, which opens up the possibility of hand-holding your camera even at night-time, particularly if you choose to use a wide aperture. When photographing landscape I would normally opt to use a tripod, but there could be occasions when hand-holding your camera proves to be a better option.

Salton Sea at night
With the sun dropping below the horizon to my right, much of the earlier contrast I had experienced had disappeared, but slowly, as my eyes adjusted to the gloom, the light rocks by the shore began to glow, producing an image revealing a strange yet eerie beauty. Canon EOS 5D Mark II, 24–105mm lens, 124 seconds at f.16, ISO 400.

NOISE REDUCTION POST-CAMERA

If, for whatever reason, it proves impractical to use the camera's NR facility, there are several image editing software packages that allow you to deal with noise post-camera. Possibly the most popular of these is Neat Image, which you can easily download by going to www.neatimage.com. Other alternatives you may wish to consider are Noise Ninja and NoiseWare Pro. Don't necessarily see these packages as a total panacea to photographing in low light as it can take quite some time to process each image. Certainly if you have quite a few to process, it might not be the ideal solution.

The RAW Converter for most cameras will also have a Noise Reduction facility which is another reasonably effective means of countering noise; but ultimately the best way of reducing it is to make sure that you do not under-expose, as noise is always most apparent in the darker parts of the image.

Sharpening	
Amount	25
Radius	1.0
Detail	25
Masking	0

Noise Reduction	
Luminance	0
Luminance Detail	
Luminance Contrast	
Color	25
Color Detail	50

For a more accurate preview, zoom the preview size to 100% or larger when adjusting the controls in this panel.

NIGHT LOCATIONS

Once the sun disappears, the sky becomes the main source of light. On a clear night, if there is a full moon, then this can also be factored in. But the main problem is that the illumination from the sky is likely to be far greater than the land, consequently the contrast between the two can exceed the dynamic range of the camera.

Ideally, what is required are locations that can reflect some of the light coming from the sky, which is why coastal locations often work so well. Water is particularly good at reflecting light back, even at night-time. In fact, any landscape that can reflect light can be successfully photographed at night. Snowy landscapes work particularly well, but so do wet roads snaking through a landscape. Illuminated landscapes typically found in urban locations also make excellent subjects for night photography. It is simply a matter of trying to balance the illumination of the sky with the land.

SUITABLE FILTERS

In order to overcome the lighting disparity between the sky and land, try using a

graduated filter. If there is very little detail appearing above the horizon, such as a coastal landscape, then try a hard grad filter, however, if there are important features appearing above the horizon, opt for a soft grad filter instead.

The Severn Bridge
The urban environment lends itself particularly well to night photography, as there is often artificial lighting which both serves as a focus, but also helps to illuminate the land.
Canon EOS 1D Mark II, 17–40mm lens, 204 seconds at f.18, ISO 100.

tip

If you are out driving in the evening or pre-dawn, just check in the mirror from time to time to see what is happening to the light behind you.

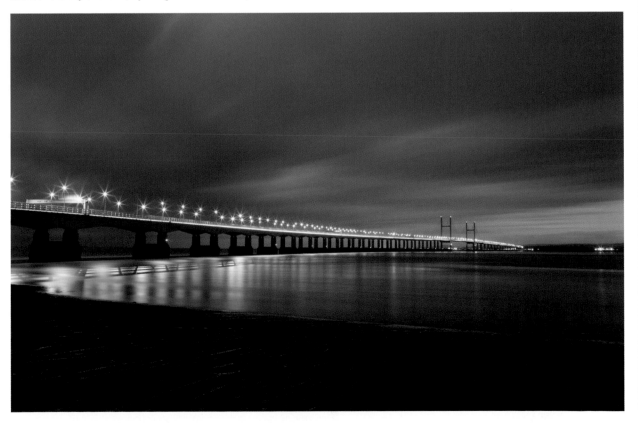

The Direction of Light

If there is one single quality that is most likely to define the success of a landscape, it is the quality of light. The way that it is angled to illuminate the subject has a great bearing on the interpretation of the landscape. This, of course, is less of an issue when the sky is overcast, but as soon as the sun appears, you will experience increased contrast. While this might pose an occasional problem, most photographers welcome strong directional light. Assessing its potential is always important, and if the angle of the light from the sun is not ideal then you may wish to return at another time of the day; if that is not possible, then check out other nearby vantage points that are better suited to the prevailing lighting conditions.

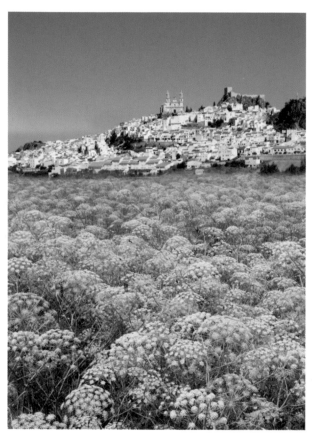

Spanish town
Frontal lighting can sometimes be very useful when you want to highlight a particular feature, in this example the group of buildings in the background. Canon EOS 1D Mark II, 17–40mm lens, 1/50th second at f.16, !SO 200.

Water on rocks
Side lighting works particularly well when you want to highlight texture. As the light was coming from left to right, I needed to use a soft ND grad positioned horizontally in order to balance the light in the sky. Canon EOS 5D Mark II, 17mm lens, 25 seconds at f.18, ISO 100.

FRONTAL LIGHTING

Going back to the earliest days of popular photography, the advice was always to ensure that the sun was over your shoulder. This was because earlier lenses were not multi-coated and were much more subject to flare. These days we are a little less inclined to use frontal lighting, largely because it is difficult to achieve a positive sense of modelling. It is, however, very useful when you wish to highlight a particular feature. Frontal lighting works at its best when the sun is very low in the sky although you do need to ensure that your own lengthening shadow is not also included. Frontal lighting can be particularly attractive when breaking through cloud cover as, once again, it can be used to highlight specific elements.

SIDE LIGHTING

Side lighting is probably the quality of lighting that most landscape photographers prefer. From a technical standpoint, you are unlikely to experience flare, while aesthetically photographers greatly enjoy using it because it helps to define textural detail. The lower the sun is in the sky, the more dramatic this becomes. Side lighting greatly increases the three-dimensional qualities of a landscape, so when photographing sand-dunes, for example, the slanting light will dramatically emphasize the richly patterned indentations. Side lighting can be anything from a 45 to 135 degree angle, so clearly embraces quite a broad spectrum of opportunities. If you are including a sky in your landscape, a polarizing filter is at its most effective when using side lighting,

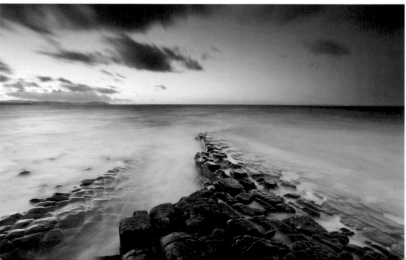

although there is a tendency for the sky to appear unevenly polarized, particularly when using a wide-angle lens. Another filter you might consider attaching is a soft ND grad filter, but positioned horizontally, (rather than vertically), so that the darkest part covers the lightest part of the sky.

BACK-LIGHTING

Back-lighting, sometimes referred to as contre jour, is possibly the most difficult lighting to handle, but when it succeeds, it can be the most dramatic. This requires photographing directly towards the source of light, so it is important always to use a lens hood. In strong, low lighting this creates silhouettes, which can sometimes be a blessing, but at other times a curse. If the silhouette is just a small feature within the landscape, it can look very effective. However, if it is too prominent, then the image will appear under-exposed; if so, you may wish to consider creating an HDR file. Contre jour seems to perform best when photographing towards light or reflective surfaces; it works particularly well when shooting water, for example. It is rarely effective when the ground surface is dark, although if there are plants present, you should be able to exploit an interesting effect called rim-lighting whereby light shines through the edges of the plants and creates a highlighted outline.

Irrigated fields
Backlit, the water from these irrigation sprinklers appears to be irradiated with light.
Canon EOS 5D Mark II, 24—105mm lens, 1/100th second at f.16, ISO 100

Pier
Contre jour can be difficult to handle because you risk grossly underexposing the foreground, however the many reflective surfaces help to create interest.
Canon EOS 5D Mark II, 17—40mm lens, 1/50th second at f.16, !SO 200.

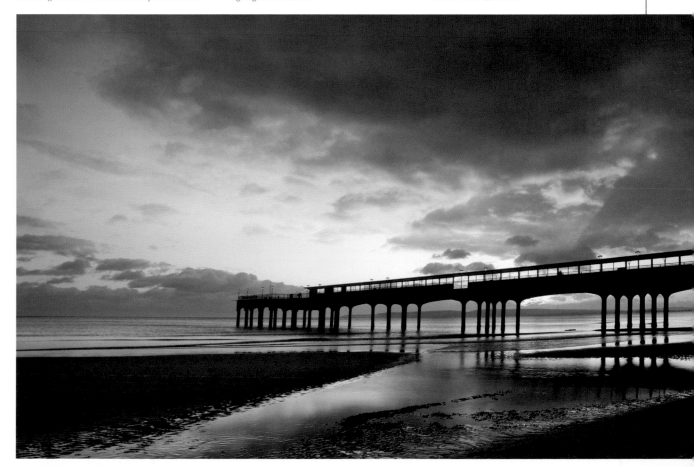

Weather Conditions

There is no such thing as ideal weather for photography — you should be able to adapt to any circumstances. There are even some photographers who specialize in taking shots in the most severe weather, including hurricanes and tornadoes, so clearly nothing should be off limits. While this extreme end of photography might not suit everyone (including myself), weather can add drama to an otherwise mundane landscape.

STORMY SKIES

Sometimes the nature of a particular landscape lends itself to quiet light, while other locations benefit from something more dramatic, but one of the most coveted of lighting conditions is when you capture a landscape under a dark and threatening sky. Approaching or passing storms can make even the most insipid landscape appear truly remarkable.

What makes storms so interesting is their total unpredictability. One assumes that wind travels in one direction, but in stormy conditions, it appears cyclonic, so guessing when the cloud is likely to break is largely serendipitous. Often the best place to be is just in front of an ensuing storm, or just behind it. With the landscape bathed in rich sunshine set against a broody, tempestuous sky, the mix can be truly theatrical.

Because of the mist and rain present in the atmosphere, try to concentrate

Approaching storm and wheat field
Even a moderately insipid landscape can be made to look interesting photographed under a dark and broody sky. Canon EOS 5D Mark II, 200mm lens, 1/640th second at f.18, ISO 800.

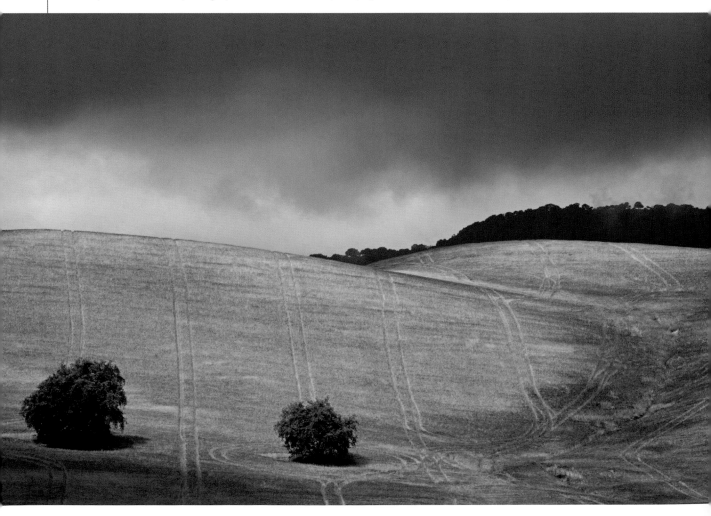

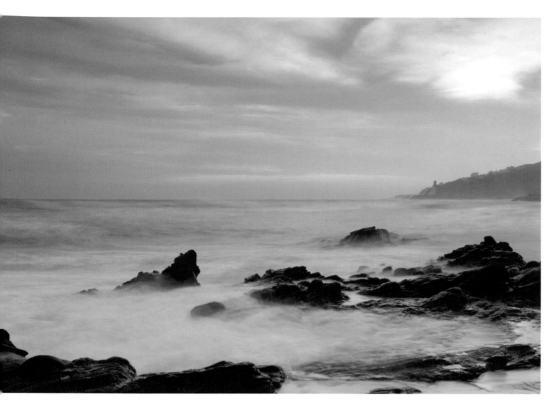

Rocky cove
Often when photographing coastal locations I prefer to use an ND grad filter, which darkens the sky without affecting the foreground. Whichever filter you use, make sure that you don't get even a single drop of water on it or you will encounter ghosting. Canon EOS 5D Mark II, 24–105mm lens, 2 seconds at f.22, ISO 100.

on relatively nearby vistas. Ambitious panoramic landscapes rarely work as an impenetrable rain storm could be just a matter of several hundred yards away. It is worth scanning the immediate landscape a full 360 degrees trying to establish those areas that are getting the best illumination from the sun. Unfortunately, you need to act quickly as the lighting does change very quickly. Don't be too fastidious about what you include in your composition, as even the most mundane landscape can be transformed in this sort of dramatic lighting. Grab the shots while you can, and do your editing later.

FILTERS FOR STORMY WEATHER

In addition to the ever-present UV (see the filters section [p16]), consider using either a polarizing or a graduated neutral density filter in order to heighten the unfolding drama. If you use a polarizing filter, expect to lose up to two or three stops, so if you are hand-holding your camera you should use an ISO of at least 400. Remember also that the polarizing filter is at its most effective when you are shooting at 90 degrees to the sun. Generally, I prefer to use an ND grad filter, which darkens the sky without affecting the foreground. Whichever filter you choose to use, make sure that you don't get a single drop of rain on it or you will encounter ghosting with the possibility of a ruined image.

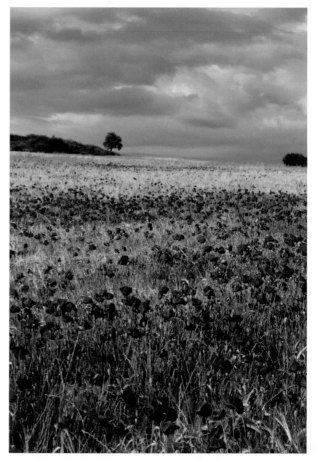

Poppies after the storm
A great time to take landscapes is just before, or just after a rain-storm has passed over. With the sun behind you, the results can be especially dramatic.
Canon EOS 5D Mark II, 24–105mm lens, 1/125th second at f.22, ISO 200.

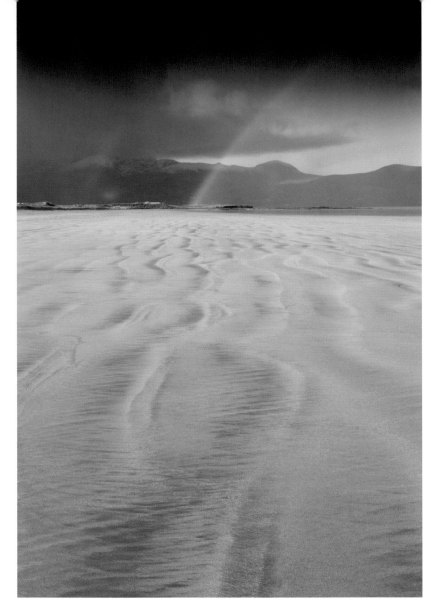

Rainbow over beach
If there is one element that is bound to add that special 'wow factor' to your landscape shot it is the inclusion of a rainbow. While they always look good to the naked eye, unfortunately they rarely look quite so dramatic when photographed, so firstly be prepared to slightly underexpose, and if that does not work, try increasing the saturation post-camera.
Canon EOS 5D Mark II, 24–105mm lens, 1/100th second at f.22, ISO 500.

PROPORTION OF SKY TO LAND

In most cases, it is the sky and not the land that is the main source of interest, so be prepared to point your camera upwards. If you find that the foreground is of equal interest then opt for a portrait format; whether you decide to make the sky the main feature or not, use a wide-angle lens, which will make the most of the ever-changing lighting conditions.

EXPOSURE

When photographing storms, the aim is to capture the mood, therefore consider under-exposing your shot by 1/3 stop in order to increase the sense of threat. If this worries you, then shoot RAW and once you have examined your shot in the RAW converter, make any required changes using the brightness adjuster. It is also important to be patient and don't automatically assume that you have your shot in the bag. Storms are an unfolding drama and it is difficult to predict when it will reach its climax. Keep shooting until the storm has fully passed.

CATCHING RAINBOWS

If there is one element that is bound to add that special wow factor it is the inclusion of a rainbow. Even non-photographers stop and take note. The most likely time to catch one is immediately after a storm. Typically this occurs as the edge of the storm moves past you and the sun reappears. This has the effect of heightening the contrast between the dark clouds and the vivid rainbow, although you do need to react quickly as the sun can so easily disappear behind a cloud once again.

While they always look good to the naked eye, unfortunately they rarely look quite so striking when photographed, so firstly be prepared to slightly underexpose, and if that does not work, try increasing the saturation post-camera.

CAPTURING LIGHTNING

Many photographers assume that capturing a bolt of lightning is a matter of luck, and if you are photographing a storm in the middle of the day, then it certainly is as a normal strike lasts

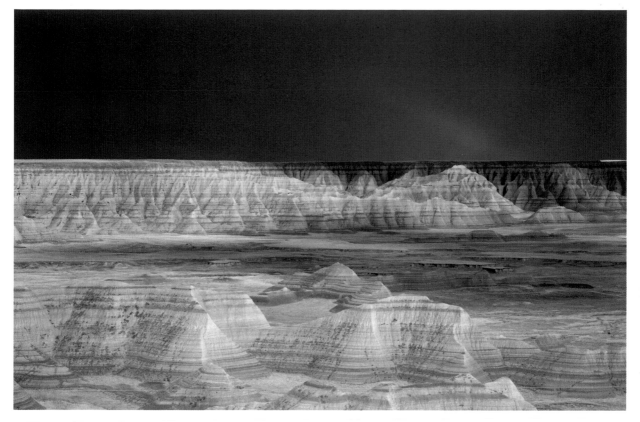

just several hundredths of a second. The secret is to capture a lightning storm in the late evening or at night. Set your camera on a tripod, point it in the direction of the storm, focus and wait. In a truly heavy storm you should expect to get a strike every few seconds. If you are able to make exposures lasting at least 30 seconds (this might require adding a filter), and with a moderately large aperture (try f.5.6 or f.8), you should be able to comfortably capture multiple strikes.

Stormy sky over the Badlands
I am rarely very patient, but on this occasion I anticipated that there was a potentially interesting photograph several hours before it occurred. I could see a distant storm to my left and waited for the clouds to slowly move in my direction. I then had to endure a lengthy downpour before the storm finally moved away, resulting in the landscape being bathed in a rich and dramatic light. It was worth the wait.
Canon EOS 5D Mark II, 70–200mm lens, 1/60th second at f.18, ISO 400.

PROTECT YOUR CAMERA
Whether a storm has just passed or one is on its way, it is very easy to get caught in an unexpected downpour, and while that might not do you much harm, even the best cameras can be damaged by rain. Moreover, water on the lens prior to taking your shots is never helpful. Whether you keep one in your car, or perhaps carry a one in your camera bag, having an umbrella available is always a good idea.

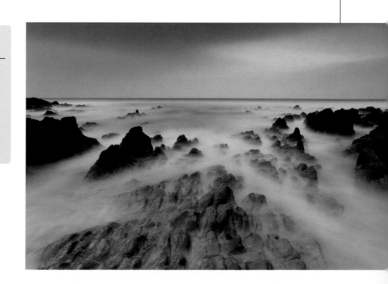

Craggy rocks
These razor sharp craggy rocks will have spelt doom to countless ships over the centuries, and photographing them in the gloom of a grey, threatening sky is a reminder of the hazards they present.
Canon EOS 5D Mark II, 24–105mm lens, 277 seconds at f.22, ISO 100.

RAIN

Landscapes taken in the rain have an indefinable, understated beauty revealing gentle, muted colours. It is very difficult to capture rain as it falls too quickly, so it is far better to illustrate the effects of rain instead. Try focusing on small puddles or ponds and photograph the ever-widening concentric circles created by the rain, or capture the rain-washed surfaces in urban streets. I particularly enjoy taking photographs of rain at night-time when the reflections from passing vehicles or adjacent buildings and structures can prove spectacularly beautiful.

TAKE PRECAUTIONS

Many photographers dread rain and yet it offers some of the best photographic opportunities, providing you take certain precautions. The first of these is that you do need to protect both yourself and your camera. If you get soaking wet, it is difficult to concentrate on photography, therefore wearing some form of waterproof clothing clearly makes sense.

Don't expect your camera to be water-tight. You can buy purpose-built underwater cameras but the majority of digital cameras, even the expensive ones, will let in water. There are now several manufacturers producing rain covers that protect the camera, yet allow you to use all the camera facilities even in the heaviest downpour. Not wishing to accumulate ever more equipment, I use a clear plastic shower hat (the type that come free at some hotels or motels), which keeps my camera dry for the short period of time I use it in the rain. More usefully, I also carry a small umbrella in my backpack, which not only prevents my camera getting wet, but also guards it from the wind. If you are completely caught off-guard, find a viewing point that offers you and your camera shelter and, if necessary, use a long angle lens.

Finally, be aware of just how one drop of rain on your lens can ruin a potentially great photograph. As you take each shot, check the monitor just to make sure that there is no tell-tale evidence of flare; if there is, have a clean, soft cloth available to dry the moisture off your filter. The ambient light will be noticeably reduced in rain, therefore you will either need to increase the ISO rating, use a larger aperture or place your camera on a tripod.

AFTER THE RAIN

Many professional landscape photographers believe that the period shortly after rainfall is one of the golden moments in photography, largely because the atmosphere appears cleansed and the cloud formations tend to have a distinct clarity: it can be one of those rare occasions when atmospheric haze is completely absent. Passing storms can

Café at night
It is possible to get interesting photographs during a downpour. Find a sheltered viewing point or, as in this example, ask a friend to hold a large umbrella over you as you take the shot.
Canon EOS 5D Mark II, 50mm lens, 38 seconds at f.20, ISO 100.

Parked car
When I spotted this parked vehicle earlier in the evening it just didn't seem to work in a photograph, but as soon as the rain started, I immediately sensed that matters would improve.
Canon EOS 5D Mark II, 200mm lens, 34 seconds at f.20, ISO 160.

Observation tower
The period immediately after rain is a great time to take photographs; it is almost as if the atmosphere has been cleansed and the sky retains a distinct clarity and beauty. In order to balance the sky and the foreground I used a soft ND grad.
Canon EOS 5D Mark II, 24–105mm lens, 1/125th at f.20, ISO 320.

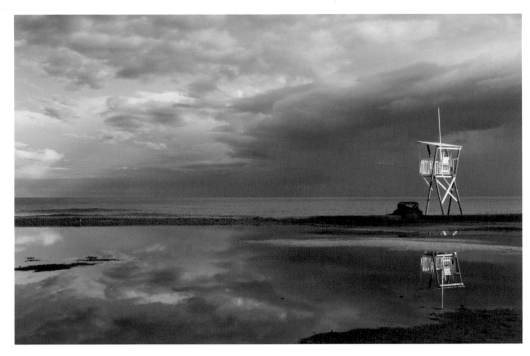

also provide other excellent photographic opportunities; look for puddles, which can create wonderful mirrors of the immediate landscape. These tend to work particularly well in urban landscapes, with streets or buildings reflected in the water, although equally exciting shots can be taken in boggy or waterlogged fields.

In order to make best use of puddles, use a wide-angle lens to include both the reflections and the subject; the closer you are able to get to the reflection, the more dynamic the image will appear. It may also help to use a polarizing filter, which will not only increase contrast in the sky, but will also remove some of the unwanted highlights in the reflections.

Extended periods of rain can certainly prove frustrating; it is not just emotionally sapping, but it can mean that you are not able to get out and take photographs. However, every cloud has a silver lining. As the landscape soaks up the rainfall, it also replenishes the natural flora and after a particularly wet winter, spring flowers appear in abundance.

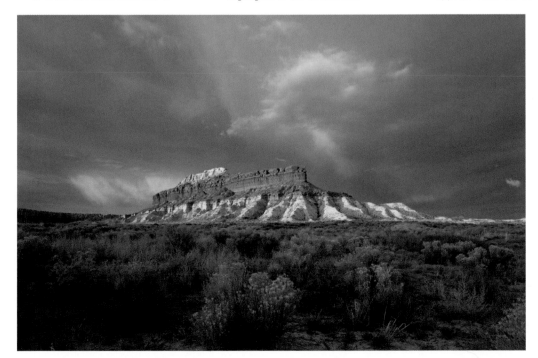

Steamboat Rock
Very often some of the best lighting conditions for landscape occur just after a period of rain. Having experienced miserable conditions for most of the day, I ventured out more in hope than in expectation. As I was unfamiliar with the area, I had little awareness of what might prove photographically interesting, but had the good fortune to stumble across this butte just as the evening light broke through the clouds.
Canon EOS 5D Mark II, 24–105mm lens, 1/30th second at f.16, ISO 400.

MIST AND FOG

Like rain, mist and fog are weather conditions we can experience at virtually any time of the year, although they are most likely to occur during the autumn months. They are caused by a climatic condition known as temperature inversion, when warm air meets cold air, although they only appear when the air is still. They offer excellent opportunities for taking mysterious and ethereal landscapes.

PREDICTING FOG

It is usually quite easy to predict fog, although it is important to understand that its intensity will not be uniform over an entire area; it tends to be most dense in places close to rivers and lakes. If you wake up to a foggy morning, it is pointless travelling around looking for shots, as it is notoriously ephemeral. It is far better to work out possible locations before the fog occurs. You need to use your imagination, as many sites that appear dull and prosaic in normal light can be wonderfully transformed in mist or fog. An unusual condition that can offer interesting opportunities for coastal photography is a sea fret. These tend to occur in the summer months when the warm air of the interior meets the cooler sea.

SUBDUED COLOUR

Shooting landscapes in fog is particularly popular with photographers, largely because of the aesthetic qualities one can exploit. Characteristically, the colour palette will be greatly subdued, creating an almost monochromatic effect. The tonal range of images is similarly limited, which is part of its charm. When photographing undulating landscape, one can often encounter a beautiful visual phenomenon known as aerial perspective; as the scene disappears towards the horizon, the layered tones appear increasingly lighter.

Irrigated fields
Even the most mundane landscapes can look interesting when shrouded in mist, as it has a capacity to create a beautiful recession of tones. Canon EOS 40D, 17–85mm lens, 1/8th second at f.18, ISO 200.

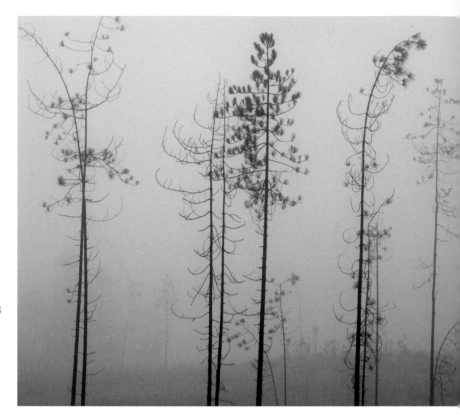

Often images taken in fog have a gentle, high-key quality, although this can be subtly exaggerated at the printing stage, creating images of particular beauty.

The ephemeral nature of fog means that it can disappear as quickly as it descends. While you can seemingly be in the midst of a proverbial 'pea-souper', the sun's rays will suddenly start to

Saplings
Under normal conditions, these delicate saplings would have remained unnoticed as they are innocuously set within a much larger forest, but because the mist has greatly restricted any sense of depth, they appear isolated and wonderfully graphic, like a traditional Japanese piece of artwork. Canon EOS 5D Mark II, 70–200mm lens, 1/40th second at f.16, ISO 100.

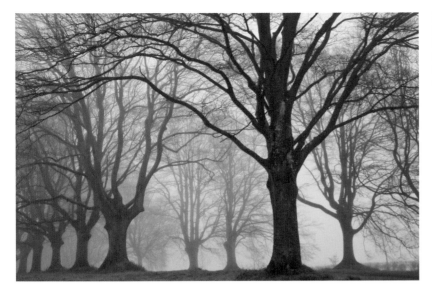

Trees in fog
Undoubtedly, the best time to photograph trees in fog is during the winter months, as the skeletal structures assume almost sculptural qualities.
Canon EOS 5D Mark II, 24–105mm lens, 1/125th second at f.20, ISO 320.

tip

> In very dense fog, it is possible to get moisture on the lens. Make sure that the lens always has a UV filter on and if you are troubled by condensation, then dry the filter with a soft, dry cloth from time to time.

appear, but this then presents fresh photographic opportunities. For example, individual trees can appear spectacularly beautiful when backlit in a rising mist.

METERING
Metering landscapes in fog can be notoriously difficult and more often than not you are likely to under-expose.

These are conditions where you need to regularly check the histogram. Expect to see it peaking in the mid-tones; if it starts to bunch to the left, open up your aperture or, alternatively, you can select a slower shutter speed. You may also consider bracketing your exposure, which is easy to do with the camera's exposure compensation facilty.

Aerial perspective
Characteristically the colour palette will be greatly subdued when photographing trees in mist, creating an almost monochromatic effect. As the trees recede into the distance, they appear lighter; this is known as aerial perspective.
Canon EOS 5D Mark II, 70–200mm lens, 1/6th second at f.25, ISO 400.

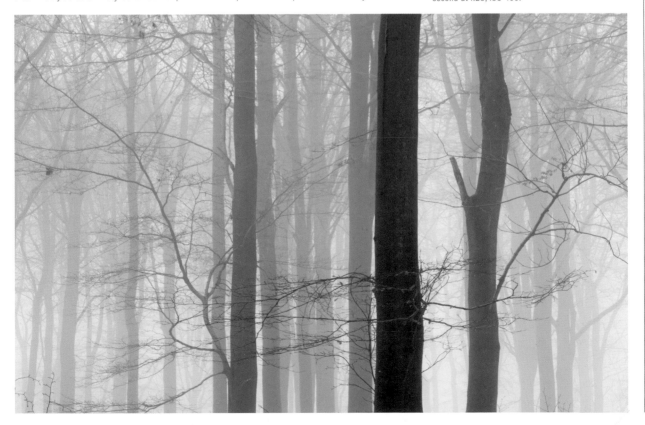

WIND

Wind can often be a great nuisance for landscape photography as it can be difficult to keep the camera steady and even blow your tripod over. But once again it is possible to change a problem into a virtue. Wind is invisible, but of course we can see the evidence of it as it passes over the land, sometimes with pleasing results. For example, watch what the wind does as it passes over a field of wheat or barley. The movement is cyclonic, so while parts of the field will be severely buffeted, other parts will briefly appear static.

Try placing your camera on a tripod – weighed down by your camera bag – then concentrate on the ever-changing landscape in front of you. You may even consider using a low shutter speed, possibly 1/8th second or less, and capture the almost abstract qualities the movement of the wind creates.

If you wish to illustrate the power of wind, trying reducing your shutter speed even further, although, unless you are photographing at night, then this effect will need to be induced by using a neutral density filter. Neutral density filters are designed to uniformly reduce the amount of light reaching the sensor, thus allowing you to greatly extend the length of your exposure. With some of the stronger filters, it should be possible to reduce a normal daytime shutter speed of say 1/60th second down to one minute or more. This allows you to enter into a world of time lapse that your eye cannot see in normal circumstances.

TREES IN THE WIND

Try using this technique when photographing trees in the wind. As the trunk of the trees are likely to prove immovable, the wind will appear to have the greatest effect on the thinner branches and leaves; the contrast this provides can often prove stunning. Try lying down on your back and viewing a group of trees above you; it really does introduce an entirely new perspective. Using a tripod from this angle might prove a little difficult and will require that you splay out the legs but,

Wind in trees
Blowing from left to right, the young saplings in the foreground are much more vulnerable to the wind than the sturdier trees in the background.
Canon EOS 5D Mark II, 200mm lens, 1/125th second at f.20, ISO 200.

Poppies in wheat
Although wind is invisible, we can constantly see its evidence. It can look particularly appealing as it blows across cereal crops.
Canon EOS 5D Mark II, 200mm lens, 1/320th second at f.20, ISO 500.

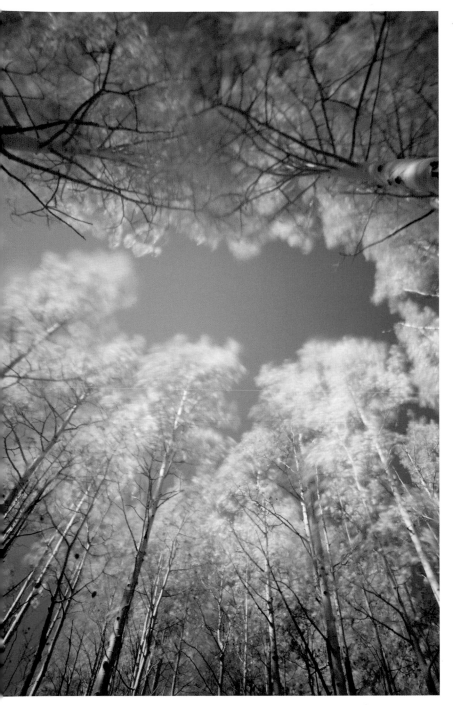

Aspens
In order to exaggerate the effects of the wind on the upper part of the aspens, I attached a strong neutral density filter, which greatly reduced the amount of light reaching the sensor; thus requiring an exposure time of over a minute.
Canon EOS 5D Mark II, 17–24mm lens, 71 seconds at f.22, ISO 100.

tip

Tripods are vulnerable in strong winds and the results can be very costly. Use your camera bag to weigh it down.

once you have mastered it, it is a technique that is well worth pursuing. Using a wide-angle lens in these situations can prove particularly dramatic.

Another alternative is to photograph trees at night. A low twilight is a particularly interesting time as you are still able to achieve a shutter speed of around six to ten seconds. If you are able to find a tree that is artificially illuminated by nearby street-lighting, then you should be able to continue taking shots at any time of the night.

THE SEA

For a great sense of drama, try photographing the sea in high winds. This can often be achieved by photographing off a pier or other suitable promontory. As the wind increases in strength, it whips up tumultuous waves, but this time make sure you are using a fast shutter speed; a minimum of 1/500 second will be required. But you do need to be careful, as salty water can easily drench you and your camera. If you can shoot where the wind is in your back, you are much less likely to get caught.

OVERCAST SKIES

Some argue that one of the worst lighting conditions we can possibly encounter is an overcast sky and that strong, dramatic lighting is required for photographing landscapes. However, you then run the risk that all your images look the same – and it reduces the opportunities to get out and take photographs. It's true that some landscapes are best photographed under a spectacular sky, but other, more quiet, scenes work better when the lighting is overcast. Learning to match the appropriate lighting with the right landscape is part of the art of landscape photography.

THE STRENGTH OF CLOUD COVER

The term 'overcast' can mean several things and ironically the more overcast and broody the sky, the easier it is to handle; there are occasions when we wish to introduce an element of menace into our work. If the sky is particularly overcast, try using a graduated ND filter, which will not only help to retain detail in the sky, but more importantly introduce a sense of mood. Unfortunately, some overcast skies are just milky and featureless; if so, there is little point in including them in your picture, although the diffused quality of light you get in these conditions is ideal for close-up landscape work.

BLACK AND WHITE IMAGES

While colour workers may debate the pros and cons of overcast skies, most monochrome enthusiasts positively welcome this kind of weather, first because the quality of the light is more rounded, therefore the tonal values are more clearly defined, and second a black and white landscape can often be enhanced when using a high-key sky, providing that the highlights are containable.

SUITABLE SUBJECTS

• **Cityscapes**

When we are surrounded by large buildings, the sky plays a much reduced role. It is rarely required to define the mood of this genre of photography, consequently cityscapes can be quite comfortably photographed under overcast skies. In fact they are an advantage as the soft lighting enhances the rich textural and architectural details one commonly sees in these environments.

Pebble on rocks
When photographing in overcast light, by excluding the sky altogether, the lighting from it serves like a large, soft white umbrella, which greatly reduces harsh shadows and reflections.
Canon EOS 5D Mark II, 50mm lens, 1/80th second at f.16, ISO 500.

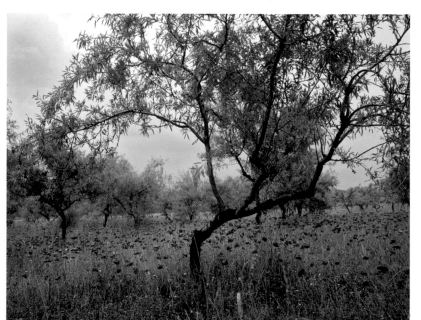

Almond trees and poppies
If you encounter a landscape on an overcast day and feel that the sky must be included, try to fill it up; this tree serves the purpose particularly well.
Canon EOS 5D Mark II, 24–105mm lens, 1/125th second at f.20, ISO 320.

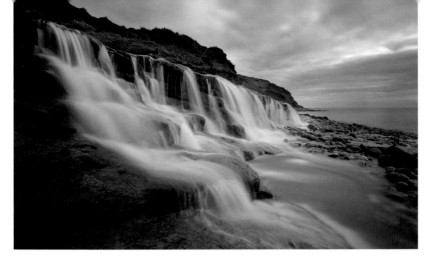

Waterfall
Often waterfalls such as this are almost impossible to photograph on sunny days because of the immense contrast created. If you do wish to include a sky, consider creating a HDR file, as I did here.
Canon EOS 5D Mark II, 17mm lens, 4 seconds at f.20, ISO 100.

EXCLUDING THE SKY

When photographing any kind of landscape on an overcast day, you always have the option of composing an image without the sky. In fact, most photographers tend to point the camera at the horizon far more often than they ought. By excluding it altogether, the lighting from the sky serves like a large, soft white umbrella, which subdues unsightly shadows and reflections. There will of course be occasions when for purely compositional reasons, the sky needs to be included. In those situations find an element, such as a tree, which fills it up.

Alternatively, if the sky needs to be included, consider creating a HDR file (see the section on creating HDR files [54]), a technique specifically designed to overcome the problems of excessive contrast, particularly when using a digital camera.

- **Waterfalls**

The best method for waterfalls is to use a slow shutter speed in order to capture those misty effects much enjoyed by landscape photographers, but this can only be successfully achieved with an overcast sky. Contrast becomes impossibly difficult to handle, particularly if sunlight is shining directly onto the moving water.

- **Floral landscapes**

When photographing flowers on sunny days, the harsh lighting creates stark shadows, unwanted reflections and burnt-out highlights. This type of photography is always far more successful when using overcast lighting. As much of the impact is created by the colour of the flowers, be prepared to do plenty of close-ups.

- **Moody landscapes**

An open, bright blue sky creates a sense of optimism, which is why the advertising industry uses it so often, but landscape can also be broody and threatening under a dark and overcast sky.

Abandoned car
This sad and melancholic landscape has been enhanced by a dark and broody sky.
Canon EOS 5D Mark II, 50mm lens, 1/200th second at f.7.1, ISO 200.

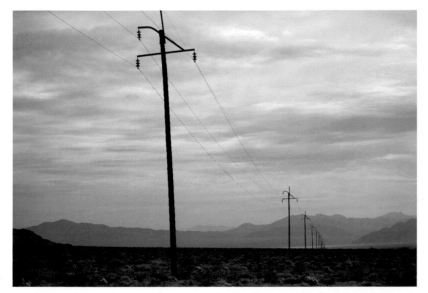

Telegraph poles
Not all landscape benefit from strong directional light, and while this landscape has been shot in colour, it suggests a gentle monochromatic quality.
Canon EOS 1Ds Mark II, 200mm lens, 1/6400th second at f.4, ISO 200.

Capturing the Seasons

Very occasionally, when the weather is bad and I have not seen the sun for days, I fantasize about living in a country that remains in summer all year round; but then I quickly snap out of it and remember just what I would be missing. The transition of the seasons not only adds great variety to our lives, but each one offers such interesting photographic opportunities, that the prospect of a constant summer very quickly pales. As committed photographers, we need to appreciate that the change of the seasons is something to be celebrated: the challenge is to identify those unique characteristics that define each of them.

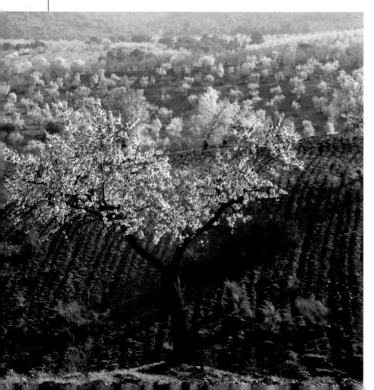

SPRING

This is the season of rebirth, as the year emerges out of the icy grip of winter. It is also the period when you are most likely to experience the greatest extremes; in a single week you may well enjoy the benefits of an early summer, only then to be thrown back into winter. Photographing during spring has many advantages; firstly, the days are getting longer, allowing you more time to take daytime shots. The atmosphere will still be clear at this time of the year, particularly in the mornings, therefore it is the ideal time to shoot panoramic landscapes. You are also likely to encounter mists, although not as frequently as in late autumn and winter.

Wild flowers under an almond tree
The display of wild flowers tends to be far richer after a long and wet winter, as all the flowers come out at the same time.
Canon EOS 5D Mark II, 24–105mm lens, 1/120th second at f.16, ISO 200.

Almond Trees, Almeria
Trees are a particularly photogenic subject to photograph in spring-time because the emerging leaves are still so new and fresh. Many species of trees will produce blossom, which, when grouped together, can provide stunning photographic opportunities.
Canon EOS 5D Mark II, 70–200mm lens, 1/30th second at f.22, ISO 100.

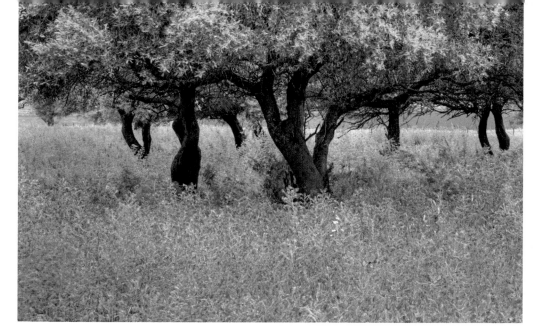

Echium under almond trees
When photographing on an overcast day when the sky is very flat and uninspiring, find a composition that excludes it.
Canon EOS 5D Mark II, 70–200mm lens, 1/5th second at f.32, ISO 200.

TREES

Trees make an excellent subject to photograph in spring because the nearly emerging leaves are still so vibrant and fresh. It is an ideal time to take close-ups as the large buds start to burst into life. Many species of trees produce blossom, which can produce stunning and colourful panoramas when grouped together. If you have a clear blue sky, try isolating a single tree against it; by using a very low vantage point, you should be able to fill the frame with its branches. This strategy also works particularly well when the weather is overcast. Use a low vantage point and let the foliage obliterate the empty sky.

SPRING FLOWERS

Spring is, of course, the seasons for flowers and whether they are produced commercially, such as tulips, or like bluebells they grow wild, few subjects are quite as compelling as flora in the landscape. The ideal scenario is where you can use the flowers in the foreground to complement some spectacular feature in the distance but an extensive carpet of flowers can also prove a worthwhile subject on its own. The wonderful irony is that you will see a far richer display after a long, cold winter, as all the flowers tend to come out at once.

Try using a polarizing filter when shooting flowers as it will cut

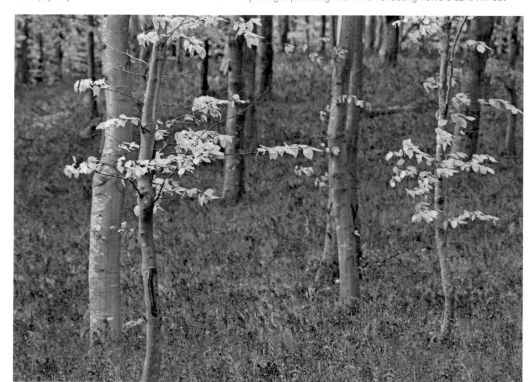

Bluebells and beech trees
Nothing heralds in spring quite as eloquently as a rich carpet of bluebells, but they are always better photographed under overcast lighting.
Canon EOS 1Ds Mark II, 70–200mm lens, 1/30th second at f.8, ISO 100.

tip

When you are dealing with a subject as beautiful as wild flowers, it is always worth exploring every possible angle.

out distracting highlights. It is also well worth experimenting with different vantage points. Sometimes it helps to distance yourself and use a long angle lens to compress the effects, while on other occasions try getting in as close as you can, giving yourself a worm's eye view. Occasionally you might find a viewing location high above the flora, allowing you to create an almost abstract image.

Check out the farmers' fields, particularly towards the end of spring, as this is the time you are likely to encounter the blazing yellow of rape seed. The newly emerging wheat and barley will still be at its Lincoln green stage and, if you are able to capture these colours in tandem, you will be rewarded with some excellent photography. This is also the period when the subtle blues of linseed begin to appear and, while their tiny flowers can appear innocuous, seen from a distance it introduces a wonderful strip of colour to the landscape. The adjacent hedgerows can also offer rich pickings, as this is the time of the year when some of our best-loved wild flowers such as cowslips, foxgloves and ox-eye daisies begin to emerge.

WATERFALLS

After the winter rains, another popular subject to photograph are waterfalls (see the section on photographing waterfalls [p140]). They are often surrounded by young trees and saplings, so the newly emerging green foliage provides an excellent foil to the flowing water.

Wheat field
In spring the fields of wheat are still green and the first of the poppies begin to emerge. If you intend to include a sky, it often helps to use a polarizing filter in order to darken the blues.
Canon EOS 1Ds Mark II, 24–105mm lens, 1/125th second at f.20, ISO 320.

USE INFRARED PHOTOGRAPHY
Late spring is undoubtedly the best time to take infrared landscapes (see the section on Infrared Photography [p126]). It is particularly sensitive to living organisms, which give off heat that some sensors are able to detect. During spring, the flow of chlorophyll is at its greatest, consequently the infrared effects are at their most dramatic. Try photographing trees, clusters of newly emerging foliage or flowers, and the results can be particularly striking.

Rape
It is difficult to ignore an expansive field of yellow rape seed at this colourful time of year. A polarizing filter has been used to retain detail in the sky.
Canon EOS 5D Mark II, 24–105mm lens, 1/125th second at f.20, ISO 320.

SUMMER

As with all seasons, summer has its own, special appeal. While we remember those lazy days on beaches, it is also the time to take long walks or cycle rides: these ventures are a great way of discovering new photographic opportunities. Summer also has the down-side that if you want to take shots pre-dawn or at dusk, you will have to do this at inconvenient times. In northern Europe, dawn begins to appear as early as 4am, and even by 6am the colour temperature will have reached 5500K, so any lingering warmth in the light will have long disappeared.

STRONG LIGHT

In summer, expect to see extended periods of strong light because the sun will be at its highest. This has the advantage that you are able to hand-hold many of your photographs but the disadvantage is that it creates extremes of light and shadow, particularly in the middle of the day. There are ways around this (see the section on shooting at high noon [p68]), but the best time to take

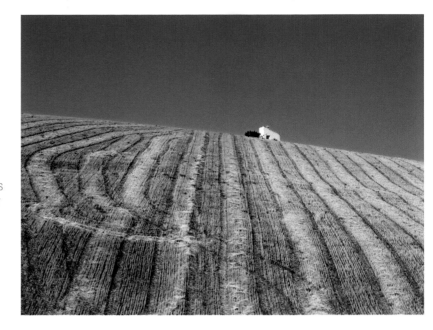

photographs is either early in the morning or late in the afternoon when you can still capture the rich colour saturation that can be seen at other times of the year.

SUMMER STORMS

While we tend to associate the summer months with long periods of sunshine, it is also the time when we are most likely to encounter thunderstorms that can be particularly spectacular. Dark thunderclouds can provide a wonderful backdrop to an otherwise mediocre landscape, so if you suspect one is brewing, get out there.

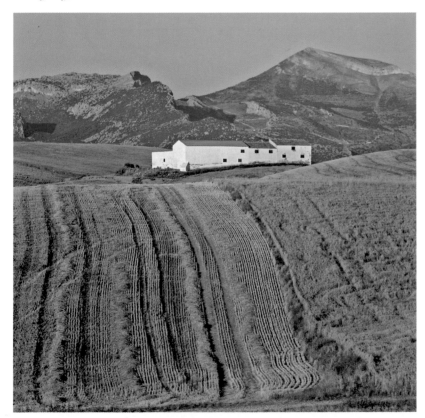

After the harvest
You can often capture strong, graphical elements after the fields have been harvested.
Canon EOS 5D Mark II, 70–200 zoom, 1/30th second at f.20, ISO 200.

tip

Do not expect to see the same clarity of light as the colder months; the heat of summer often produces a rather unattractive haze.

Wheatfield
Summer is a great time to photograph agricultural fields. They appear to change almost on a weekly basis as the green cereal crops start to ripen, are harvested and then the fields are ploughed.
Canon EOS 5D Mark II, 200mm lens, 1/50th second at f.20, ISO 400.

AGRICULTURE

Summer is a great time to photograph agricultural fields, as farms are so active at this time of year. They appear to change almost on a weekly basis as the green cereal crops start to ripen and are then harvested. Later in the season, as the fields are ploughed, you are presented with further exciting challenges.

SUMMER FLOWERS

It is not, of course, just cereal crops that start to ripen in the summer months; increasingly farmers are setting aside fields to grow sunflowers, which can be spectacularly beautiful. If you stumble across a patch, be prepared to return in the morning; they are best photographed then as the heads always face east towards the rising sun. It is surprising just how tall sunflowers can grow and if you are unable to find an elevated vantage point, use a set of stepladders to give you that additional height.

The summer is a great time to photograph poppies, which seem to appear quite randomly. The seeds can remain dormant for decades, and then they unpredictably appear on the side of roads, or in the middle of a field of crops, particularly after the soil has recently been disturbed. Poppies can be photographed in any way you care to imagine; they can be taken in strong directional lighting or on an overcast day; you can use a wide-angle lens to create impact, or alternatively you may decide to compress the effects by using a long-angle lens. If you do come across a cluster of poppies, take the time to make the most of them.

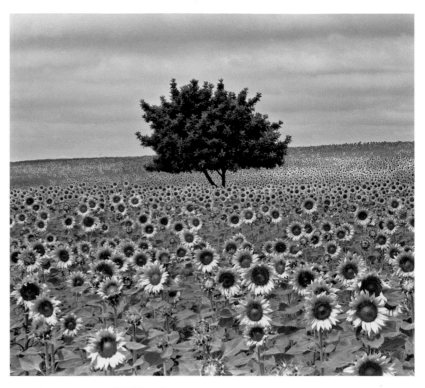

Field of sunflowers
Nothing epitomizes summer quite as eloquently as a dazzling display of sunflowers. It is important to find a viewpoint where none of the sunflowers heads have ripened too early. A fully grown sunflower can easily reach the height of an adult person, so in order to get a slightly higher vantage point, I used a set of stepladders I kept in the boot of my car.
Canon EOS 5D Mark II, 200mm lens, 1/15th second at f.32, ISO 160.

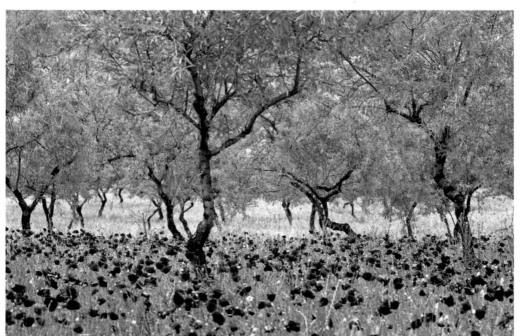

Poppies under almond trees
A spread of poppies within a landscape truly is one of the most delightful aspects of summer. Whether you decide to use either a wide-angle or a long angle lens, the results can be especially charming. Photograph by Eva Worobiec.
Canon EOS 1Ds Mark II, 24—105mm lens, 1/45th second at f.20, ISO 320.

AUTUMN

This 'season of mists and mellow fruitfulness', bridges the last lingering days of summer and the winter solstice and offers the landscape photographer a multitude of opportunities. You are likely to encounter morning mists, which envelop the landscape in a gentle hue and it is also the time when farmers plough their fields, producing stunning graphic effects. If you are fortunate enough to live near an orchard, or perhaps you are visiting a vineyard, great photos are there for the taking.

AUTUMN COLOUR

Of course, autumn is most synonymous with dramatic colour changes in the trees, as the flow of chlorophyll diminishes and the leaves start to turn. So how do we best capture autumn's glory? Fortunately, autumnal foliage can be photographed at any time of the day. As the sun never rises too high in the sky, you should always benefit from some directional light; if however you are

Aspens
This wonderful tangle of aspens creates an almost abstract pattern as the autumnal leaves present a vibrant background of yellow. Photographing trees in autumn is often best done in overcast light.
Canon EOS 5D Mark II, 200mm lens, 1/100 second at f.22, ISO 800

able to take your shots later in the day, you will enjoy the added advantage of a much warmer light which accentuates the golden yellows and oranges of the leaves. Avoid taking your shots directly into the sun as the richness of the colours will be lost.

Autumnal colours are always at their most glorious after a period of sunny days and frosty nights. Ideally, visit your planned locations before the inevitable winds arrive. Increasingly weather forecasters are now giving us regular updates on potentially promising areas, which allows us to plan more carefully. A period of wind and rain can certainly present difficulties, not only because it prevents us getting out, but also because it can quickly strip the trees of their leaves

Whether you decide to include a sky in your composition or not, use a polarizing filter, which will help to subdue some of the atmospheric haze that can pose a problem at this time of the year and also increase the saturation of the colours. Polarizing filters have the added advantage of eliminating distracting highlights when photographing foliage in strong sunlight.

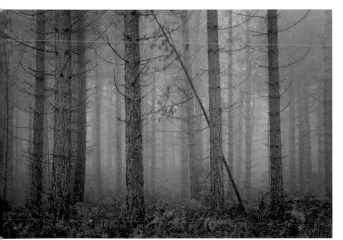

Pine Forest
Pine forests are not the most obvious areas of woodland to photograph in autumn as the changes in the foliage are slight, but they can often prove quite interesting when taken in a gentle autumnal mist.
Canon EOS 5D Mark II, 24–105mm zoom, 1/15th second at f.16. 1SO 150.

Wood's edge
Try using a long angle lens when photographing trees in autumn, as it is much easier to identify some sense of order amid the chaos.
Canon EOS 5D Mark II, 24–105mm lens, 1/60th second at f.14, ISO 400.

Poplars
As the leaves start to disappear, the skeletal qualities
of the woodlands are gradually revealed.
Canon EOS 5D Mark II, 24–105mm lens, 1/60th
second at f.14, ISO 400.

Towering aspens
If you are looking for impact, try setting the yellow/
orange leaves of autumn against the rich blue sky as
these two colours are opposites on the colour wheel.
Canon EOS 1Ds Mark II, 24–105mm lens, 1/60th
second at f.14, ISO 400.

Don't underestimate the advantages of photographing autumnal colours on
dull overcast days. If the sky appears featureless, don't worry, as you are
likely to have plenty of strong colours to make an interesting picture; just
exclude the sky entirely. Consider using a long angle lens, so that you are
able to compress the effects of autumn. An added advantage is that the
trunks of the trees retain all their detail in overcast lighting as the problems
of contrast are considerably reduced.

Look to your feet. After a very cold night the foliage can almost
simultaneously fall to the ground, blanketing it in a thick layer of leaves.
This is the time to use a wide-angle lens, but make sure that you are
pointing the camera downward. Try concentrating just on the fallen leaves
and allow the trunks of the trees to appear on the edges of the image.

COLOUR CONTRAST

If you wish to exploit colour contrast while looking for detail, isolate certain
groupings of leaves. For example, try setting orange ones against a blue
sky, while setting red leaves against a background of rich green foliage.
These combinations of colours work well because each is opposite the
other on the colour wheel. Alternatively, you may wish to achieve strong
colour harmonies instead, in which case look for groups of trees of the
same species and aim to exclude all other distractions.

For the richest colour saturation, try under-exposing your shots by
1/3 of a stop. If you are shooting RAW, this could be done in the RAW
converter. Alternatively, you might consider increasing saturation in
Photoshop, although don't overdo this otherwise your image will look false.

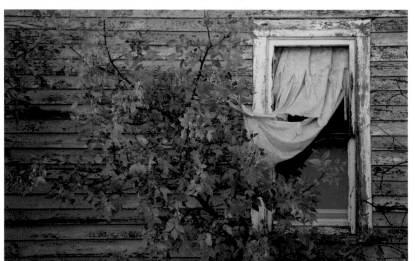

Window and cottonwood tree
The signs of autumn can be spotted in all sorts
of unlikely places. The curtain of this abandoned
homestead has become snared in the branches of the
cottonwood tree.
Canon 5D Mark II, 24–105mm lens, 1/60th second
at f.14, ISO 400.

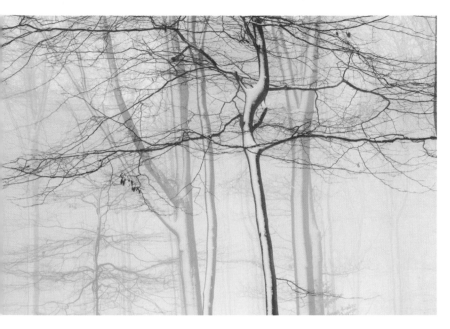

Trees in mist
While it is easy to take shots of the snow when the sun is shining, some of the best photographs can be taken when there is a cold winter mist; the harshness of the season is far more eloquently expressed in these conditions.
Canon 5D Mark II, 24–105mm lens, 8 seconds at f.32, ISO 100.

WINTER

A cold, wet season, when the days are short and the nights are impossibly long, it is so easy to convince yourself that this is the time to hang up your camera, but as most committed landscape photographers will tell you, this is possibly the best season for taking photographs.

WINTER WONDERS

Winter offers so much. First, those very short days make taking pre-dawn, night and evening shots far more convenient. Second, as the sun will always remain low in the sky, the landscape will constantly be illuminated by dramatic lighting, and third, while we all might curse the cold from time to time, the frosts and snow that are a feature of this time of the year can radically, and often favourably, alter the appearance of the land.

Ploughed and devoid of crops, fields look much more graphic in winter, trees stripped of their foliage appear enticingly skeletal, while mountains and hills are likely to be covered in snow. I have never done it, but if I was to plot a graph of when I take my photographs, I feel confident that it would peak between the months of December to March.

Poplars in hoar frost
This line of poplars and the immediate surrounding area was covered in deep hoar frost, but just a few miles in any direction the landscape was frost free. It was created as a result of steam from a nearby power station freezing in the cold winter air and then falling back to earth; a rather unusual take on global warming.
Canon EOS 5D Mark II, 24–105mm lens, 1/50th second at f.11, ISO 200.

MORNING FROSTS

Quite common during the winter months, frosts have the capacity to transform a landscape, and even a very familiar location can be changed into an enticing winter-wonderland. Once the sun begins to rise, it gently starts to thaw the frost, so you have to get out early. The best time to take your shots is just after the sun has risen, although, because of the whiteness of the frost, you should also be able to grab one or two pre-dawn shots as well.

Predicting morning frosts is relatively easy; if you are experiencing cold night-time temperatures (0 degrees centigrade and below), the skies are clear and there is little wind, then you are likely to encounter frost the following morning. As ever, anticipate when you are likely to

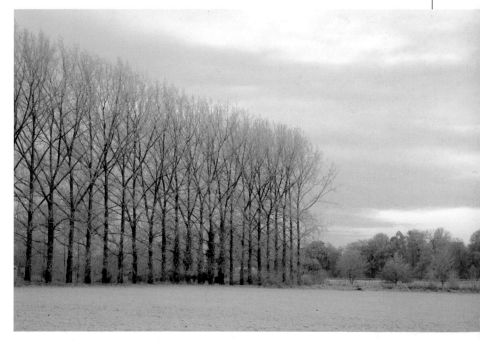

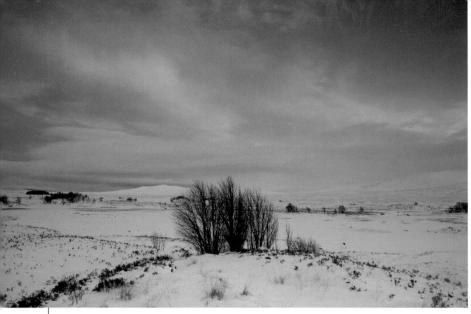

Snow scenes can look very effective when produced as monochromes so shoot in colour and experiment with converting them afterwards.

experience one and plan possible locations.

If you are able to use side lighting it will help to exaggerate the natural textural qualities. You will also need to think about exposure. Your light meter will always aim to give a reading of 18 per cent grey, which can result in under-exposure. To compensate for this, try over-exposing between + 1/2 stop and + 1 stop. As ever, continue to check the histogram, and while you should expect to see it peaking to the right, make sure that none of the highlight detail is burnt out.

SNOW

Even the most reluctant photographer can be tempted by the sight of a snow-covered landscape, although many of the problems one experiences when shooting in frost apply. Metering for snow is notoriously difficult, largely because of the degree of under-exposure you are likely to encounter. This can be up to two or even three stops, but can be resolved in the following ways:

- Using the spot-metering facility of your camera and taking a reading directly from an area of snow, but then adding between two and three stops to your exposure depending on how white you want the snow to appear.
- Bracketing your exposure, by one and then two stops and then constantly checking both the monitor and the histogram.

The photographic opportunities in snow are too numerous to mention, particularly for producing minimal or abstract landscapes. While a snowy landscape will always look wonderful when set against a deep blue sky, it can appear equally enticing when photographed in dull, overcast lighting. Whether you attempt to photograph snow backlit, frontally lit or illuminated from the side, the results will always be spectacular, so the scope is endless. Because of the reflective qualities of snow, if it is photographed at dawn or dusk, it will reflect some of the colours of the sky, which can look particularly attractive.

Finally, while many other landscapes are difficult to photograph at night, because of its reflective qualities it is possible to capture wonderful nocturnal snowscapes.

Snow on moorland
Because of the highly reflective nature of snow, it should be possible to photograph a wintry landscape well after the sun has set and still retain good foreground detail.
Canon 5D Mark II, 24mm lens, 1 second at f.16, ISO 100.

Winter trees
Set against a deep blue sky on a clear, sunny day, the delicate tracery of these winter trees are shown to best advantage.
Canon 5D Mark II, 17mm lens, 1/50th second at f.16, ISO 100.

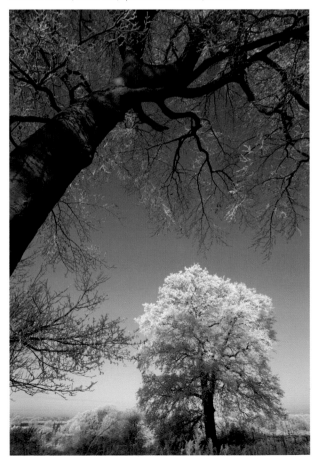

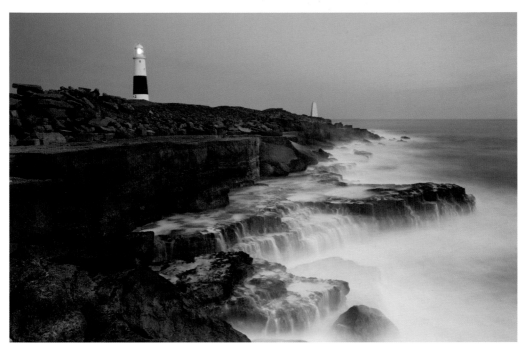

Stormy sea
Don't ignore coastal locations during the winter months. Because of the constantly low elevation of the sun coupled with relatively late dawns and early dusks, this is the ideal time to take moody, slow exposure sea shots. Canon 5D Mark II, 24mm lens, 124 seconds at f.18, ISO 100.

COASTAL SHOTS IN WINTER

Coastal photography is often overlooked at this time of the year. Because of the constantly low elevation of the sun coupled with relatively late dawns and early dusks, this is the ideal time to take evocatively moody, slow exposure sea shots. While the lighting can be dramatic at this time of the year, the strength of the light is reduced, therefore if you wish to use a wide depth of field you will certainly need a tripod. You will also find one useful if you are taking close-ups of the delicate patterns in the ice or wonderful clusters of icicles one sees in winter.

DRESSING FOR THE WEATHER

Make sure you stay warm when photographing in winter. Don't underestimate how much more vulnerable you are to the cold when you are standing around waiting for the light to change. If you feel cold, then you cannot concentrate on photography, so make sure that your head and feet are adequately covered. If you are working on the coast, ensure that you have a spare pair of socks available, just in case you get your feet wet.

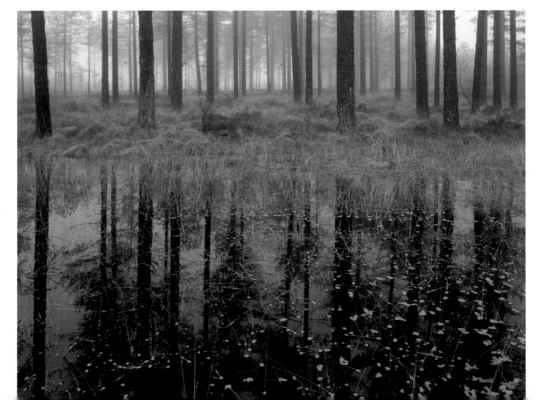

Wet woodland
When the weather is cold, overcast or wet, it is hard to muster the enthusiasm to venture out, but often this is when we are able to take some of our most interesting photographs. As a result of melting snow, this area of woodland had become heavily waterlogged presenting a temporary opportunity for some reflection shots. Canon 5D Mark II, 24–105mm lens, 1/6th second at f.16, ISO 100.

Creative Landscapes

While most images of landscape inevitably retain a certain 'documentary' quality, the most interesting examples also exude mystery and a special sense of uniqueness. This can only be achieved by exploring the moods of a particular landscape, or by identifying its defining facets that are ignored by others. Searching out details that are a microcosm of the much larger landscape is one way of achieving this.

EXPLORING MOOD

The French Impressionist, Claude Monet, did a great deal to inspire interest in the parochial landscape and much of his work illustrates that it is not the structure of the land that you should be concerned with but rather the mood you are able to capture. In the latter stages of his life, he would constantly revisit the same location and produce a sequence of images from precisely the same spot, recording the varying weather and lighting conditions. Perhaps, had colour photography been available to Monet at the time, he would have abandoned the paintbrush in favour of the camera, as photography has the capacity to spontaneously capture landscape.

FAMILIAR LOCATIONS

While many of your more exciting landscape photographs may well have been be taken when travelling abroad, you are a hostage to fortune as you have to accept the weather and lighting conditions available at the time; sometimes you are lucky, but generally you are not. The big advantage of photographing a location closer to home is that you can re-visit it again and again, responding to the changing conditions as they occur.

One of my favourite photography books *Bay/Sky* (Bulfinch Press), shows a sequence of images by the American photographer Joel Meyerowitz, who photographs the same New England bay, seeking to capture the varying nuances of colour and light over an extended period of time; the parallels with Monet are obvious. So, if you wish to try this kind of photography, select an area that you are able to revisit, and aim to be responsive to the ever changing qualities of the light.

CHANGES IN THE LANDSCAPE

Landscape is constantly in flux; it can vary from month to month, day to day, hour to hour, or even minute to minute. The important thing is to anticipate what those changes are likely to be. Living by the coast, I am greatly aware of how the tide can transform a particular rocky cove I enjoy visiting, but the weather and the time of day will also play a significant part. In fact, I could set up my tripod in precisely the same spot and, because of the constantly changing circumstances, never capture the same shot twice. Maybe there are fields, clearings in forests, areas of moorland or a cluster of trees that you will be familiar with, which will evolve through the course of the seasons. By recording these changes, you are able to capture the very spirit of the land.

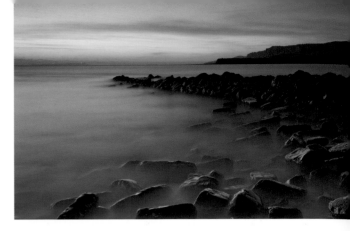

Kimmeridge 1
Living close to the Dorset coast, this is a location I have revisited countless times, particularly in the evening during the winter months when the lighting is often very special.
Canon 5D Mark II, 17–24mm lens, 234 seconds at f.20, ISO 100.

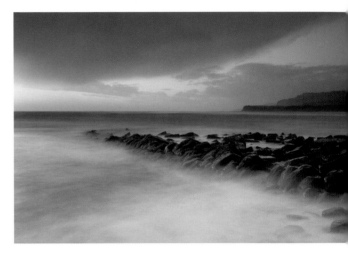

Kimmeridge 2
Taken from virtually the same spot as the earlier example, but with a different sky and taken just a little later in the evening, the mood of the image has changed. Using a graduated neutral density is particularly helpful, as I am able to balance the exposure for both the sky and the foreground and thus retain detail throughout.
Canon 5D Mark II, 17–40mm lens, 8 seconds at f.11, ISO 100.

Kimmeridge 3
While I never normally visit this location in the summer, on this occasion I decided I would and, while I was able to take the shot from my well-worn tripod holes, this image is still subtly different from any other I had taken previously.
Canon 5D Mark II, 17–24mm lens, 83 seconds at f.18, ISO 100.

Rocks 1

I visit Nerja in southern Spain three or four times a year and have become very familiar with this stretch of coast. I particularly enjoy photographing it pre-dawn, and I have become fascinated by how each day offers a subtly different mood. I find the process of re-photographing the same location day after day strangely cathartic. In the gentle early morning light, this image exudes a sense of calmness and tranquility.

Canon 5D Mark II, 24–105mm lens, 402 seconds at f.16, ISO 100.

Rocks 2

Taken just a few days after picture one, the sky on this occasion was considerably more threatening; also, because the tide has receded, more of the rocks in the foreground are visible.

Canon 5D Mark II, 24–105mm lens, 230 seconds at f.16, ISO 100.

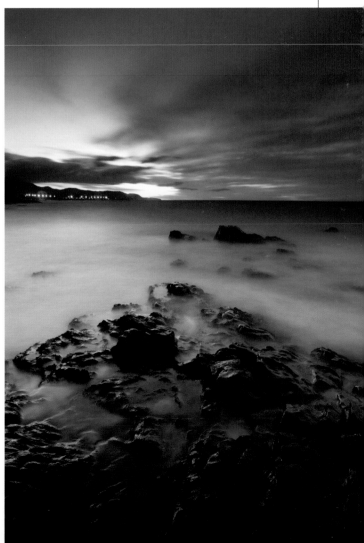

You can approach this subject in various ways. I have known photographers who methodically re-visit a particular location irrespective of the lighting conditions and will dutifully photograph the landscape as it presents itself, but that method is perhaps just a bit too clinical. My own approach is more subjective, as I try to photograph only when I think the landscape has something positive to offer.

Keep a careful eye open for interesting lighting, cloud formations or weather conditions that will give your photograph that added dimension. Treat it as a stage, in which the scenery remains constant, but the ever-changing spotlights highlight different features. Selecting the right location is clearly important, and aside from the obvious practicalities of choosing one that you can easily re-visit, it must also have qualities that specifically resonate with you. Without being overly romantic, I do find that some landscapes possess an almost spiritual quality, which keeps drawing me back. Even on those occasions when I have not been successful, I do not feel I have wasted my time.

When trying to capture the mood of a landscape, it is important that you approach the task in the right frame of mind. I rarely wish to share the experience with anybody else, preferring just to stand quietly and absorb what I am seeing. There will be a need for some measure of objectivity concerning the selection of shutter speeds or use of filters, but ultimately the process of capturing mood in a landscape should primarily be a subjective one.

TECHNIQUES TO ENHANCE MOOD
Shutter speed
Your choice of shutter speed can be particularly important when trying to create a mood. While there is a tradition for using a moderately fast shutter speed when photographing landscapes, sometimes using a slower one can create intriguing and mysterious images. Certainly when photographing moving water, a slower shutter speed is useful, but this technique can be equally applied when taking trees and moving grasses, helping to create wonderfully evocative photographs.

Focusing
Rather than use a small aperture in order to ensure than the entire image is sharp, why not try opening it up and throw large parts of the image out of focus – the results can often prove particularly impressionistic. Be prepared to turn convention on its head. For example, normally we expect to see something sharp in our photographs, but why not consider de-focusing the entire image? Another alternative is to select a slow shutter speed, while hand-holding your camera. The resulting image might well prove more interesting.

Filter choice
Your choice of filters can be particularly important when considering the mood you wish to capture, although I would always argue that it should never be your intention to falsify it. Nature offers so many amazing nuances, and there should never be the

Tree in spring
Spring can be an interesting time of the year and while the trees have started to bloom the fields can remain strangely empty.
Canon EOS 5D Mark II, 200mm lens, 1/250th second at f.14, ISO 1000.

Tree in summer
Photographed several months later, the character of this landscape completely changes. Shot in rich, evening light, the colours are infinitely warmer.
Canon EOS 5D Mark II, 200mm lens, 1/20th second at f.32, ISO 400.

Tree in autumn
Photographed in late autumn with very few leaves still remaining, the field appears quite bleak and empty once it has been harvested. While this single tree has been photographed from precisely the same position, its mood markedly changes with the seasons.
Canon EOS 5D Mark II, 200mm lens, 1/250th second at f.14, ISO 1000.

Tree in winter
Even without sky, a landscape can convey an atmosphere. Taken in winter, the strong, raking shadows create a harsh and slightly intimidating mood.
Canon 5D Mark II, 200mm lens, 1/64th second at f.22, ISO 100

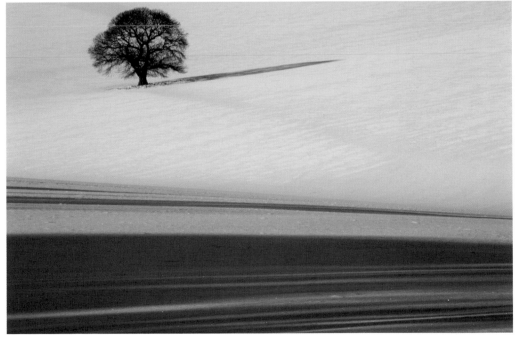

need to change what is already there.

The sky is invariably the key component to establishing the tenor of a landscape so use a filter that enhances rather than disguises it. If you have interesting sky detail, use a graduated neutral density filter in order to retain detail in both the sky and the foreground. Other alternatives you might wish to consider are polarizing filters or possibly warm-up filters, but do steer clear of radical alternatives such as a tobacco filter, which only serves to falsify the image. One filter I find particularly helpful when trying to create a mood is a medium neutral density, as it allows me to reduce the shutter speed even when there is quite a lot of available light.

Swirling rocks
Without reference to anything tangible, this image appears thoroughly abstract. The secret to this kind of photography is to be guided by your aesthetic judgment and try to identify simple graphic elements.
Canon EOS 5D Mark II, 70–200mm lens, 1 second at f.25, ISO 100.

THE INTIMATE LANDSCAPE

When shooting a landscape, the temptation is always to point the camera towards the horizon, but there is also merit in taking photographs which completely exclude the sky. If we develop this idea just a little further, we should also be able to find worthwhile images down at our feet, or possibly in small nooks and crannies that are not normally considered rich pickings for photography.

WHERE TO LOOK

Look carefully at seemingly inconsequential elements such as small clusters of flowers, formations of rocks, or marks in the sand and you will discover elements of detail that can serve as a microcosm for the whole. Look for exciting colour combinations, rich textures or patterns, as these can provide the basis for the photograph. I find this to be a deeply satisfying, almost contemplative aspect of photography, as it requires that you work slowly. Once I find an area that interests me, I tend to move cautiously, almost metre by metre, checking out potentially exciting bits of detail. It is very easy to get lost in a world of the miniature.

YOUR INTUITION

This kind of work helps to define you as a photographer. With conventional landscape photography, it is very easy to follow others who have photographed the same area in the past. While one never intentionally aims to plagiarize, it is hard to ignore a particular vantage point if you know somebody else has enjoyed success from the same location. The great thing about the intimate landscape is that it is personal, as only you have ever noticed it. It is unlikely that anyone else will stumble upon precisely what you photographed, but in order to be successful much will depend on your powers of observation, your understanding of the visual elements and your imagination.

Pebble on rock
The best time to explore the intimate landscape is in dull lighting; if you have arrived at a location and lighting is poor, try looking for detail instead. After a period of light rain, the colours appear richer and more saturated.
Canon EOS 5D Mark II, 24–105mm lens, 1/200th second at f.7.1, ISO 500.

Marks in the sand
Beaches are a wonderful location for identifying intimate landscapes. As the tide flows and ebbs, it can create some remarkably beautifully yet totally ephemeral marks.
Canon 5D Mark 11, 24–105mm lens, 1/20th second at f.20, ISO 100.

this works far better when the entire image appears sharp, so the closer you get to the subject, the more likely you are to need a small aperture. Using a tripod is helpful when doing this sort of photography; not only does it allow you to use a slower ISO (and thus maximize the quality of the image), but you are also able to select the aperture you require. Zoom lenses are particularly helpful as they encourage you to explore a variety of compositional options.

THE BEST LIGHT

The best time to explore the intimate landscape is when the weather is overcast; if you have arrived at a location and you are disappointed by the lighting, try looking for details instead. My own experiences are that this kind of photography is often best done after a period of light rain as the saturation of the colours is richer while the tones appear more rounded. It is a perfect alternative for those days when nothing else seems to work. If you do try shooting small elements on a bright day, look out for stray shafts of light that can appear across your image; occasionally it helps, but not often.

Photographing the intimate landscape encourages individuality. Very often the images you produce lack scale, but that merely adds to the interest. They will also sometimes appear to lack depth, so having an appreciation of the graphic arts will help you to spot potential subject matter. The essential thing is to be guided by your own judgment and try to reduce the composition down to the simplest visual elements.

LENS CHOICE

For this kind of photography, put away your wide-angle lenses; you will be far better served by using a standard, a macro, or even a long angle lens. You need to develop an instinct for the abstract, and

Snow
Often an intimate landscape can serve as a microcosm for a much larger one. In this example, The small strands of grass appearing through the snow express a moorland scene in winter.
Photograph by Eva Worobiec.
Canon 5D Mark 11, 24–105mm lens, 1/160th second at f.16, ISO 125.

MINIMALIST IMAGES

It is often assumed, correctly I believe, that the more complex an image, the more difficult it is to compose, but paradoxically, paring it down to just the simplest of elements can bring with it its own problems as well. Minimalism in photography, inspired by the art movement, is not new, and those of you who indulge in this style of photography will know how difficult it is to organize just a few elements so that the entire image looks balanced.

UNDERSTANDING MINIMALISM

Minimal art developed in the 1950s and 1960s and aimed to reduce the visual elements to such an extent that the viewer is immediately challenged. The idea was to create images that conveyed mood at the expense of detail. By definition, this form of art is very sparse and defies traditional conventions; rather interestingly, it has been enthusiastically embraced by many contemporary photographers

So how do we successfully introduce this into our own work? Well the first thing we must do is to consider the visual elements that make up a photograph, which are line, shape, form, tone, colour, pattern, and texture. We use these to develop a meaningful

composition in order to promote balance, proportion and depth. By significantly reducing the elements used, then much greater emphasis is placed on those that remain, and as a result the character of the image changes.

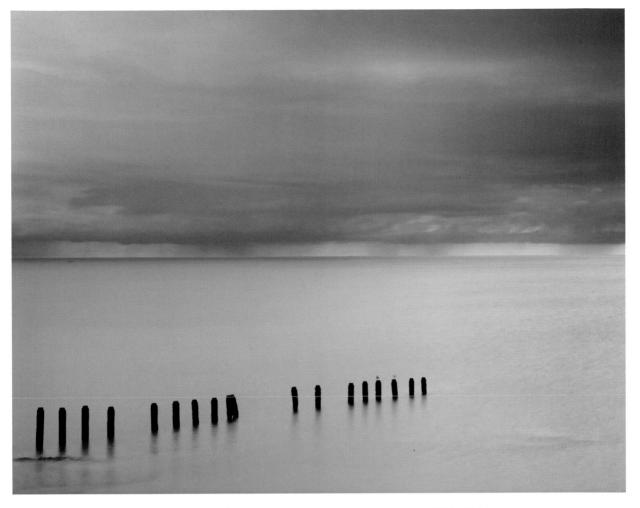

EXPLOITING TONE

This can be achieved by drastically reducing the range of tones available, which requires working either high-key, low-key, or with an extremely restricted range of mid-tones. Each of these has its own unique characteristics. Of these, possibly high-key is the most difficult to achieve, and getting your exposure right is important. As your light-meter is programmed to achieve 18 per cent grey, you will need to override it in order to get a correct reading. Landscapes featuring snow or light sand can work particularly well in high-key.

If it is your intention to convey mood through your photography, working high-key will undoubtedly help to achieve this. These very restricted tonal values can often have an uplifting effect on the viewer, even when dealing with traditionally dour subjects such as winter. From a practical standpoint, this really is where you need

Groynes

Coastal landscapes can often appear quite 'minimal-ist' because of the lack of clutter. While this was taken in the middle of the afternoon, I wanted to reduce the movement of the sea to a mere blur, so I have used a strong neutral density filter in order to greatly extend the length of the exposure.
Canon EOS 5D Mark II, 24–105 zoom, 85 seconds at f.18, ISO 400.

to consult the histogram; unquestionably the most enticing high-key landscapes are those that verge on the cusp, but you must ensure that none of the delicate highlights are burnt out. Typically it should show them peaking to the right, but without any of the details registering pure white.

In contrast, some landscapes work well when presented low-key, when all the tones are presented dark. These express an entirely different mood and can often appear gloomy and intimidating. The more the tones are condensed, the more threatening the landscape appears.

High-key histogram

For a high-key image, highlights peak to the right.

USING COLOUR

Achieving a sense of minimalism through colour is achieved by greatly reducing the range of colours used. It could be that you wish to capture the nuances of green in a verdant landscape, the gentle hues of a seascape or the vibrant reds of an expansive field of poppies; in each case, it is necessary to greatly restrict or, ideally, totally eliminate the incidence of any other colours. This may sound like a challenging concept, but look around and you will quickly discover countless opportunities at any time of the year.

SHAPE AND FORM

This involves viewing your subject critically and assessing how much you can cut out and yet still retain interest. Paring your composition down to the simplest of shapes, such as a triangle, a curve or semicircle is a very effective way of exploring minimalism. It helps to use a long angle or macro lens, although it is surprising how minimalist you can be when just using a standard lens.

TEXTURE

Interesting minimalist images can be created by concentrating on texture to the exclusion of all the other visual elements, although you will need to use strong tones in order to exploit the textural qualities. To succeed in this kind of photography, it is important to remove the image from its initial context, so that it can be read afresh. If the content is easily identified, the image will lose its appeal.

BALANCE AND EMPTY SPACES

The real challenge when identifying a potential minimalist landscape is to understand how an empty space can significantly contribute to the success of an image. There is always a concern that you may merely be presenting a visual take on 'the Emperor's new clothes', but providing you understand how important it is to juxtapose minimalist elements within that empty space, your photography really will communicate with others; you almost need to adopt a Zen approach.

The sea at night

Just occasionally you stumble upon a landscape of such remarkable simplicity you are left wondering what else is required. As I looked out to sea, the relationship between the night sky and the sea in the foreground was just about perfect. The small rock at the bottom of the picture adds just that slightest hint of scale.
Canon EOS 5D Mark II, 24–105mm lens, 165 seconds at f.16, ISO 200.

CONTENT

Finally, a minimalist image can be created by reducing the content down to a very few elements. Identify a feature and then explore a variety of angles that presents it in the simplest way possible. If you have a problem doing this, try using a wide aperture as this will throw everything except the features you wish to highlight out of focus.

As you whittle away the elements, your compositional sense really needs to be acute as you are placing such importance on possibly just one critical part of the image. This kind of photography certainly is demanding, but if you get it right, the images you create will be stunning.

When producing minimal images you walk the tightrope between producing an image that is striking and something others may view as boring. It is important to remember that photography is a form of visual communication, therefore you should firstly consider which of the elements you wish to employ, and how this improves the message you wish to communicate. If you find your image interesting, so will others.

tip

Minimalist images can work very well when displayed together. Why not work on a sequence using one of the themes described here?

Copse of trees in snow
A covering of snow has the wonderful capacity of greatly simplifying a landscape. Devoid of colour and detail, it is much easier to identify minimal features that would otherwise remain unseen. A soft winter mist and flat lighting have helped to further reduce the elements. Canon EOS 5D Mark II, 24–105mm lens, 1/30th second at f.16, ISO 100

Wheat field
Most abstract landscapes are taken from a slighter higher vantage point allowing the photographer to exclude the sky. By using a slow shutter speed, this field of wheat resembles a painting by an abstract expressionist.
Canon EOS 5D Mark II, 24–105mm lens, 1/160th second at f.18, ISO 200.

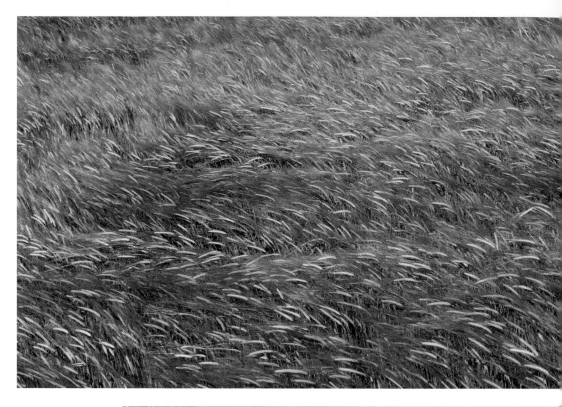

ABSTRACT PHOTOGRAPHY

The word 'abstract' may conjure up something quite alien, but as I have suggested on several occasions, it does pay to appreciate other aspects of the visual arts. In truth, 'abstract photography' is a bit of a misnomer, because the notion would suggest images entirely removed from reality. As all photography reflects reality, no matter how obliquely, then abstract photography cannot truly exist; but that should not deter us from learning what we can from abstract artists and then draw inspiration from them.

THE AIMS OF AN ABSTRACT ARTIST

Abstract art was pioneered by Pablo Picasso and Georges Braque early in the 20th century, but was brought to fruition by artists such as Wassily Kandinsky and particularly Piet Mondrian. Their work influenced all aspects of design, including architecture. Essentially they pioneered an approach to art which explores the visual elements of colour, tone, line, shape and texture without reference to specific objects. Consequently, much of their work is devoid of the qualities one associates with realism, such as perspective and tonal recession. So how do we translate this into landscape photography?

Pattern in the sand
One way of creating an abstract is to identify a subject which appears to emphasize just one of the visual elements at the expense of all the others. In this example, the strong side-lighting highlights the textural qualities of wet sand producing an almost sculptural effect.
Canon EOS 5D Mark II, 50mm lens, 1/250th second at f.13, ISO 250.

Landscape with dykes
The great quality about abstract work is that it encourages you to be imaginative.
This example reminded me of an aerial view of an arid landscape with a network
of dykes. Because there is nothing in this picture to suggest scale, it is easy to
imagine that it is much larger than it actually is.
Canon EOS 1Ds Mark II, 50mm lens, 1/125th second at f.20, ISO 400.

INTERPRETING ABSTRACTS IN THE LANDSCAPE

When we see a landscape in its entirety, we are aware of all the
visual elements present. To create an abstract, we need to select
just one or two and emphasize these while at the same time
subduing the others. This helps to remove the image from its
initial reality and thus create a photographic abstract.

Some might ask: Why bother? When we photograph
a landscape, it is more than likely that somebody has
photographed something similar before. In fact, you may well
have been inspired to take the photograph because of a picture
you have previously seen. We all visit well-known locations, but
if we are to develop as individual photographers, it is important
that we constantly strive to see afresh. Photographing abstracts
is one way of achieving this.

FINDING INSPIRATION

While you will no doubt buy books by photographers you greatly
admire, or visit websites showing magnificent landscapes, be
prepared to look outside of photography for some of your
inspiration. Most good photographers regularly visit art galleries,
as they are aware that, while often dealing with the same subject
matter, artists do view things slightly differently. I certainly would
suggest that you track down 20th century artists such as Paul
Klee or Mark Rothko, whose work has influenced countless
photographers over the years.

Look also at images from cultures that reject realism, such as
Japanese or Islamic art. In fact, the more varied the art you are
familiar with, the more open you are to alternative and exciting
ways of interpreting landscape.

Marks on rock
By isolating parts of the landscape
it is very easy to create interesting
abstracts.
Canon 5D Mark II, 70–200mm lens,
1/40th second at f.25, ISO 400.

Ripples in sand
Taken in overcast light, this image does not conform to the usual photograph of sand-dunes, largely because of the blue colour cast, which allows us to examine the image afresh. Canon EOS 5D Mark II, 24–105mm lens, 1/125th second at f.11, ISO 400.

WAYS OF ACHIEVING ABSTRACTS

• Use a long angle lens
The big advantage of using a long angle lens is that it compresses perspective, which as a consequence reduces the element of realism. It also allows you to focus in on small parts of the landscape, which when isolated from its context increasingly looks more abstract. Agricultural landscape with its ploughed fields or regular rows of crops offers rich creative pickings, although one can equally identify abstraction in wilderness landscapes as well; try examining cliffs or canyons in detail and once again you will start to identify interesting non-figurative qualities.

• Use a macro lens
There are quite literally countless abstract features all around us, although they often tend to be quite small. The textures on the bark of a tree, the mud cracking on the ground, or the staining one often sees in small parts of rock will provide countless exciting opportunities. If you are shooting macro use as small an aperture as possible in order to ensure that the entire image remains sharp.

• Dispense with scale
The whole idea of creating an abstract image is to completely remove it from reality, therefore it is important to make sure that there is nothing in the composition that suggests scale. For example, you may have found a wonderful vantage point overlooking a beach: the marks left by the receding tide are both visually exciting and abstract, but if you were to include a couple walking by, the image would immediately lose its mystery. When photographing land, you may well have identified a perfect abstract, but if you then decide to include a tree, the image becomes a little less challenging. For an abstract to truly work, you must ensure that you do not include any extraneous detail.

• Consider the sky
In most cases, once you include the sky in your photograph, the viewer is immediately able to identify both the subject and the scale, but abstract photography is about creating visual enigmas. In order to exclude the sky, you might need to work from a higher vantage point. Occasionally, however, including the sky does work providing that the viewer is not aware of what it is. For example, you may have spotted a field with a strip of red poppies in front of a field of wheat. If you are able to present it as just three simple stripes of colour, blue, over ochre, over red, and there are no other distracting features, it would then be viewed as an abstract image.

• Be creative with your aperture
When using a long angle lens to isolate part of the landscape, be prepared to experiment with varying apertures. While interesting results can be achieved by using a very small aperture, equally enigmatic shots can be gained by opening up your aperture instead. You may even consider de-focusing completely just to see what happens.

• Enhance the abstract qualities

Generally I am unhappy about too much editing post-camera as you run the risk of disconnecting the landscape from reality, but in this instance, that is precisely what you are aiming to achieve. If you have decided to present an abstract in which colour is a significant feature, consider increasing the saturation in order to make your intentions clear. Alternatively, you may be fascinated by the textures in your abstract, so consider using Curves in order to increase contrast.

• Isolate a visual element

All landscapes comprise the visual elements of colour, tone, form, texture and line but with a little imagination, it is possible to isolate just one of these elements and construct the picture round it. For example, you may be fascinated by how well certain blocks of colour work together: think how you can select an angle or apply a photographic technique which highlights just the colours while diminishing all the other elements.

Like the abstract painters of the 20th century, by applying a little bit of imagination, you should also be able to create photographic abstractions that can justly be called art. You can find these in the most unlikely of landscapes – it is simply a matter of remaining aware. The most positive aspect of creating these abstract images is that it will greatly help you to develop a unique and personal style.

White stripes on rock
Often some of the best abstract landscapes are to be found at our feet. The great value of this kind of photography is that it positively encourages ones individual perception.
Canon EOS 1Ds Mark II, 24–105mm lens, 1/180th second at f.20, ISO 500.

Abstract marks on rock
The closer one looks at the details of landscape, the easier it is to find true abstracts. What caught my eye in this example are the light stains on the rocks. Because of the lack of scale or semblance of reality, this image could so easily be mistaken for an example of textile art.
Canon EOS 5D Mark II, 70–200mm lens, 1/40th second at f.25, ISO 400.

MONOCHROMATIC COLOUR

The phrase 'monochromatic colour' must appear something of an oxymoron, but it is an aspect of photography many serious landscape photographers find appealing. Essentially it is an image that reveals all the tones and shades of a single hue, so it is not the colour variation that sustains your interest, but rather the subtle range of tones. In landscape, we frequently encounter scenes which appear to lack colour but, because of their gentle and evocative hues, they are still cable of capturing our imaginations.

EXPLORING TONAL VALUES

When photographing landscapes with an extremely limited colour palette, one needs to assess the tonal values particularly carefully to make sure that it really can retain interest. If you have had experience of working in black and white, then you will have an immediate empathy for this kind of work.

When looking through the viewfinder, it is important that the relationship between the light and dark areas are balanced, otherwise you risk producing an image that just looks flat. Ideally, you should organize your composition so that the greatest tonal contrast appears at the main points of interest. It is also important that the design is strong.

Some might question whether you should not just convert the image into a monochrome, but a monochrome colour landscape often reveals delicate hues and understated blushes of colour that would be lost if the image was converted to monochrome. Often the most appealing examples reveal gentle colours interspersed with black, greys and white.

SUITABLE SUBJECTS

Obviously, there are certain subjects that do not lend themselves to this sort of treatment; a very showy floral landscape immediately springs to mind. The best examples of monochromatic colour are found in those locations many inexperienced colour workers are likely to reject: it could be a rocky beach, a drab estuary or a craggy mountainside. Often, when passing these sorts of

tip

Avoid using filters other than a UV as you might distort the delicate hues you are trying to capture.

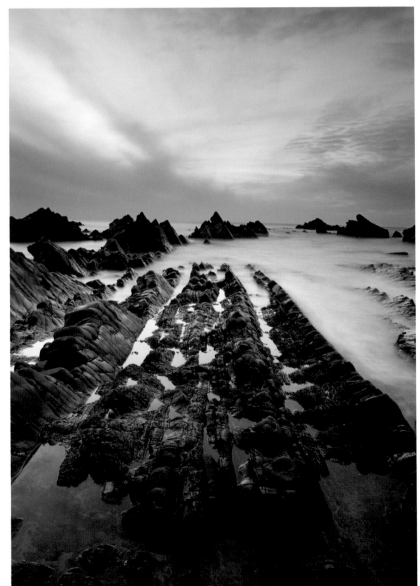

Craggy rocks
This image looks just like a black and white photograph that has been toned blue. If you have had experience of working in monochrome, then you will have an immediate empathy for this kind of work. Canon EOS 5D Mark II, 24mm lens, 85 seconds at f.22, ISO 100.

places, our natural inclination is to conclude that there is nothing to be had, although what initially might look boring could offer genuine potential. The understated mood created by a successful monochromatic landscape can prove to be contemplative.

IDEAL LIGHT

The opportunities for monochromatic colour are most commonly seen on grey, overcast days when we are most tempted to put away our cameras. Rather bizarrely, photographing landscape under an overcast sky at night-time can prove particularly interesting, as the entire image assumes an overall blue, as if the image had been produced as a black and white print and then toned. One might also conclude that subtle monochromatic colours can be achieved when it is raining but, paradoxically, rain has the capacity to heighten rather than subdue colours.

TRY IT IN PHOTOSHOP

If you remain unconvinced that you should go down this particular path, take an image that you have photographed, then, in Photoshop, make an adjustment layer and gently desaturate it until you have just a vestige of colour remaining. Needless to say, the character of your picture will change, and sometimes for the better. The results that can be achieved replicate techniques that highly experienced darkroom workers spent hours trying to get.

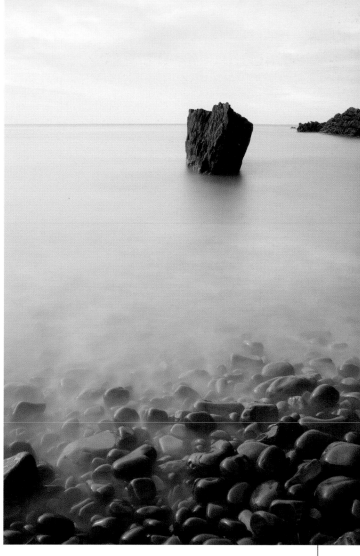

Sea stack
There are occasions when landscape can appear delicately understated. It was only after spending many minutes looking out to sea, that I appreciated that the sky had a very subtle pinkness, but it is precisely these gentle aberrations that give this kind of photography its unique charm.
Canon EOS 1Ds Mark II, 24mm lens, 94 seconds at f.18, ISO 100.

Striated rock
When the lighting appears unfavourable, try looking for smaller details. The overcast light has left this particular image apparently lacking colour, and yet when you look carefully you are able to identify delicate pinks, blues and browns.
Canon EOS 1D Mark II, 24–105 zoom, ¼ second at f.20, ISO 100.

Landscape in Black and White

It is difficult to imagine a comprehensive book on landscape photography without considering monochrome. Its appeal continues and one consistently sees beautiful black and white images gracing posters or in lifestyle magazines. The tradition for landscape photography was largely defined by the great American monochrome photographers of the 1940s and 50s, notably Ansel Adams, Edward Weston and Minor White. Still today, some dedicated purists can only see landscape in terms of black and white.

GETTING STARTED

Prior to digital, photographers were required to make a choice whether to use colour or black and white film. While anyone using a modern camera should never need to worry about this, it is surprising just how many photographers fail to exploit the possibilities of monochrome.

The first question to answer is what works well as a monochrome. If you randomly select and desaturate an image in Photoshop you might be disappointed. What works well as a colour image will not necessarily succeed in black and white. In essence you are dealing with two quite different issues; while the appeal of colour is obvious, when producing a monochrome image, you need to be far more aware of its tonal values.

Consider this example; you have a colour photograph of a bright red hut set against rich green fields. As red and green are opposites, the contrast between the two will immediately be apparent but once you translate those two colours into tones of grey, that contrast will be lost. When an image is converted to monochrome, contrast is created by setting lighter tones next to darker ones.

SEEING IN MONOCHROME

The world is in colour, we view it in colour, so how does one recognize the potential for a good monochrome landscape? There are various ways.
• Most DSLR cameras have a monochrome setting within the menu option, which allows you to capture black and white images. This is an excellent facility for alerting you to the potential of monochrome, but this is not the best means of capture. Your

Abandoned car
If you sense that a given scenario has potential, but lacks any colour interest, try presenting it as a black and white; you might be pleasantly surprised. Canon EOS 1Ds Mark II, 24mm lens, 1/20th second at f.16, ISO 100.

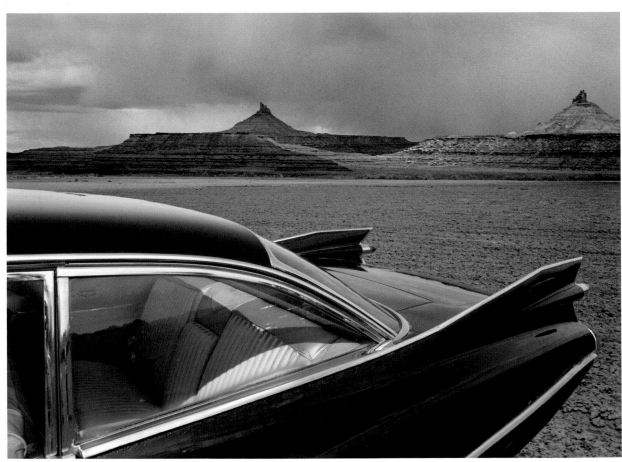

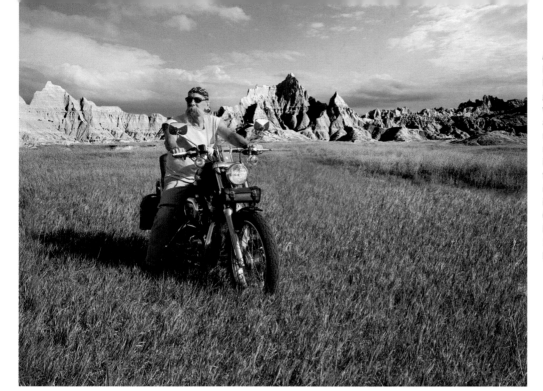

Biker in the Badlands
Black and white
landscapes tend
generally to work better
with an overcast sky,
as the mood can be
more purposefully
manipulated. However,
if you do use an image
taken in bright light,
make sure the sky has
interesting cloud detail.
Canon EOS 5D Mark
II, 24–105mm lens,
1/125th second at f.16,
ISO 200.

camera is also likely to have a Filters Effect option,
which simulates the effects one would have got
when using traditional monochrome filters such as
yellow, orange, red and green. Once again these
provide an excellent guide. You should, however,
resist the temptation to shoot your image as a
black and white file. If you like what you see, you
are far better served by shooting full colour, and
then desaturating your landscape, in either the
RAW convertor, or in some other editing software
such as Photoshop or Lightbox.
• If you find it hard to see tonal values, try putting
an orange filter over the lens prior to taking a shot.
This immediately obscures the colour and allows
you to see the landscape in terms of black and
white. Obviously you will need to remove it prior to
taking your shot.
• Once you start to take landscapes specifically
for monochrome, you will very quickly begin to see
in terms of tones, but one way of increasing this
ability is to screw up your eyes, which allows you
just to see larger tonal areas.

Tree and shack
If the lighting situation is not well suited for colour, consider
shooting for monochrome instead. Photographed under a
leaden sky, there was very little colour around, but, tonally, this
location offered wonderful opportunities. It helps to get into
a monochrome mindset, because it encourages you to take
landscape shots regardless of the lighting conditions.
Canon 5D EOS Mark II, 24–105mm lens, 1/100th second at
f.20, ISO 400.

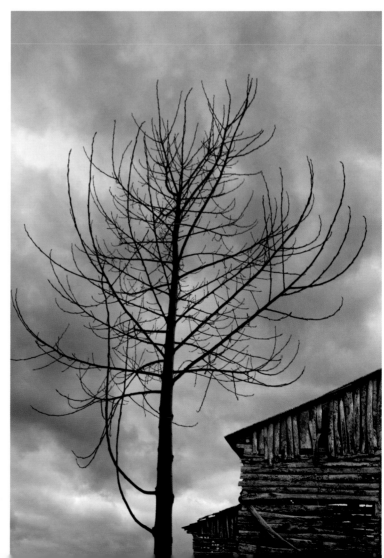

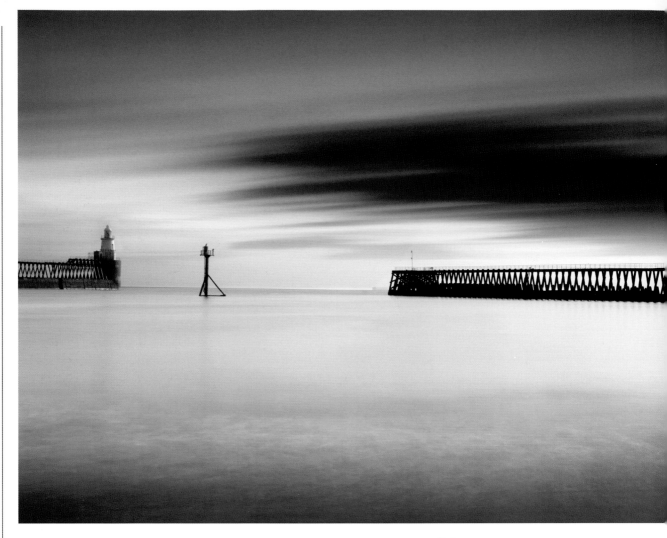

WHAT WORKS IN MONO?

• Moody landscapes

Look at the best examples of black and white landscape work and they almost invariably convey a mood, which is difficult to achieve in colour. By making the decision to present your images in monochrome, a certain process of abstraction has occurred which starts to distance the image from reality.

If you radically alter a colour image in any way, it can very easily look false. However, when you introduce changes to a monochrome image, the process can be much more forgiving. This means, for example, that if you are dealing with a landscape featuring a moody sky, then this can quite easily be exaggerated while still retaining sincerity. A truly great black and white landscape conveys emotion and this can easily be done by orchestrating the tonal values. For example, a low-key landscape can create an eerie, threatening and even sinister image, particularly if the sky is printed down. In contrast, by using lighter tones, the image will appear open, optimistic and reassuring.

• Strong graphical elements

While one can produce excellent and bold graphic images in colour, somehow they seem to work particularly well in black and white. There are so many wonderful opportunities in landscape. The simple patterns created by trees, the rhythmic marks in the sand or perhaps the corduroy fields created by the farmer's plough. Graphic elements in landscape are most evident when the lighting is strong and directional and if produced in black and white can look truly stunning.

Harbour

When presented as colour, this location appeared dull and uninteresting, but as soon as it was converted to a monochrome, one immediately became aware of its rich tonal values. While this was taken in the middle of the day, I used a strong neutral density filter in order to greatly extend the exposure, creating a beautiful ethereal effect in both the water and sky. Without the filter a shutter speed of 1/15th second was required, but with filter attached the exposure was increased to 30 seconds.
Canon EOS 5D Mark II, 24mm lens, 30 seconds at f.22, ISO 100.

Rocks on beach
Simple locations featuring strong graphical elements generally seem to work well as monochromes.
Canon EOS 5D Mark II, 24–105mm lens, 24 seconds at f.20, ISO 100.

tip

Landscapes that appear not to work in colour usually prove successful in monochrome.

FILTERS FOR MONO

If you are a committed monochrome worker, and have only recently drifted from film to digital, then you will no doubt wish to continue to use traditional monochrome filters, particularly orange, yellow and red. However, there is no need. In fact, using any of these filters could cause problems when converting the file from colour to black and white. The effects of these filters can be accurately simulated using the Black and White Command in Photoshop. There are, however, several filters that you can continue to use that will positively help your monochrome work.

• **Polarizing filter –** use this when you wish to emphasize the clouds in a blue sky, as it has the effect of darkening the blue, which greatly increases contrast. The effect is not dissimilar to using an orange or red filter in traditional black and white photography.

• **ND filter –** this is a particularly popular filter as it can so easily be applied to black and white photography; the results are often very contemporary. It has the effect of greatly reducing the amount of light reaching the sensor, so that you are able to create the effects of night in the middle of the day. It works particularly well when aiming to exaggerate the effects of moving water or clouds.

• **Graduated grey filter –** this also has the effect of greatly dramatizing

the sky. More often than not, the sky in the landscape will be lighter than the foreground, thus creating a tonal imbalance, but by using a graduated grey filter, this can easily be corrected. It is particularly useful when you wish to emphasize a stormy sky.

Sculpted rocks
While you can produce strong, graphic images in colour, it is often more effective to convert to black and white. Rocks, particularly those found in the inter-tidal zones, can often offer excellent photographic opportunities.
Canon EOS 5D Mark II, 24–105mm lens, 1/30th second at f.16, ISO 200.

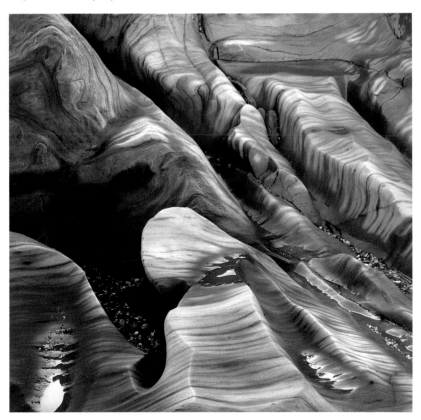

CONVERTING A FILE TO MONOCHROME

For reasons already explained, if you wish to create a monochrome image, it is far better to convert a full colour file (ideally a RAW file), to black and white. Most modern editing software packages have a simple method for making this conversion and while I have chosen to illustrate this using Photoshop, very similar conversion facilities are also available on the most recent RAW Converters.

USING PHOTOSHOP

1. With your start image in RGB, make an Adjustment Layer and select Black and White Command. It defaults to black and white, but by using the various channel sliders you are able to alter the tonal balance of your image. Do remember that a black and white image is far more forgiving when making such changes than a colour one.

2. By scrolling the Preset at the top of the dialog, you are offered various options, some of which simulate traditional monochrome filters such as Blue, Green, Red and Yellow. Certainly there is no harm in experimenting with these, but in this example I wanted to emphasize the blacks, so I used the Maximum Black preset. This helps to reinforce the graphical nature of the image. There is also a tick box at the bottom of the dialog inviting you to tint your work; toning can often enhance a monochrome image but this is not the best way of achieving it.

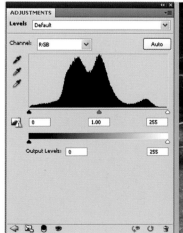

Levels
More so than with colour, monochrome images are best presented when showing a full tonal range. The best way of achieving this is to make an adjustment layer, select Levels and then clip the lightest and darkest points.

Mono conversion
Presented purely in terms of black and white, the graphical
qualities of this image become considerably more evident.

Original image
Shot as RGB, the colour range was extremely limited in this detail, making it an
ideal subject for monochrome.
Canon EOS 5D Mark II, 24–105mm lens, 1/50th second at f.6.3, ISO 200.

SEPIA TONING

While the tradition for sepia toning dates back to the 19th century, it is one that has an enduring popularity and even today many monochrome posters and greeting cards appear as sepia. I find it most effective when the sepia is applied subtly, which is why I would recommend that you do not use the Tint option on the Black and White Command, and certainly not the sepia option available on the camera. There are two simple methods for sepia toning using Photoshop.

USING CHANNELS

1. With the image in RGB mode, make an Adjustment Layer and select Curves. Scroll the Channels box at the top of the dialog box, select Red and gently pull it upwards. This will introduce a subtle red hue throughout the image.

2. Select the Blue channel but, this time, carefully pull the Curve downwards until a subtle hint of yellow is introduced; together these two colours should create sepia and if you are happy with the toning effect, flatten and save the file.

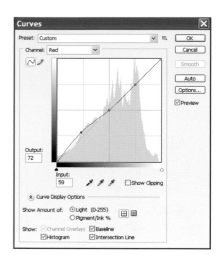

3. More experienced monochrome workers learned how to split tone their images. This means restricting the toning effect to just part of the tonal range, usually the darker tones. This has the advantage of giving the image greater depth. To achieve this using Channels, simply 'peg' the top half of the curve, before adjusting the bottom half, which then restricts the toning just to the darker tones.

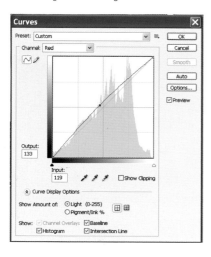

USING COLOR FILL

1. This is another effective method for toning a monochrome image. With the image in RGB mode, make an adjustment layer and select Solid Color.

2. Using the Color Picker, select a hue that closely resembles sepia. If you find difficulty achieving this try dialing in Red 210, Green 165 and Blue 90 as a starting point.

3. When you click OK, a solid colour will appear over the entire image, but by selecting Overlay from the Blending Mode, the image will reappear through the Color Fill Layer. If you feel the hue is too intense, lessen its effect by reducing the Fill slider to 50%. While this method has been used to illustrate a sepia effect, it can easily be used to create a blue-toning or any other toning effect, merely by selecting the required hue from the Color Picker box.

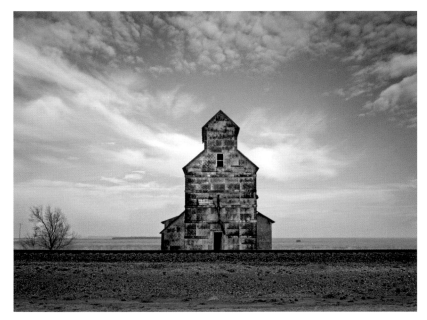

Untoned silo
This rather nostalgic landscape makes an ideal subject for sepia toning.
Canon EOS 5D Mark II, 24–105mm lens, 1/80th second at f.11, ISO 200.

NIK SOFTWARE SILVER EFEX PRO

An increasing number of black and white enthusiasts are using software other than Photoshop to make their conversions, and in particular Nik Software Silver Efex Pro (www.niksoftware.com). In addition to a very effective conversion facility, it has a number of presets that allow you to mimic specific black and white films, although I sense that you needed to have been an experienced darkroom worker to appreciate many of the subtleties of this particular option. Others mimic classic filters used by monochrome workers to control tone and contrast, such as the red, yellow and green filters. It also has numerous options for toning and split-toning images.

Sepia-toned silo
While the tradition for sepia toning dates back to the 19th century, its appeal has endured right through to the present day.

INFRARED PHOTOGRAPHY

Infrared photography was particularly valued by monochrome workers because they were able to achieve beautiful high-key effects, which transformed the landscape into something quite surreal. It required using a highly specialized film and, as more photographers opted to work digitally, it looked under threat. Fortunately there are now several methods that you can use to recreate the wonderful effects of infrared.

WHAT IS INFRARED?

In infrared photography, the film or the image sensor is specifically manufactured to be sensitive only to that part of the light spectrum, while blocking out all or most of the visible light we can normally see. The results can be spectacularly beautiful, creating fantastic dreamlike images.

The effects are particularly noticeable on grass and foliage, mainly in the spring and summer when the production of chlorophyll is at its most active. Trees and pastures are transformed, appearing iridescently white as if covered by a coating of snow, while the sky appears unusually dark. It is sometimes suggested that infrared can only be captured in strong sunlight, however equally beautiful results can be taken in overcast lighting as well.

DIGITAL INFRARED
Using software

You can take a standard colour shot on your DSLR, convert it to monochrome and then use editing software to change it to infrared. In Photoshop, this can be done using Channel Mixer: with the image retained in RGB, if you increase the Green Channel to its maximum of 200%, and then reduce the Red Channel to -70% and the Blue Channel to -30%, you are able to achieve a reasonably plausible infrared effect, but only with certain images.

Abandoned car
One of the defining characteristics of infrared is that it creates a rather ghostly atmosphere which admirably suits this abandoned and forlorn scenario. Canon EOS 40D (converted to infrared) 17–105mm lens, 1/125th second at f.11, ISO 100.

Church on prairie
Infrared scenes can be spectacularly beautiful, creating fantastic, dreamlike images. The effects are particularly noticeable on grass and foliage, mainly in spring and summer when the production of chlorophyll is at its most active. Canon EOS 40D (converted to infrared) 17–105mm zoom, 1/200th second at f.10, ISO 100.

Landscape with trees
This has been taken with an older DSLR camera, which I have had specially converted to infrared. The results are as close to the tradition infrared film as it is possible to get. Canon EOS 40D (converted to infrared) 17–105mm lens, 1/80th second at f.22, ISO 400.

Lime tree
The high-key,
monochromatic nature
of infrared often creates
interesting, abstract
images. This severely
cropped, minimalist shot
merely enhances those
qualities.
Canon EOS 40D
(converted to infrared)
17–105mm lens,
1/125th second at f.14,
ISO 400.

Some Black and White Conversion Commands now offer an Infrared option in the pre-set, although the results vary. In addition to an excellent Monochrome Conversion facility, *Nik Software Silver Efex Pro* [p125] has an extremely effective Infrared option you may wish to consider instead.

With a filter
Alternatively, you can elect to use a purpose made infrared filter (such as the Hoya R72), which you place over your lens each time you wish to take an infrared shot. Like other filters, this just screws on the front of the lens, except that it separates out normal light and only allows infrared to reach the sensor. The disadvantage of these filters is that they are quite opaque and require much longer exposures than normal, therefore all work must be done using a tripod. You also need to pre-focus before you attach it.

Converting a camera
The most radical solution is to have one of your older digital cameras converted to infrared. This involves removing the existing sensor and replacing it with one that is only sensitive to infrared. As sensors increase in size and the technology of DSLRs improve, many earlier cameras are now becoming redundant; converting one of them to infrared could be a sensible use of an otherwise unwanted resource.

Details of companies making these conversions can be found on the Internet, or advertised in photographic magazines. Expect to pay at least £250 for a conversion (it will depend on the size of your sensor and the camera marque), but the results are about as close as you can get to traditional infrared film.

Once the conversion is made, the camera can be used without the necessity of using a filter. It handles just like a normal DSLR, except that the images appeared toned. They should be processed through the Black and White command in exactly the same way as a normal digital colour file. They tend to have a restricted tonal range, typically peaking in the mid-tones, but with just a little post-camera manipulation, you can achieve plausible results.

Trees at Avebury
Located on the edge of a site of ancient standing stones, these trees certainly have a presence. Taken in the height of summer, very little light was able to penetrate the thick canopy of leaves, which meant that I needed to make a longer exposure than normal, but despite this, the characteristic and defining infrared halation is still clearly evident.
Canon EOS 40D (converted to infrared) 17–105mm lens, 1/25th second at f.11, ISO 100.

SECTION 3 Popular Landscape Topics

Deserts and Arid Landscapes

Deserts are often stereotyped in films and on TV as baking hot places, full of precipitous sand dunes, but in reality they are much more varied than that. Approximately one third of the Earth's land surface is desert and only 15 per cent of that is pure sand, although the word 'desert' immediately conjures up visions of the vast African Sahara. They exist in every continent, including Europe, and are usually situated in the rain shadow of a mountain range, which serves to block precipitation — any area getting less than 25cm (10in) of rain per year can be classed as a desert.

Despite their differences, deserts do have some common characteristics. They are rarely used for agriculture, consequently the presence of man is significantly reduced. One might encounter the odd nomadic tribe or small communities scratching out a living, but they are one of those rare regions in the world where you are unlikely to come across roads, fences or urban development. If it is the true wilderness that you are after, look no further.

VEGETATION AND WILDLIFE

From a photography standpoint, deserts often reveal unusual and beautiful vegetation, which is capable of withstanding extended periods of drought. The range of plants you are likely to encounter is truly impressive and includes large cacti such as the organ pipe and the saguaro as well as smaller plants such as broom, ocotillo, desert holly, prickly pear, mesquite, agaves and brittlebush. Any of these species can serve as useful foreground interest. It is often assumed that deserts are devoid of wildlife, but amazingly many do have a complex eco-system that supports snakes, lizards, small mammals and birds of prey. If you are in doubt, just check the ground in the early morning as you will see countless small tracks criss-crossing the dusty desert surface.

HOSTILE ENVIRONMENT

Because of the lack of cloud, deserts are relatively easy places to take photographs, although a constant blue sky does not suit everyone. Photographers frequently talk about the wonderful clarity of light in deserts, which can create stunning shadows and rich textures, although others complain about its harshness. By way of contrast, if you are lucky enough to encounter a very rare thunderstorm, while it will offer fabulous photographic opportunities, you need to be aware of the risks as well. When you do experience a deluge, as the dry land is not able to soak up the water, dangerous channels are created that can sweep away all in its path, including your car.

On an equally cautionary note, you must always remember that the desert is an environment that is hostile to man. You should not wander around aimlessly, and certainly not in the middle of the day. It is always recommended that you take sufficient drinking water, use plenty of sunblock, and that you wear a hat as protection from the sun.

Dunes
Long angle lenses are particularly effective when photographing dunes in the distance, often creating fascinating abstracts.
Canon EOS 5D Mark II, 200mm lens, 1/50th second at f.22, ISO 400.

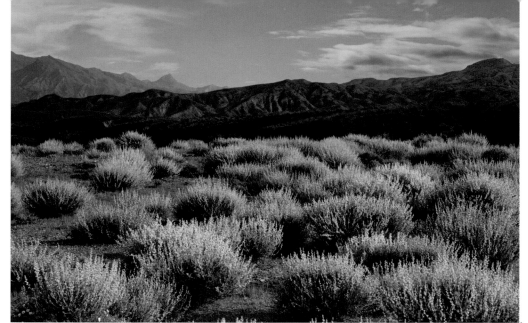

Desert, Almeria Province, Spain
It is sometimes assumed that deserts only occur in far flung parts of the world, but they can also be found in Europe. This particularly beautiful part of south eastern Spain has frequently been used as a location for the so-called 'Spaghetti Westerns'. Canon EOS 5D Mark II, 24–105mm lens, 1/8th second at f.22, ISO 320

It is also an environment that can cause damage to your equipment, so one does need to be cautious. The fine dust and sand one frequently encounters in deserts can get into the body of the camera, and often rather irritatingly onto the camera's sensor, so keep changing of lenses down to a minimum. Ideally keep all your equipment secure in your backpack until you really need it and make sure that you constantly keep a UV filter on your lens, as any dust or sand blown on the wind could damage it.

tip

When photographing sand dunes, to avoid getting dust onto the sensor, just use a single standard zoom lens.

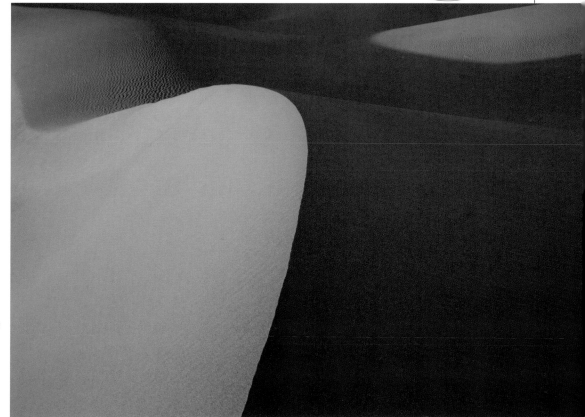

Dunes in evening light
Photographers often talk about the wonderful clarity of light one encounters in deserts; exploit the side-lighting to capture rich textural detail.
Canon EOS 5D Mark II, 24–105mm lens, 1/50th second at f.20, ISO 100

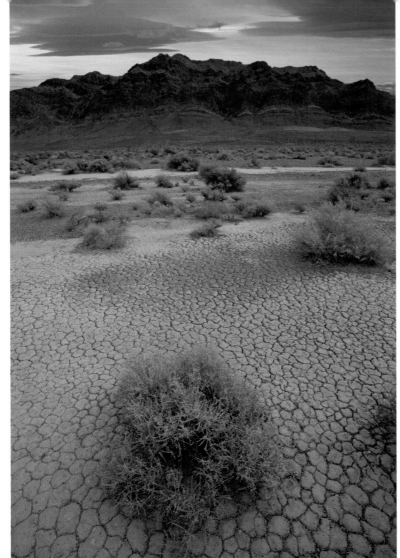

DAWN LIGHT

Having considered the precautions one needs to take in such environments, the photographic opportunities are second to none. The best time to take your shots is just before and after dawn. Not only is it likely to be the coolest time of the day, but any footprints left by previous visitors will have been erased by the night winds. The lighting at that time of the day can also be spectacularly beautiful. Some photographers opt to take their shots in the evening instead but, while the lighting can prove equally as dramatic, they can be frustrated by the myriad of footprints left by the activities of the day. If that poses an unavoidable problem, then you might need to use the Cloning tool in Photoshop to remove them.

TEXTURE AND PATTERN

Irrespective of whether you opt to photograph at dawn or in the evening, try to exploit the rich textural detail you are likely to encounter by using side-lighting. Photographing deserts encourages you to use lenses at the extreme focal lengths. Use a super wide-angle lens to capture the ephemeral patterns in the sand, which can create fabulous graphic effects; alternatively opt for a long angle lens to condense the undulating dunes. If the sky is featureless (which is fairly common in deserts), then use this lens to exclude it.

Passing storm
The very occasional rainfall is sufficient to maintain a particularly hardy variety of plants.
Canon EOS 5D Mark II, 17mm lens, 1/100th second at f.18, ISO 200.

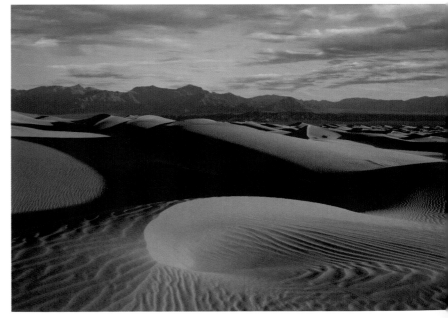

Sand dunes at dawn
The best time to photograph sand dunes is in the early morning, particularly if there have been winds during the previous night; while evening light can be just as flattering, you are likely to encounter a matrix of footprints left by other enthusiastic visitors.
Canon EOS 5D Mark II, 24–105mm lens, 1/60th second at f.20, ISO 400.

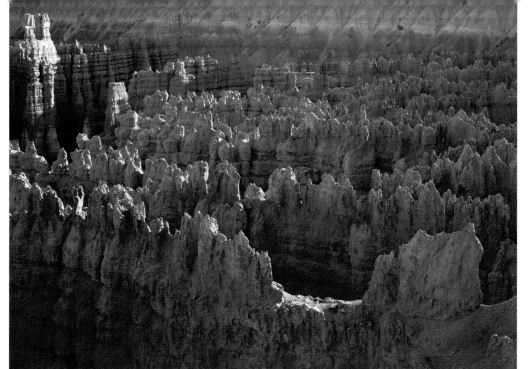

Bryce Canyon
Visiting possible viewing points in the middle of the day, when the lighting is not quite so favourable, is time well spent. It is pointless trying to find good locations when the lighting gets interesting, as it can be so transient. Canon EOS 5D Mark II, 24–105mm lens, 1/25th second at f.16, ISO 100.

Buttes and Canyons

Landscape photographers will always be drawn to canyons as they possess their own particular allure. Part of the appeal is that you can experience a true wilderness, where the presence of man is virtually non-existent. Obviously getting to such places often requires travelling, sometimes great distances, but the results you can come away with generally make this inconvenience well worthwhile.

HOW CANYONS ARE FORMED

When photographing unusual geological locations such as canyons, it helps to understand how they were formed. Canyons are created by water eroding flat plateaus; some of our most dramatic ones have been produced by powerful rivers, which over millions of years have carved enormous ravines through the plateau, resulting in the splendours we see today. Other have been formed by occasional, but very severe rainfall that creates fast-moving streams carrying loose debris, which is capable of scouring the soft rock. Often these plateaus are situated in locations that experience baking hot summers but freezing winters; as water

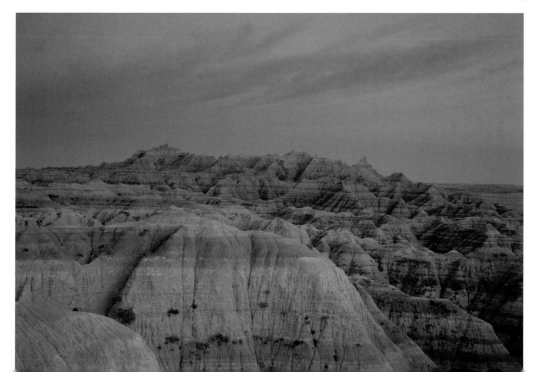

Badlands
When photographing any landscape, it does help to understand how it was formed. Most canyons are created from flat plateaus which have been shaped by water and frost erosion over millions of years. Canon EOS 5D Mark II, 50mm lens, 3 seconds at f/22, ISO 100.

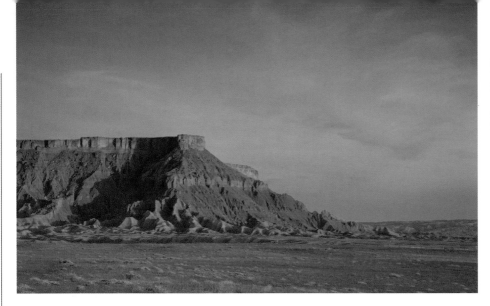

Butte near Hanksville
Photographed in rich early morning light, the textural qualities of this butte are brought to the fore.
Canon EOS 5D Mark II, 70–200mm lens, 1/40th second at f.14, ISO 400.

seeps into the cracks caused by water erosion, it freezes and then thaws and consequently shatters the rock. This process of constant erosion over a prolonged period of time produces a landscape of extraordinary beauty.

TIMING YOUR SHOOT

Canyons are best photographed at dawn or late in the evening when the sun is at its lowest, as the colours are likely to be at their most intense. Simply wandering into a canyon in the middle of the day, hoping to grab a shot, rarely works. Be prepared to commit at least one day, if possible one evening and then a further morning, if you are to do the location justice. Spend the middle part of the day checking out potential viewing points, thinking about possible angles and the direction of the sun.

Some canyons are structured rather like an amphitheatre, which should offer you the choice of directional or frontal lighting. When the light really starts to get interesting, there is always a temptation to race around trying to get as many shots as you can, but that

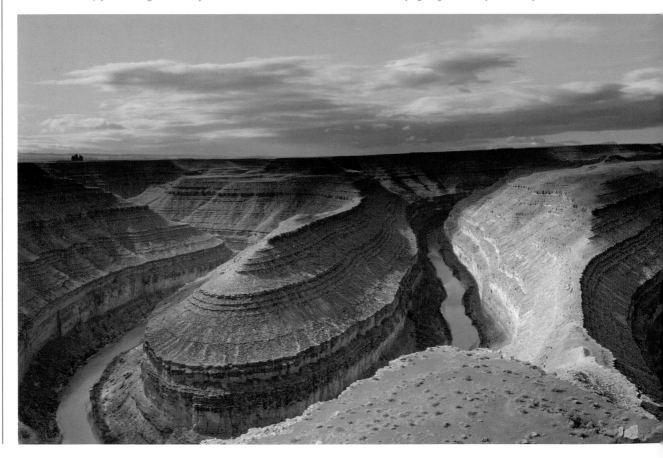

rarely pays off. Trust your judgment in your earlier reconnoitering and wait for the light to give you your best possible photographic opportunity.

While it is, of course, impossible to control weather, it certainly helps if the character of the sky complements the canyon. In landscape terms these are often muscular and intimidating places which suit being photographed under dramatic and tempestuous skies. While the natural colours of the rocks can often appear bland, when you have a fiery sky, interesting hues are reflected back into them.

LENS CHOICE

The normal advice for travelling is to restrict how many lenses you should take, but when photographing canyons you need to be prepared for a variety of opportunities; you may need to change from a wide-angle approach to using a long angle lens as the lighting changes. If it is necessary to make a long trek in order to get to your location, then consider taking two zooms instead.

Some of the most notable canyons will have been photographed by countless photographers before you and it will not be easy to escape the proverbial tripod holes, but that is not to say that you cannot be original, which is where using zoom lenses can prove so useful. By exploring a range of focal lengths and thinking carefully how to frame the image, it should still be possible to get an original shot. It is hard not to be influenced by others, but rely on your own aesthetic judgment. One feature that most canyons reveal, particularly when seen in low directional light, is a strong rhythmic quality; aim to exploit this. Devoid of vegetation, it is often possible to see the structure of the land, which offers excellent opportunities for innovative photography, particularly when using a long angle lens.

If you decide to use a wide-angle lens instead, try to establish a focal point in the foreground which can serve as a foil for the surrounding landscape. Canyons tend to be littered with rocky outcrops or gnarled branches, which serve this purpose particularly well.

tip

If you have a sun compass, this will serve as a very useful guide to the direction of the sun.

Goosenecks
Some canyons invite being photographed as a panorama. In this example I took three separate shots using a DSLR and then merged them together using Photomerge, (see the technique for Creating a panorama [40]). Canon EOS 5D Mark II, 24mm lens, 1/30th second at f.22, ISO 100.

Mountains and Hills

While this is considered the most difficult aspect of landscape photography, you don't need to travel to the Himalayas in order to get great shots. Whether you live in Europe or America, you will no doubt live within a day's travel of some interesting uplands. Not only does it provide excellent exercise, but walking the hills and mountains is spiritually uplifting as well.

EQUIPMENT TO TAKE

Unless you intend to take all your shots from the valley below, you need to think carefully about the gear you take with you. Carrying a full camera bag with every conceivable lens is a non-starter, particularly when you consider the additional equipment you will also need to bring. Ideally if you have a wide-ranging super-zoom, just take this one lens in order to reduce weight. I am a real zoom enthusiast, not only because of their practicality, but because they encourage you to accurately compose in difficult landscape situations. It is usually the long angle end of the zoom that proves most helpful as it allows you to capture interesting abstracts.

Whether to take a tripod is another burning question. Once again, you do not want to burden yourself to such an extent that you are reluctant to walk too far. There are now several excellent carbon fibre tripods you can buy, which are much lighter to carry. They will invariably have a hook, which you attach your bag to in

Twin peaks
One of the best times to photograph mountains is in winter as the snowy peaks add a particularly photogenic aspect to the shot.
Canon EOS 5D Mark II, 24–105mm lens, 1/60th second at f.18, ISO 200.

Buchaille Etive Mor
If you are shooting from a valley, find something that offers foreground interest: it could be a flowing stream, a cluster of bracken or a windswept tree. Because of the blanket of snow, in this example there were very few features available except for a small frozen stream.
Canon EOS 1Ds Mark II, 17mm lens, 1/60th second at f.16, ISO 200.

order to increase stability. Many seasoned mountain photographers rely on placing their cameras on a steady outcrop of rock, or use a small, but sometimes very useful gorillapod (see the section on tripods [p24]). With the ever-improving quality of sensors, it may well be possible to increase your ISO rating and hand-hold your camera without sacrificing image quality. Sometimes needs must — do whatever you can to get the shot.

METERING

In higher altitudes, metering can be more difficult and the general advice is never to meter off the sky, or even to allow the sky to appear in the general reading as this is likely to lead to under-exposure. It is far better to select a brighter portion of the landscape and spot-meter that instead. As ever, see what you have taken in the monitor and, of course, check your histogram for exposure.

PICKING YOUR VIEWPOINT

It is sometimes assumed that you can only take great shots having conquered a steep climb, but that just offers you an alternative view. Obviously, if you have made the effort to get to the top, look across and find a viewpoint of the adjacent hills or mountains. If you are shooting from the valley, try to find something that offers foreground interest: it could be a flowing stream, a cluster of bracken or a wind-swept tree. Using a wide-angle lens in this situation certainly helps. Selecting a viewpoint will obviously be governed by your immediate location, the lighting conditions at the time and your sense of composition.

USE THE DAYLIGHT

While theoretically the available daylight hours are the same as anywhere else, because of the towering mountains surrounding you, your actual daylight hours are reduced, as it takes the sun longer

Mountain mist
Given the geography of mountains, they are often subject to swirling mists, which can add a certain interest.
Canon EOS 5D Mark II, 200mm lens, 1/50th second at f.32, ISO 800.

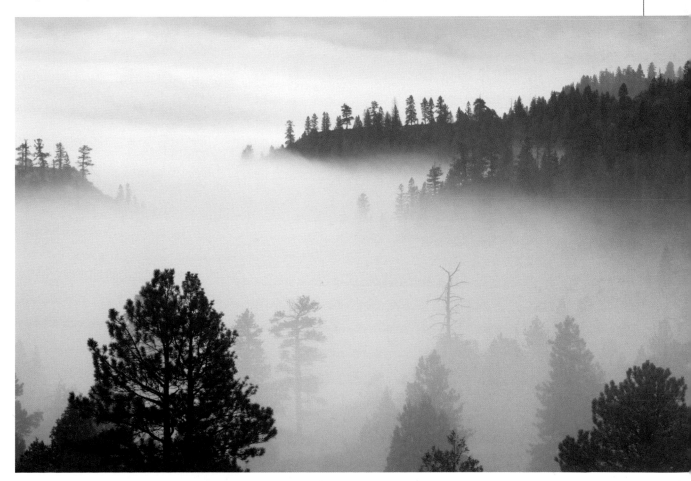

Evening clouds
Sometimes the simplest of detail can prove sufficient.
I was fascinated by the relationship of the snowy peak
and the moving clouds here. This effect has been
exaggerated by using a neutral density filter, which
has served to greatly extend the exposure time.
Canon EOS 1Ds Mark II, 24–105mm lens, 66 seconds
at f.18, ISO 100.

to emerge above the mountains – by the same token it disappears more quickly at the
end of the day. This needs to be factored in when planning your photography. If you are
prepared to venture into the mountains pre-dawn, watch out for a wonderful phenomenon
called 'alpenglow', a beautiful pink light that illuminates the mountain peaks.

THINK SAFETY

As beautiful as our mountain regions are, it is important that you constantly think about
your safety.

- Be aware of the possible weather conditions; while it might be warm and sunny when
 you set off, mountains are notoriously capable of changing almost in the blink of an
 eye. Always take warm clothing with you. While it is easy to take off a layer, if you
 venture up unprepared, you are putting yourself at risk. Also, take the trouble to get an
 up-to-date forecast
- Always let somebody know precisely where you are going and when you anticipate
 returning. It might help taking a mobile, but don't necessarily rely on getting a signal. A
 torch might prove more useful.
- Unless you are very familiar with the location, never venture into the mountains at
 night-time. Plan your route so that you can get back to safety in daylight.

tip

Mountains are always at
their most magnificent
during the winter months
when they are likely to be
covered in snow and ice.

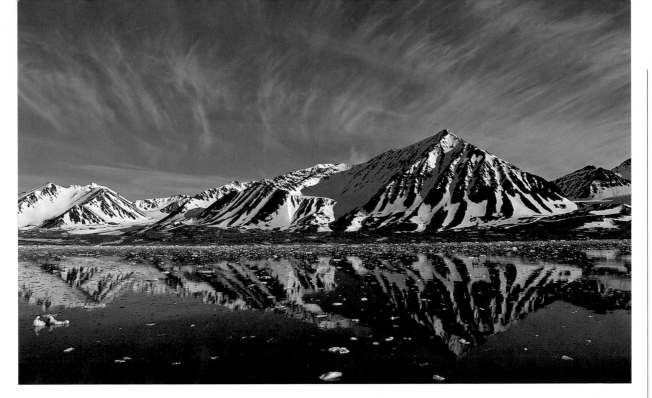

Frozen lake
When photographing a range of mountains, look for suitable foreground interest. In this example, the snow covered rocks in the foreground serve to mimic the monumental peaks in the distance.
Canon EOS 5D Mark II, 24–105mm lens, 1/125th second at f.16, ISO 400.

Mountain reflections
Just occasionally, when photographing the wilderness, one encounters a scenario that is just so perfect it takes your breath away. A snow-capped mountain reflected in still water will always be an intoxicating mix. Photograph by John Chamberlin. Nikon D200, 17–35mm zoom, 1/640th second at f.11, ISO 400.

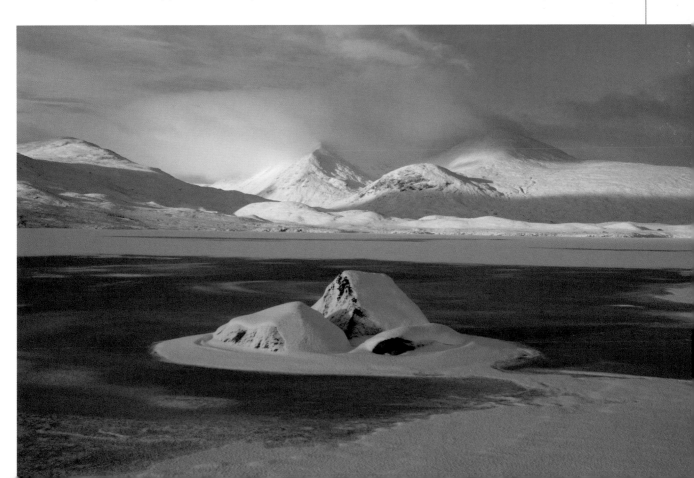

Aspens
Forests and woodlands can be successfully photographed at any time of the year, but they are possibly at their most photogenic during autumn when the leaves start to change colour.
Canon EOS 5D, 24–105mm lens, 1/4 second at f.16, ISO 100.

Beech trees in snow
Despite the lack of colour, shooting woodland during winter can be advantageous. Photographed in a typical December mist, the weather has introduced a simplicity and elegance that is hard to capture at other times of the year.
Canon EOS 5D, 70–200mm lens, 1/10th second at f.16, ISO 250.

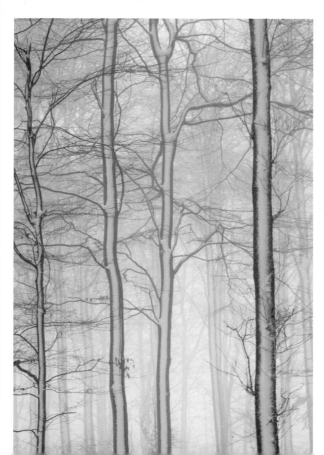

Woodlands and Forests

Forests and woodlands are another very popular subject for landscape photographers, if only because they are so accessible. If you live in a rural area, you will be spoilt for choice, although it is quite surprising just how many larger cities have retained some of their woodlands. Do not underestimate the value of these inner-city retreats; with some it is quite easy to imagine you are in the middle of the countryside, even if you have a motorway a few hundred yards away.

LOW LIGHT

If you have not done very much of this kind of photography, you might be surprised by just how little available light there is in woodland, particularly in the summer months as the leaves create a dense canopy which greatly reduces the penetration of the light. While you should be able to take some of your shots hand-held, for most circumstances consider taking a tripod. If that proves impractical, then increase your ISO.

CAPTURE MOVEMENT

Some of the most creative landscape shots are taken in wooded landscapes, largely because it is an environment that encourages so many different techniques. For example, if on a particularly windy day, you attach your camera to a tripod, select a low ISO and point your camera slightly upwards, you should be able to capture the trees swaying in the wind. While the trunks will remain static, the thinner branches and leaves will move, creating interesting impressionistic effects. A moderate neutral density filter will slow the exposure even more, and thus exaggerate the effect.

LENS CHOICES

Try experimenting with different lenses. For example long angle lenses seem to work particularly well when photographing on the edge of woodlands, as they compress the trees, often creating interesting patterns. By way of contrast, wide-angle lenses seem to be most effective when you are working inside woods. Depending on the lighting and weather conditions, look at the effects of varying depths of field.

THE SEASONS

One of the reasons woodlands are such a popular subject is because they can so easily be photographed throughout the seasons. In spring, deciduous woods begin to show the first signs of growth as the large buds on the trees begin to emerge. It is also a period when natural flora begin to appear at ground level. In summer, the trees are at their most magnificent, producing a rich and dense canopy, which invites abstract photography. During the autumn months, woodlands undergo yet another transformation and with some species of trees the colour changes can be quite spectacular. In winter, much of the magnificence of the foliage will have disappeared, however the skeletal structures of the trees provide a wonderful subject to photograph, particularly in fog, frost and snow. Be aware of whether the woodlands are coniferous or deciduous, as this will also have a bearing on the changes you can expect through the seasons.

EXPERIMENT

Try producing some panoramic shots, particularly of the edge of the forest. If you don't have a panoramic camera, there is so much software available that will allow you to stitch various files together (see the technique for creating a panorama [p40]). As a total contrast, look for small details – the forest is rich in natural forms such as fungi, ferns and flora. Experiment with vantage points; looking upward often produces exciting results or try lying on your back just to create some interesting abstract shots. If the sky is blue, use a polarizing filter to add impact. However, if you are fortunate enough to be photographing woodland in misty conditions, point your camera upwards and capture the shafts of sunlight penetrating the misty canopy.

The only time you might have difficulty photographing woodlands and forests is in strong sunlight, as it produces erratic dappling effects and strong contrast. This not only creates confusing images, but it can also make metering extremely difficult.

Defoliated trees
Although these trees were photographed relatively early in autumn, they have quickly lost their leaves because of the particularly cold nights one experiences at high altitudes.
Canon EOS 5D, 70–200mm lens, 1/30th second at f.22, ISO 250.

September, Rocky Mountains
There are few sights more splendid than a panoramic vista of aspens in full autumnal colour on the slopes of the American Rockies.
Canon EOS 5D, 70–200mm zoom, 1/15th second at f.22, ISO 200.

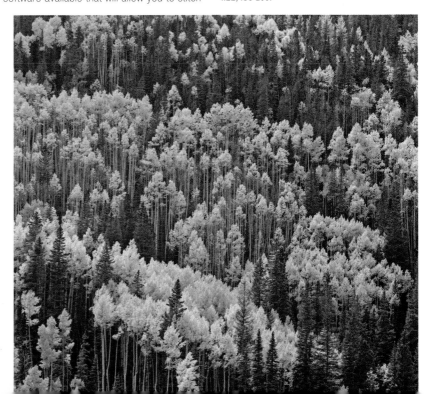

Waterfalls

Most aspects of landscape photography are spiritually uplifting, but few more so than waterfalls. I have seen countless non-photographers just staring in wonderment, so you can imagine how stimulating these places are for those with a camera. Waterfalls are particularly tranquil spots, and the constant thunderous flow relaxes us: watching the cascading water is a truly meditative experience but the longer we stare, the more we identify exciting patterns and details. Waterfalls occur most frequently on higher ground, although there are countless coastal waterfalls tumbling into the sea — any half-decent map will indicate where they are. Some will be named, others will not, but that shouldn't deter you.

SHUTTER SPEED

When you arrive, you then have a choice of whether to use a fast or a slow shutter speed. If you opt for the former, you should be able to capture each unique, energized droplet as the water cascades downwards. If you choose this style of photography, you will need a shutter speed of 1/500 second or faster; this requires increasing your ISO rating to at least 400. However, most photographers opt to use their lowest ISO rating, aiming to capture the beautiful silky effects one can get when using a slow shutter speed. To achieve this, use a shutter speed of 1/4 second or longer. Clearly, in these circumstances you will need to use a tripod. If you wish to reduce the shutter speed even more, consider using a ND filter.

When composing your image, you rarely need to include the sky but if you decide you do want to, use a soft ND grad filter

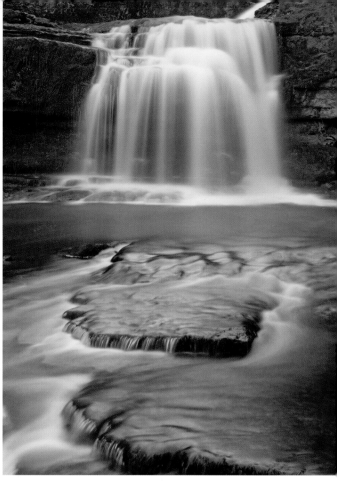

Thornton Force
One can often find interesting cascades slightly downstream from the main waterfall, which adds further interest. In order to extend the length of the exposure, I needed to use a 0.9 neutral density filter.
Canon EOS 5D Mark II, 24–105mm lens, 7 seconds at f.16, ISO 100.

Water and rocks
The power of the cascading water really is awesome and this can be best illustrated by featuring the eroded rocks at the bottom of the falls.
Canon EOS 5D Mark II, 24–105mm lens, 1/4 second at f.22, ISO 100.

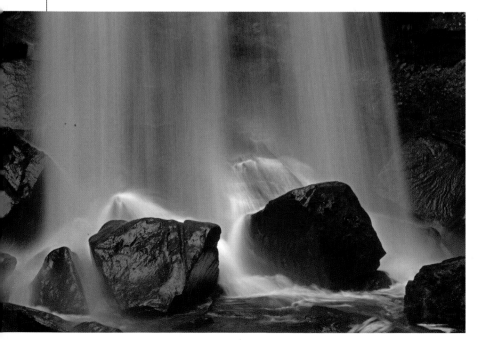

tip

Think about footwear and clothing as you may need to get muddy or wet to gain the best viewpoint.

to balance out the exposure. Another solution is to make several exposures and create a HDR file (see the section on HDR techniques [54]).

OVERCAST LIGHT

As a general rule, because of the high contrasts you are likely to encounter, it is far better photographing waterfalls in overcast light, particularly if you wish to exploit the slow shutter speed effect. Even if you want to capture the fast moving water, strong shafts of sunlight can create impossible contrast problems. Some waterfalls are situated in deep dells, where sunlight is not a problem, but if it is in a more open location, wait for a passing cloud to mask the sun. If, on the other hand, you want to capture the fast flowing water but the lighting is poor, consider using a burst of flash.

Without doubt you will need to use a UV filter, if only to keep water off your lens. The turbulence created by the cascading water produces a fine spray, which frequently drifts towards you and your camera; it pays to clean your lens with a dry cloth from time to time.

LENS CHOICE

There are great advantages to using a long angle zoom, as it helps to keep you clear of the swirling mists, particularly those created by larger, more powerful waterfalls. Long angle zooms also encourage you to find interesting elements of detail rather than photograph the entire waterfall. Use a wide-angle lens if you wish to include a foreground feature such as a rock or a smaller pool of still water. Providing the waterfall in the background is sufficiently distant, you should stay clear of the spray.

THE TIME OF YEAR

One of the great advantages of photographing waterfalls is that they can be taken at most times of the year. Rivers and streams are at their fullest in winter and spring, which is when the cascading water is likely to be most dramatic. It is possible to capture great waterfall shots in the summer, as the rich green foliage works as an excellent foil to the tumbling water, although obviously there is little point trying

this during a drought. Autumn can often prove to be the best time to photograph them, particularly if you can capture one surrounded by autumnal colour.

Finally, and somewhat paradoxically, do not assume that photographing waterfalls immediately after a long and torrential downpour is the ideal time. If there is too much water, the effects of the cascades will be lost and the excessive turbulence can stir up silts in the river, which colours the water. Your walk to a suitable viewing location might not be quite as easy as you imagine – be prepared to wade through mud and water.

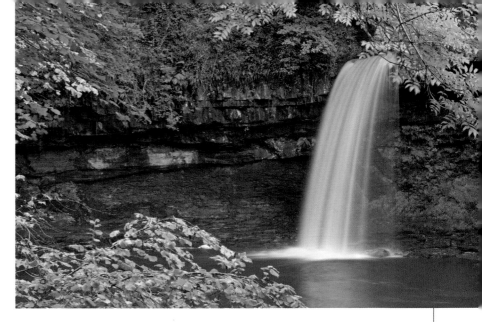

Spouting waterfall
The most photogenic waterfalls are usually those that cascade. If you find one that 'spouts' then look for other features you can use as a balance.
Canon EOS 5D Mark II, 24–105mm lens, 1 second at f.22, ISO 100.

Scalebar
In addition to the cold and rain, we experienced strong winds, even within this relatively sheltered dell. The only way I was able to take this photograph was with the help of a colleague who held an umbrella over me and my camera, thus preventing water getting onto the lens. Compositionally, I like the way the smaller cascades in the foreground echo the main waterfall.
Canon EOS 5D Mark II, 17mm lens, 4 seconds at f.22, ISO 100.

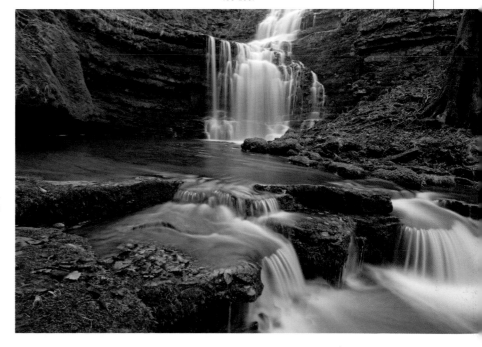

Carpet of flowers
One of the best times to photograph flowers is after a period of rain. One can often see a variety of flora existing symbiotically, as these echiums and crown daisies illustrate.
Canon EOS 5D Mark II, 200mm lens, 1/400th second at f.22, ISO 1000.

tip

Try photographing floral pastures shortly after in has rained, as the additional moisture seems to reinvigorate the plants.

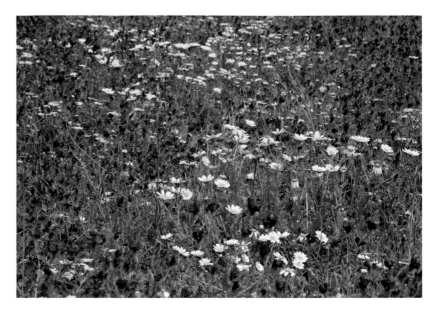

Pastures and Meadows

I live about two miles from a water meadow which for most of the year appears uninteresting, but for a brief couple of weeks it can be transformed into an area of spectacular beauty. In winter it is often flooded (which is what water meadows are supposed to do), while in summer it appears dowdy and featureless, but in late spring, almost by magic, the entire area is carpeted in a luxuriant display. I make this point because you do not need to travel to some Alpine idyll. Sometimes unpromising areas, even urban wasteland, can be briefly transformed into something truly wonderful, it is a matter of anticipating when.

BLURRING EFFECTS

When photographing a sweeping carpet of wild flowers, aesthetically it often helps to include some small element, be it a post, a tree, or a building as a means of introducing a focal point. Try experimenting with shutter speeds: if the flowers are swaying in the wind, your natural inclination is to use a shutter speed of at least 1/250 second in order to freeze any movement, but sometimes you can capture equally interesting results by using a very slow shutter speed instead. With your camera set on a tripod, and using a shutter speed of 1/4 second or less, you can create an almost Impressionist effect.

This technique can work particularly well when you are experiencing short gusts of wind, as part of the meadow will appear static, while others parts will blur.

Flora under almond tree
Wild flowers often benefit from being photographed using a long angle lens. Not only does it allow you to get closer to the subject, but it has the effect of compressing the flora, making them appear denser and more lush.
Canon EOS 5D Mark II, 200mm lens, 1/40th second at f.32, ISO 1000.

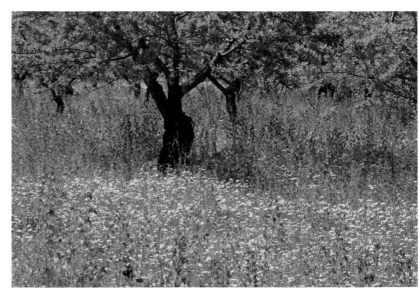

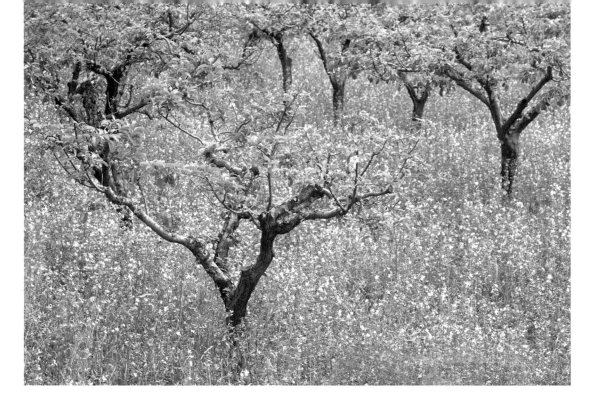

LENS CHOICE

This is an aspect of landscape photography that can be successfully explored by using any lens. Often when passing a meadow from a distance, the density of the flora can appear deceptively lush, but as you get closer, unsightly gaps appear. In these circumstances try using a long angle lens, which has the effect of compressing the detail. By way of contrast, select a wide-angle lens if there is some other interesting feature in the distance. Place the lens as close as possible to a healthy cluster of flowers in the foreground and allow the lens to create a sweeping floral vista leading to your focal point.

In addition to the all-purpose UV, I would strongly recommend you use a polarizing filter. Foliage can create unwanted highlights, particularly in strong light, and this filter will help to reduce them.

Photographing meadows can have one further advantage, as they are best photographed in the middle of the day, when other landscape subjects may be best avoided. If you are experiencing an overcast sky, simply point the camera downwards in order to exclude it, but if there are some interesting cloud formations, then of course include it.

Orchard in spring
Often the best time to take this kind of photography is on an overcast day in spring. A higher vantage point has also helped, allowing the sky to be excluded altogether. Photograph by Eva Worobiec.
Canon EOS 5D Mark II, 24–105mm lens, 1/30th second at f.22, ISO 100.

Trail of poppies
Normally when photographing a subject like this, I would opt to use either a standard or long angle lens to compress the effects of the flowers, but as I also wanted to include the distant copse of trees, I decided to use a wide-angle lens instead.
Canon EOS 5D Mark II, 24–105mm lens, 1/50th second at f.20, ISO 125.

Harvested field and finca
Almost irrespective of the crops being grown, the period immediately after the harvest is a great time to take photographs. The harvesting machinery follows the contours of the land, which tends to accentuate the natural topography.
Canon EOS 5D Mark II, 70–200 zoom, 1/30th second at f.22, ISO 100.

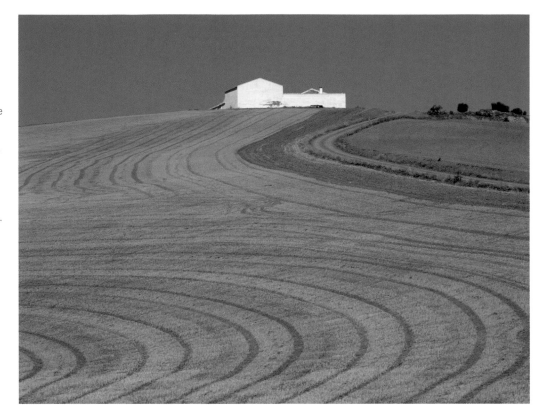

The Marks of Man

It is difficult to escape the presence of man, with his ubiquitous pylons, fences and dry-stone walls. Only if you travel to some locations on the coast, or escape into the true wilderness are you able to experience a landscape where the hand of man is absent. But that is to suggest that his presence is always unwelcome. In reality man's involvement has created many interesting patterns in the landscape.

SUITABLE LENSES

It is, of course, partly about style, but it is often easier to photograph an undulating terrain, as the marks created by agricultural machinery are far more obvious. In these situations a long angle zoom can prove to be particularly useful; the advantage of these lenses is that they allow you to pick out small elements of detail. Find a location that offers you a higher vantage point, which then means that you can concentrate your eye on patterns. If you are photographing a flat landscape, it pays to use a wide-angle lens instead and make the sky a feature; you will also make the fields appear infinitely vaster.

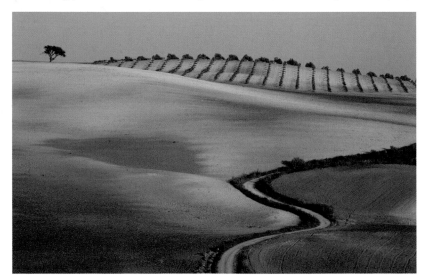

Track and olive grove
Sometimes it is worth imagining what an area would look like if it had not been cultivated. In this example, the small olive grove would certainly be missing, there would have been no track and the tree in the top left would also have been absent, In short, it would have been an uninspiring tract of land. From a photographic point of view, man's intervention can have a positive impact.
Canon EOS 5D Mark II, 200mm lens, 1/32 second at f.25, ISO 100.

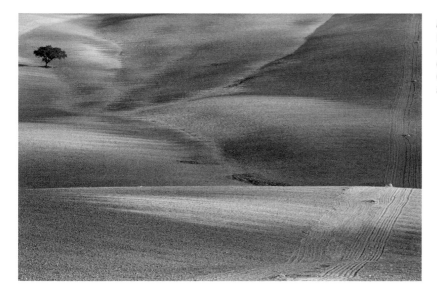

Lone tree
Even in winter, agricultural areas devoid of crops still retain an appeal. Individual trees scattering farmland can often make a useful point of focus.
Canon EOS 5D Mark II, 200mm lens, 1/80th second at f.22, ISO 200.

LOOK FOR THE LIGHT

When you discover an interesting agricultural area, think carefully about how it can best be photographed. For example, fields that have recently been ploughed create wonderful patterns, but these could look considerably more dramatic when photographed in early morning or late evening light, particularly if they are lit from the side. It really is worth reconnoitering an area and establishing the best viewing points and then returning when the light is likely to be at its best.

THE YEARLY CYCLE

The great advantage about agriculture is that it goes through an annual cycle, so that in each month, the fields change. Sometimes the fields are left fallow, on other occasions they will be prepared and new crops introduced. As these mature, further photographic opportunities are created. Whether you choose to document the entire yearly cycle or simply select particular parts, farming certainly offers the landscape photographer plenty of scope.

AFTER THE HARVEST

Almost irrespective of the crops being grown, the period immediately after the harvest is a great time to take photographs. The harvesting machinery follows the contours of the land, which tends to

accentuate the natural topography. But, of course, it is not just after the harvest that farm machinery will leave distinctive marks, as interesting tracks can be spotted at any time of the year.

MEANDERING TRACKS

While maps will feature all the roads in a particular area, look out for the many smaller tracks that also tend to criss-cross farmland. These can be used in a composition to draw the eye to a particular feature you want to highlight. It is also worthwhile parking at the entry to one of these tracks so that you can explore on foot parts of the landscape that are obscured from the road.

PLACEMENT OF TREES

Finally, most of the trees that you find in agricultural areas have been planted, and usually they have been placed with some care. If you are using a long angle lens and need a simple point of focus, they serve this purpose excellently.

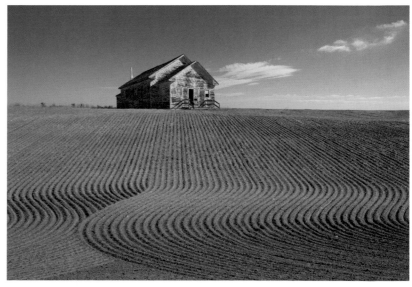

Abandoned school
When looking at a landscape like this, you can almost sense the fun the farmer had when dragging his plough over this field. While highly manufactured, you cannot but admire the marks he has left behind.
Canon EOS 5D Mark II, 70–200mm lens, 1/200th second at f/11, ISO 400.

Roads in Landscape

It is sometimes suggested that it is far better to travel than to arrive, which is a sentiment I can share. How can anyone resist not picking up a camera and heading for the open road? There is a tradition for excluding them from our photographs, but that strikes me as naïve, as some have the capacity to define a landscape. When you see a road devoid of traffic snaking its way across a barren backdrop, it is just as capable of expressing wilderness as a shot that aims to exclude it. So for better or for worse, the road is an intrinsic part of the landscape and to disregard it would be a wasted opportunity.

USING A WIDE-ANGLE LENS

When photographing roads, think carefully about the lens you wish to use. If you are photographing a relatively quiet one in a large and open landscape, get down as low as you can with a wide-angle lens and exaggerate the sheer scale. Find a distorted cats-eye, a crumbling road mark or a pot-hole to use as foreground interest. Obviously you will need to check that there is no immediate danger of traffic bearing down on you, although waiting

for a single vehicle to appear in the distance can certainly add interest. But nothing is quite as evocative as the arrow straight highway disappearing into the horizon with only desert on either side.

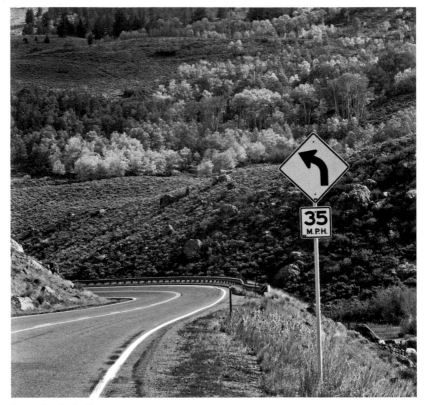

Descending the Rockies
Long angle lenses are great for drawing together the road and its immediate environment. The road signs serve as a reminder that, even in the middle of a wilderness, man is ever-present.
Canon EOS 5D Mark II, 200mm lens, 1/30th second at f.22, ISO 100.

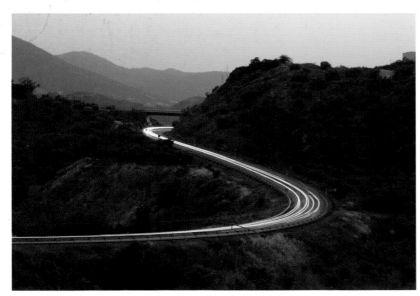

tip

To record traffic trails at night, find a high viewpoint such as a bridge, set the camera on Bulb and cover the lens in between cars.

Traffic trails
A great time to photograph a road within the landscape is at night. Wait for a period when a group of vehicles all pass at the same time; alternatively with the camera set to Bulb, cover the lens with a piece of card each time there is a lull in the traffic, removing it only as more vehicles come by.
Canon EOS 5D Mark II, 70–200 lens, 104 seconds at f.22, ISO 125.

Telegraph poles
The presence of a road or track can easily be hinted at merely by photographing the roadside paraphernalia. Using a long angle lens has compressed and exaggerated the effect of the receding telegraph poles.
Canon EOS 5 Mark II, 200mm lens, 1/250th second at f.32, ISO 800.

USING A LONG LENS

Use a long angle lens when you want compress the road relative to the landscape; this tends to work particularly well if you can find a curve in the road. If you are able to find one that meanders through the landscape, that is even better, as it will serve to emphasize the inherent topography. This often requires working from a slightly higher vantage point. Another advantage of using a long lens is that you can comfortably include a vehicle without putting yourself in danger.

ROADS AT NIGHT

A great time to photograph is at night-time. Once again, try photographing from a higher vantage point so that you are looking down onto the road. With your camera attached to a tripod, try taking long exposures and while you cannot possibly capture the moving vehicles, aim to photograph the light trails they create instead. If you wish to intensify this effect, try placing a piece of dark card over the lens during the lulls in the traffic and then removing the card as further vehicles pass by.

BAD WEATHER

During or after rain, the road surface becomes reflective and as many vehicles are still likely to have their dipped headlights on, the results can be quite dramatic. Mists and fog can also create wonderful road shots. In addition to the obvious tonal recession, the appearance of a distant vehicle with its headlights can introduce a slight hint of menace to your picture. Snow can also present some

excellent photographic opportunities. The striking graphic effects left by passing traffic can add an additional element of interest.

THE URBAN HIGHWAY

The more I travel, the more complex and beautiful many of our motorway intersections seem to get, but of course it is impossible to stop and take photographs. Once again some purists might question whether this is truly 'landscape', but the sight of long lines of traffic weaving their way over a complicated network of bridges and overpasses is not just a reflection of the times, but is something to be admired and, if possible, photographed. Finding a suitable viewing point is the challenge.

THE ROAD-SIDE

It is possible to suggest a road without ever including it: by concentrating on the paraphernalia one commonly sees on the sides of roads, you can suggest its presence. Long lines of telegraph poles, fences stretching over the undulating land, or close-ups of road signs will indicate the proximity of a highway.

Road through snow
The tracks in the snow help to lead the eye to the distant hills. Linking the road to the surrounding landscape in this way is a very effective means of relating these quite disparate elements.
Canon EOS 1DS Mark II, 17mm lens, 1/125th second at f/14, ISO 400.

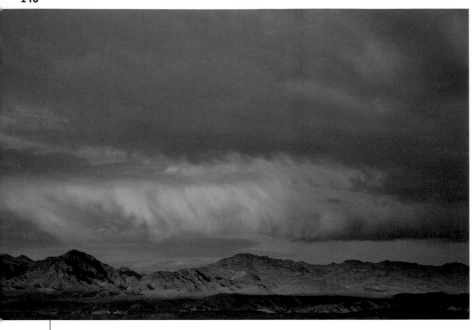

After rain
The evening sky can often appear dramatic, but never more so than just after a period of rain. The light assumes a wonderful clarity under these conditions. Canon EOS 5D Mark II, 24–105mm lens, 1/30th second at f.16, ISO 800.

Streaking clouds
Using a very long shutter speed to capture the moving clouds creates an interesting streaking effect. Canon EOS 5D Mark II, 24mm lens, 98 seconds at f.22, ISO 100.

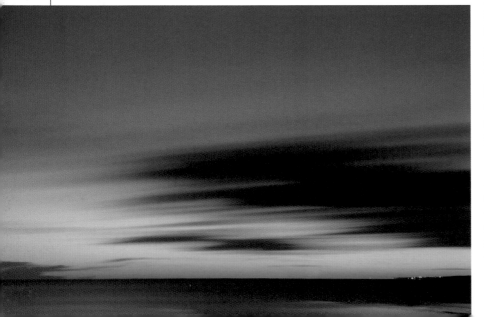

Dramatic Skies

Just occasionally you see a sky that is so incredibly beautiful, nothing else is required to make a great picture. In those situations, find a vantage point that gives you an uninterrupted view. Keep your horizon as low as possible, or if necessary exclude it altogether. The best place to take sky shots is by water as it provides an unbroken view, as well as reflecting the light from the sky.

DAWN AND DUSK

These are undoubtedly the most popular times to photograph skies, largely because of the resplendent colours one sees at those times of the day. If the sun is still visible, then it should be sufficiently low for you to be able to look at it without squinting your eyes. Generally, any features in the foreground will appear silhouetted, and it is therefore best to keep these to a minimum. Try underexposing by 1/3 stop in order to increase the colour saturation; this might also allow you to retain some detail in the setting or emerging sun.

DAY-TIME DRAMA

If you photograph skies in the middle of the day, you will not experience quite the same range of colours, although the billowing cumulus clouds one typically sees prior to, or just after, a storm can prove to be equally photogenic. Once again, try slightly under-exposing your shots both to darken the blues and to ensure that you retain all highlight detail in the clouds. Use a polarizing filter to boost contrast.

CAPTURING LIGHTNING

Lightning is much harder to capture than you might think, particularly if you are hand-holding your camera, as a flash of lightning occurs in milliseconds, far faster than your normal reaction times. The best time to shoot lightning is pre-dawn or during the evening, although great shots can also be taken at night. With your camera on a tripod and the shutter set to Bulb, look to the most active part of the sky. You can achieve far more interesting results if you are able to get several strikes onto a single exposure, therefore keep the shutter open for a least a minute. If necessary, use a polarizing filter to reduce speed.

LONG EXPOSURES

One technique you may wish to exploit is to use an extended exposure to illustrate moving clouds; this creates a hauntingly beautiful streaking effect across the sky. Using a wide-angle lens, try taking these shots early in the morning or in the evening when there is

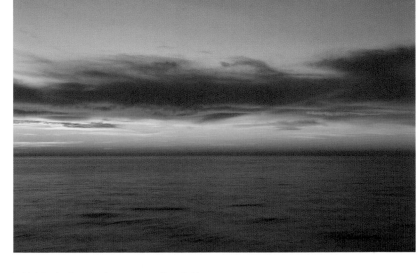

Sea and sky
If you are able to photograph a dramatic sky over a stretch of water, the foreground will reflect the light from the sky and produce a more balanced picture. Canon EOS 5D Mark II, 24–105mm lens, 4 seconds at f.22, ISO 100.

plenty of broken cloud. It is also possible to achieve similar results during the day, although you will need to use a very strong neutral density filter to cut down the light reaching the lens. Whether you choose to take your photographs at dawn, dusk or during the day, you should be aiming for a minimum of a three minute exposure.

The results are particularly interesting when the wind is blowing the clouds across your line of vision, although exciting results can also be achieved if the winds are blowing towards or away from you.

SEEING STARS

Only consider this technique if you have plenty of time on your hands; you will need to make an exposure of at least 30 minutes, although the best results require exposures lasting hours. This can only be achieved on a clear night, and from a location which is free of light pollution. With your camera fixed to a tripod and the shutter set to Bulb (B), open up your aperture to f.5.6 or f.8. Use a standard or a moderate wide-angle lens. Switch off the auto-focus facility, manually set the lens to infinity, and then take your photograph. It is particularly irritating to find after making a very lengthy exposure that it has blurred as a result of movement, so find a stable vantage point, which is sheltered from the wind.

tip

It is worth building up a 'bank' of good sky images that you can use to replace a bland sky in otherwise worthwhile photographs — a simple procedure in Photoshop.

Passing storm
Some of the best skies appear at the end of a particularly overcast day. If you spot even the tiniest break in the clouds, reach for your camera.
Canon EOS 1Ds Mark II, 24–105mm lens, 1/4 second at f.18, ISO 100.

Star-trails
This is quite a specialist area of photography, but can be easily achieved with a standard DSLR camera. With the camera on a tripod and the focus set to infinity, be prepared to expose your shot for an hour.
Canon EOS 5D Mark II, 24–105mm lens, 40 minutes at f.8, ISO 400.

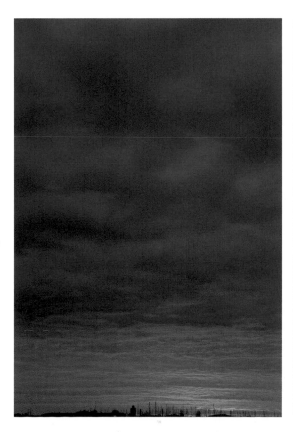

The Urban Landscape

Several years ago, while taking a flight from Las Vegas to Los Angeles, I was fascinated by the absolute contrast of the emptiness of the desert with the intricacy of the vast sprawling metropolis below, and quickly appreciated that the urban landscape offered an exciting, but challenging subject for photography. Some dismiss this genre, wishing instead to adopt a wholly romantic notion of landscape, but a more contemporary view is that the urban environment provides worthy, interesting and exciting opportunities.

THE WEATHER

When shooting urban landscape, the weather will have a bearing, but possibly in a slightly different way to conventional landscapes. Because you are likely to be surrounded by large buildings, the sky rarely plays an important role; whether it is blue or just overcast seems not to matter.

Cities can often be photographed to best advantage in the rain, as the concrete and asphalt reflect the surrounding details helping to create lively images. Even in the daytime, vehicles tend to have their headlights on when it is raining, which can greatly add interest. The metropolis can also look wonderfully transformed on one of those very rare occasions when it is covered in snow.

LIGHTING

Conveniently, some of the best lighting conditions for photographing towns and cities are those that are unsuited for more traditional landscape work. Because of the varied textures,

Granada, Spain

When photographing a large city, find a vantage point that offers you an elevated view. Cities seem to come alive when seen at night. With the wonderfully illuminated streets and buildings, opportunities for great photographs abound. This image reminds me of an illuminated circuit board.
Canon EOS 5D Mark II, 24–105mm lens, 58 seconds at f.20, ISO 100.

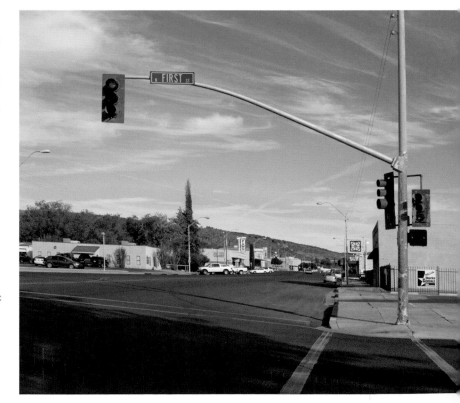

Kingman, Arizona

Urban landscape encourages working in a panoramic format; presented in this manner, the image has a contemporary feel. This image has been stitched together using three separate files; while I was able to use a relatively fast shutter speed, I still found it useful to take each of the exposures using a tripod.
Canon EOS 5D Mark II, 24–105mm lens, 1/100th second at f.20, ISO 200.

The Alhambra, Granada
It is pointless driving around a large city aimlessly looking for a good shot. With busy traffic hot on your tail, this can prove more than challenging. I found this viewing point earlier in the day, and decided to return to take advantage of the evening light. Canon EOS 1Ds Mark II, 24–105mm lens, 39 seconds at f.16, ISO 100.

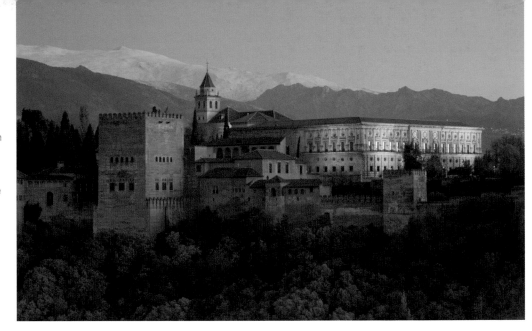

the ornate detail and the sheer busyness of cities, soft, overcast lighting generally works best. In fact, strong, directional lighting can often prove detrimental unless it is shining directly onto the subject. Harsh shadows appearing across buildings can easily distract the eye.

IDEAS TO TRY

Try experimenting with a variety of apertures and shutter speeds; with the constant flow of traffic and the movement of pedestrians, set your camera on a tripod with a slow shutter speed selection and you should produce some wonderfully creative results. Alternatively, you might wish use a very wide aperture and focus on just one small architectural feature. Another possibility is to produce a panorama. City views lend themselves particularly well to this sort of treatment. As most digital cameras are now provided with the appropriate software, try 'stitching' various files, taken consecutively, together (see the technique for creating a panorama [p40]).

Bath
Photographed in warm afternoon light, the topography of the land is clearly evident. Using a long angle lens has helped to compress this image, thus creating interesting patterns.
Canon EOS 1D Mark II, 200mm lens, 1/320th second at f.13, ISO 800.

Just as with any other aspect of landscape photography, explore a range of vantage points. You might discover an area of higher ground outside the city that offers an excellent view, or alternatively you might consider taking your shot from the other side of a river. If you are able to access a particularly high building or structure within the city, this will offer superb views. Be specific about those features you wish to concentrate on, such as buildings, transport or inner city parks.

CONVERGING VERTICALS

Wide-angle lenses work particularly well when photographing cities, but be aware of the problems posed by converging verticals (when the sides of a building seem to lean into each other). This sort of distortion is less visible when shooting traditional landscapes, but can be very apparent when photographing buildings. There are various ways of overcoming this. First, if you are considering doing a lot of urban work, you might consider buying a shift lens. These are expensive but hiring one is another option. Second, you may wish to use a spirit

Railway siding
Every large town or city has its quiet corners and areas near a railway often provide these. While it is difficult to directly compare this image with shots of the wilderness, it does nevertheless retain a quirky sort of charm.
Canon EOS 5D Mark II, 24–105mm lens, 5 seconds at f.22, ISO 100.

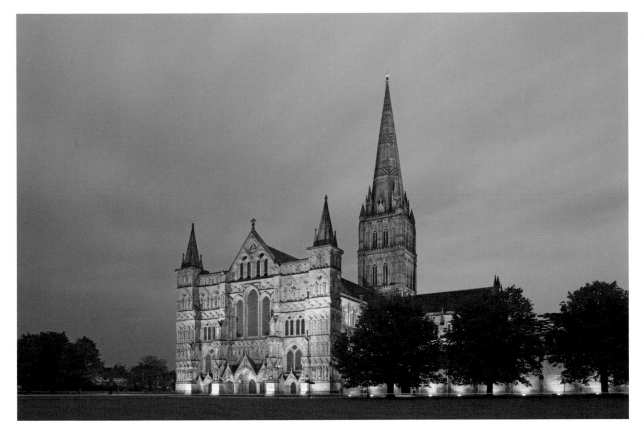

Salisbury Cathedral
Converging verticals are a problem when photographing large buildings. Because of the restricted viewing points, it is very difficult to photograph most city buildings without using a wide-angle lens, although the distortions these create can easily be remedied using editing software.
Canon EOS 5D Mark II, 24–105mm lens, 68 seconds at f.16, ISO 100.

level attached to either the camera or tripod in order to keep your camera level, but this will restrict your room for manoeuvre. The easiest solution is to correct the distortions in Photoshop by using the Transform/Perspective facility.

CITIES AT NIGHT

Cities seems to come alive at night-time: with the wonderfully illuminated streets and buildings, opportunities for great photographs abound. In order to be successful with this genre of photography, being able to anticipate how parts of the city might appear at night is essential. If you have just arrived and envisage staying several days, use one of your evenings to do a thorough reconnoiter; this really is good use of your time.

If you wish to photograph an illuminated building, try taking your shot pre-dawn or shortly after the sun has set so that you are able to capture it in cross-over lighting (i.e. when the light in the sky matches the illuminated building). The great thing about photographing cities is that, as dusk slips into night, you can continue taking photographs, providing you choose not to include too much sky. Often you can find a higher vantage point (multi-storey car-parks are often great places to take photographs from), which allows you to look over the city. One problem you are likely to encounter is excessive contrast, but this can easily be overcome by making a HDR file (see the section on HDR techniques [p54]).

The white balance selection can sometime pose difficulties when photographing an illuminated building in evening light. Do you set the WB for the sky, or do you ascertain the source of the illumination and set it for that instead? Clearly you cannot do both. In these circumstances, always set it for the sky. If there is an obvious colour cast in the sky, the image will always look wrong, however the warm orange light one gets with tungsten can often make a building look interesting. Only if you decide to exclude the sky altogether, should you consider setting the WB to counter the artificial light source.

tip

A tripod is invaluable for night shots but some European cities place restrictions on their use. If that is the case, place a bean bag or your camera bag on a solid surface.

Coastal Landscapes

The coast is an aspect of landscape photography that is sometimes strangely overlooked. In Britain, there is hardly a community that does not live within 65 miles of the sea. Even in much larger countries, populations tend to gravitate towards the coast. In Australia, for example, 80 per cent of the population lives within just 80 miles of the sea, while over half of all Americans are able to get to it within a day. I make this point because so many aspiring landscape photographers fail to recognize the superb opportunities that exist relatively close to their home.

The photographic potential of most coastal locations is overwhelming. The sea presents so many moods, and with the ever-changing tides and lighting conditions, fresh openings are always available. It possesses such a wonderfully enigmatic quality, that it encourages each photographer to discover a personal style, whether using a very fast shutter speed in the middle of the day, or exploring the endless possibilities of making long exposures at night. The subject matter varies enormously including harbours, beaches, estuaries, coves, piers, lighthouses, promenades — in fact the list is almost endless.

What makes photographing the coast so easy is that you are dealing with simple elements. The sea and the sky provide the perfect scenario for exploring mood. Treat the sea almost like a canvas, adding interesting features as you see fit.

BEACHES

Whether you are travelling close to home or abroad, the casual walk along a beach is something we have all done, but because it is such a commonplace experience many of us fail to recognize its true photographic potential.

LOOKING FOR ABSTRACTS

The beach offers so many variations. As the tide drifts in, it is constantly shifting the sand and then depositing it in new and exciting patterns. The marks left by the sea are a reflection of the movement of the water, which has a distinctive yet transient, abstract quality. Try to take your shots as the tide begins to recede but before the sand is disturbed by other visitors.

The constant ebb and flow of the sea is a source of fascination for anyone who enjoys the coast; its gentle hypnotic movement encourages you to take minimalist images. In order to add variation, look for a stream flowing from the land to the sea. These

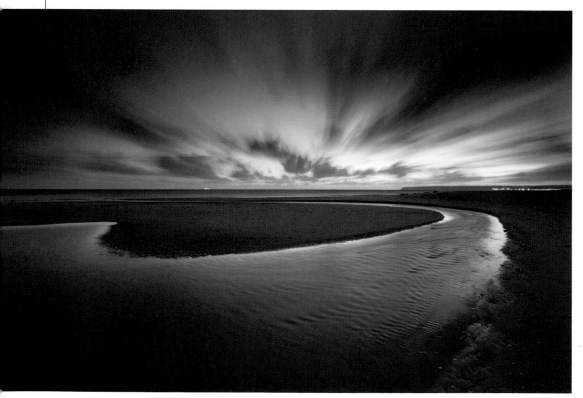

Costa de la Luz
Unquestionably, one of the best times to take shots of the beach is at night. The gentle flow of the water in the foreground is balanced by the movement of the clouds created by the very long exposure. Canon EOS 5D Mark II, 17mm lens, 287 seconds at f.13, ISO 100.

Beach pools in sand
The receding tide can leave a beautiful myriad of pools in its wake. This sort of subject is usually best shot contre jour. Canon EOS 5D Mark II, 17mm lens, 1/30 second at f.13, ISO 400.

shots are usually best taken early in the morning or late in the day when you are able to use a slow shutter speed, although if the light is too bright there are various filters you can use to counter this.

THE BEACH AT NIGHT
The beach is possibly one of the simplest places to photograph at night. First, when compared to many other locations, it is relatively easy to get to. Second, because of the light tones of the beach

and the reflective qualities of the water, you should be able to retain foreground detail, except possibly in the deepest shadows. With your camera attached to a tripod, take a light reading off either the beach or sea. Make a second light reading from the sky and then use the appropriate graduated neutral density filter to balance the exposure. If that is not possible, make two separate exposures, one for the sea and the second for the foreground and use HDR (see the technique for creating HDR files [p54]).

At certain times of the year, urban beaches will have funfairs or

Dingle Bay
With the tide fully out, some beaches can appear immensely expansive. With beautiful cloud formations seemingly echoed in the puddles in the foreground, the distant headland in the far right serves as a small but important focal point. Canon EOS 5D Mark II, 17mm lens, 1/30th second at f.22, ISO 100.

Observation tower
Beaches tend to be littered with strange and quirky structures, which appear quite meaningless out of season, but nevertheless make excellent points of focus. Using a polarizing filter has greatly emphasized the clouds, which serve as a counterbalance to the observation tower.
Canon EOS 5D Mark II, 24–105mm lens, 1/80th second at f.18, ISO 100.

Reflected clouds
If you want to take simple images, then you will be in your element photographing beachscapes. Walking along the water's edge, I was struck by how clearly the sky was reflected in the wet sand. In order to establish a well balanced exposure, I used a hard neutral density graduated filter.
Canon EOS 5D Mark II, 20mm lens, 1/40th second at f.16, ISO 100.

THINGS TO WATCH OUT FOR

- **Straight horizons**
 When taking any landscape it helps to keep the horizon as straight as possible, but when photographing the sea, this is especially important. As you are dealing with such simple elements and as the horizon is likely to be so prominent, being out by just one degree will show. It may not be convenient taking a tripod onto a beach, but it is one way of ensuring that your horizons remain level. Some tripods have a built-in spirit level; if yours does not, you can buy a cheap spirit level attachment that fits onto the camera's hot-shoe.

- **Sand and dust**
 Don't underestimate the capacity for sand and dust to get into the camera, or the damage it can do. Keep the camera in your backpack for as long as you need to, bringing it out only when required. Anticipate which lens you are likely to use prior to going onto the beach, and keep your changes down to a minimum; ideally aim to make no changes at all. Often when you are on a sandy beach, you will encounter breezes that whip it up. It really is important that you do everything you can to keep your camera protected; if you have a rain cover for your camera, use it.

- **Unwanted people**
 Beaches are popular places for recreation and, even in the colder months, expect to see visitors, particularly during the more convenient hours of

the day. The best time to take serious beachscapes is early in the morning and during the late afternoon. Not only is the lighting likely to be more favourable, but you will encounter fewer people. No matter how large the beach might seem, you will find the footprints left by hordes of visitors frustrating.

- **Over-exposure**
 With the brightness of the sand and the reflections of the water, it is easy for your light meter to be fooled into over-exposing particularly at midday, so bracket your shots, or at least check your histogram to make sure that your highlights are not burning out.

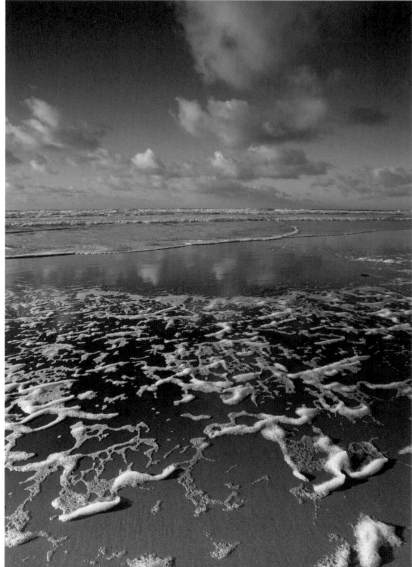

Drifting cloud

Dawn can be a great time to photograph beaches; there is very little likelihood that any one else will be around, and the lighting at this time of the day can be truly captivating.
Canon EOS 5D Mark II. 20mm lens, 1/15th second at f.11, ISO 100.

Sea foam

Sea foam is quite a common feature on beaches, particularly after a storm. By using a wide-angle lens and getting close to the ground, I have been able to make a feature of an otherwise mundane subject.
Canon EOS 5D Mark II, 17mm lens, 1/64th second at f.16, ISO 400.

THE ROCKY SHORELINE

The coast does not only comprise sandy beaches: you are just as likely to encounter a rocky shoreline instead, which of course provides entirely different photographic challenges. Some will be inaccessible, although you should still be able to get to most. It is a type of coast that is entirely different in character and is often associated with smuggling, shipwrecks and disasters; the way we photograph them should reflect something of the menace they can pose.

ROCK STRUCTURES

When photographing these areas, the general guidance is to look out to sea and let your eye follow the natural strata of the rock. These are usually an extension of the surrounding geology, and while this might not be quite so apparent when facing inland, the sea has the capacity to erode the top cover to reveal the skeletal structure of the land. Nearby cliffs can also give a clue to the underlying geology.

The rocks on our beaches vary in terms of hardness, colour and texture – qualities that will determine how they erode. While granite and limestone can be wonderfully sculpted by the constant attrition of the sea, sandstone is often fashioned into fascinating structured layers. Some rocks are easily pitted by the saltiness of the water while others are more unyielding. They also vary in colour, ranging from warm beige, or a subtle pink through to a steely grey. Responding to these varying characteristics is part of the challenge.

ROCK POOLS

The best shots are usually taken within the inter-tidal zone where most of the interesting erosion has occurred; this is also where you are likely to find rock pools. The deposits of seaweed and other tidal detritus are more likely to occur further up

Kimmeridge
It is often assumed that a rocky coastline is by definition a craggy coastline, however, sometimes they can also appear very gentle. In this example, the shale rock appears almost like paving stones set against a very gentle. motionless sea.
Canon EOS 5D Mark II, 17mm lens, 187 seconds at f.16, ISO 100.

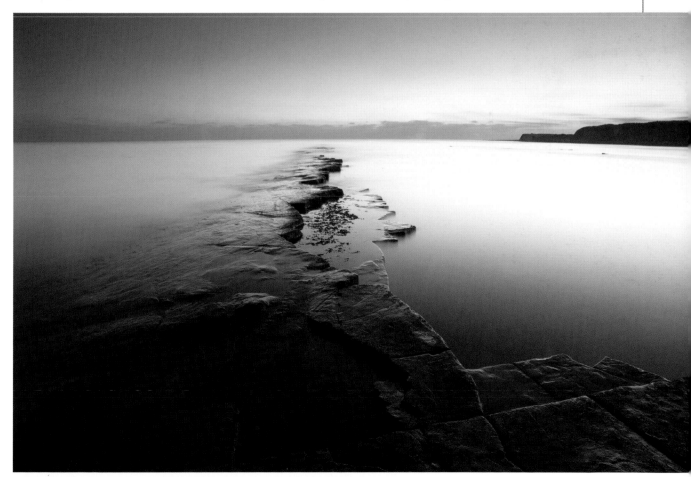

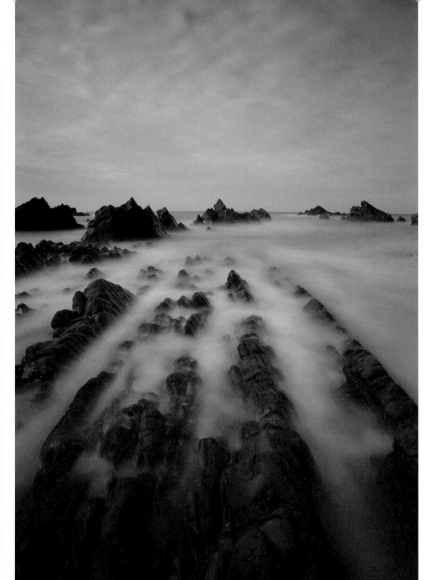

the beach. Finally, while it is usually more advantageous to photographs rocks while facing out to sea, if you have an interesting headland, particularly if it is illuminated by the sun, this should also provide good photographic potential.

THE TIDE

While, of course, we do not have the power to alter tides, it is easier to take your shots as it recedes. This is partly because the waves tend to be gentler, but also because the rocks will still be wet. It is possible to get good shots with an incoming tide, however do watch for splashes on your lens. Always have a soft cloth available to clean your filter otherwise your images could appear blotchy. When photographing in these sorts of locations, it is important that you understand the tide; you need to be aware that when it is coming in, you can easily get cut off.

TIMING

The best shots are usually taken early in the morning or late in the evening, set against a dramatic sky created by a rising or setting sun. In these situations, use a hard grad filter in order to balance out the exposure for the sky and the foreground. It is also possible to capture interesting shots under overcast skies, but this tends to work better at night, when the image assumes a subtle overall blue. This kind of

Jagged rocks
Jagged outcrops are often associated with shipwrecks and disasters; with this in mind, the images we produce should reflect something of the menace these areas can pose.
Canon EOS 1Ds Mark II, 24–105mm lens, 92 seconds at f.16, ISO 100.

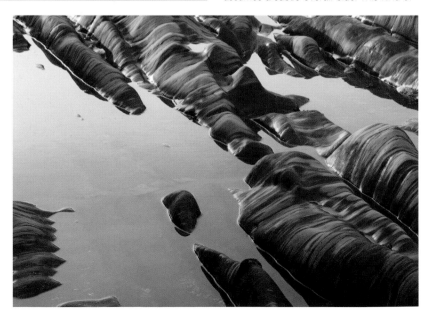

Rock pools
The inter-tidal zone is a wonderful area to explore, particularly after the tide has gone back as there are likely to be so many interesting pools left behind.
Canon EOS 5D Mark II, 24–105mm lens, 1/50th second at f.18, ISO 400.

photography invites slow exposures, as the silkiness of the moving water contrasts with the jaggedness of the rocks. If you are photographing a rocky coastline in the middle of the day, use a faster shutter speed and capture the crashing waves breaking on the rocks.

EQUIPMENT

If you have to limit yourself to just one lens, then opt for a wide-angle, because it greatly exaggerates the sense of perspective, particularly with the diminishing shelves of rock jutting out to sea. Get as low as possible in order to emphasize the foreground. When working on a rocky shoreline, think very carefully about footwear. Even if a surface appears free of slime, it can still be extremely slippery. Wear either a pair of hiking boots, which will offer some grip, or even better a good quality pair of wellingtons, which will allow you to step into the water in order to secure a better vantage point.

tip

When working close to water, it is very easy to get splashes onto your front element or filter. Always carry a clean, microfibre lens cloth to wipe them away.

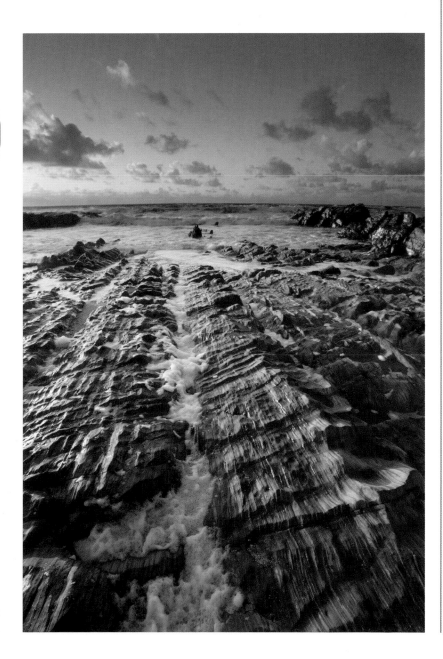

Foam on shoreline
After a heavy storm, foam is washed up and is trapped by coastal rocks.
Canon EOS 5D Mark II, 17mm lens, 1/6th second at f.16, ISO 100.

CLIFFS AND HEADLANDS

When photographing the coast, it always helps if you can find a strong natural feature to use as your main focal point; cliffs and headlands make excellent subjects in this respect. While many can be found merely by walking a coastal path, others might be more difficult to track down. Most prominent cliffs and headlands will be named and consequently can easily be found by referring to a local map. Often the greatest difficulty is establishing the best means of access by road.

One of the great joys of exploring cliffs and headlands is the sheer variety on offer. They are, of course, an extension of the geology of the surrounding landscape. While some cliffs comprise soft white chalks, others will be made from something much firmer and that ultimately has a bearing on its shape and structure. It also helps to understand the nature of the stone; a sedimentary outcrop will erode in an entirely different way to a headland made of a metamorphic rock.

VANTAGE POINTS

Think carefully about the best place to shoot from. If you are walking along a coastal path, you will have plenty of opportunities to get a shot from a higher vantage point and thus contrast the shape of the cliff against the surrounding sea. Often the coastline can appear serrated when viewed higher up, which is when a long angle lens can prove useful as it is able to exaggerate this pattern.

By way of contrast, fabulous photographs can also be taken when shooting at sea level looking upwards, but obviously this can only be done when the tide is out. In this instance, a wide-angle lens usually works best. If you are able to photograph from the beach, look for possible foreground interest; the reflections found in small pools left by the receding tide serve this purpose well. Often at sea level you also find rocks and boulders that were once part of the cliff scattered along the beach but have been beautifully shaped by the incessant erosion of the sea. Once again, these provide excellent foreground interest

Illuminated headland
Don't assume that just because the sun has gone down, you need to pack up your gear. This shot was taken 40 minutes after sunset, although I did need to use a ND grad filter to ensure that a balance was maintained between the foreground and sky. Canon EOS 5D Mark II, 17mm lens, 36 seconds at f.16, ISO 100.

Cliff and rock pools
If you are photographing at sea level, look out for rock pools left by the receding tide. Canon EOS 5D Mark II, 17–24mm lens, 1/6th second at f.20, ISO 100.

THE TIME OF DAY

Cliffs and headlands can be photographed at any time of the day, although if you are able to take your shots at either dawn or dusk, the results can be particularly attractive as the low, rich lighting flatters the natural colours of the rock. Don't discount taking your photograph after twilight; on a clear evening, successful shots can still be taken up to 40 minutes after the sun has disappeared.

The orientation of the coastline is, of course, important as whether it is west or possibly south facing will have a bearing on the lighting you are able to use. The time of year should also be considered, as this will determine precisely where the sun will rise and set. Living near a south-facing coast, there are numerous locations I know that I can successfully photograph in the winter that are considerably more difficult to shoot in summer.

Don't overlook the potential for getting great shots by doing some close-ups of the cliffs. Seen in detail, they often reveal interesting textural and colour details that encourage abstract photography. This is usually best achieved on an overcast day, or perhaps when the cliffs are side-lit.

PERSONAL SAFETY

Cliffs and headlands are potentially dangerous places and you don't need me to tell you that if you venture too close to the edge, you are putting yourself at risk. Moreover, particularly when there is a stormy sea, the risks of sea erosion will be constant. Most photographers prefer photographing at sea level, but this can also prove hazardous if you don't give the matter sufficient thought. While I am not suggesting that you should only take your photographs when the tide is going back, if it is coming in, you do need to ensure that you do not get cut off.

Cliffs in evening light
Just occasionally we experience a quality of light that keeps us riveted to the spot. In this example, I failed to notice that the tide was coming in more quickly than I had anticipated and nearly got cut off. Canon EOS 5D Mark II, 17–24mm lens, 17 seconds at f.16, ISO 100.

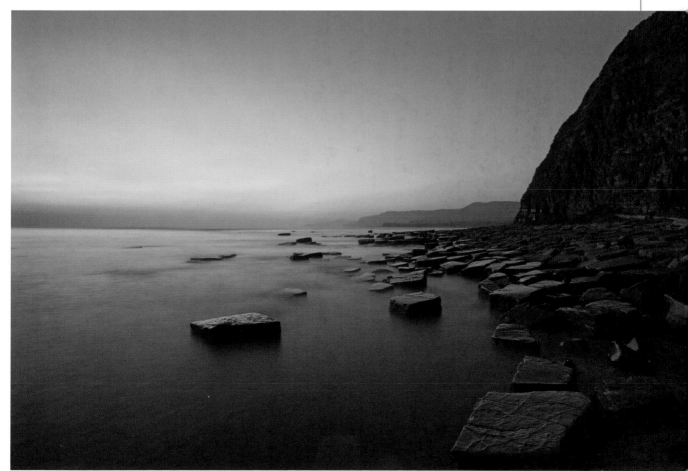

COASTAL FEATURES

Beaches, cliffs and rocky shorelines provide a wonderful variety of photographic opportunities, but occasionally you need just one further element to make your shot truly distinctive. Fortunately there are countless unique features, some of them natural, others man-made, located along our coasts that serve this purpose particularly well.

STACKS AND ARCHES

Because of the erosive qualities of the sea and the varying hardness of the rocks that make up our maritime peninsulas, the coast is littered with small and large stacks and arches. Tracking these places down is never too difficult. Getting an interesting angle is always the challenge and if there is a coastal path nearby, it certainly helps to check out as many viewing points as you can. Constructed of stone, most of these natural features are best photographed in the early morning or evening when the low rich lighting warms up the natural hues of the rock. These features rarely photograph well in overcast light, but can look absolutely magnificent when set against a dramatic sky.

Durdle Dor
Because of the erosive qualities of the sea and the varying hardness of the rocks that make up our maritime peninsulas, the coast is littered with small and large stacks and arches. A neutral density filter, factor 10, was used to greatly extend the exposure.
Canon EOS 1D Mark II, 24–105mm lens, 57 seconds at f.16, ISO 100.

SAND DUNES

While natural stacks and arches are most likely to occur along an undulating coast, sand dunes are more common where the land is flat. Possibly not as eye-catching as some other coastal features, nevertheless they do make excellent subjects for photography.

This is yet another situation where strong lighting is preferred as this helps to highlight the rolling nature of the dunes. There is rarely an obvious viewpoint when photographing them, but aim to use side-lighting whenever possible. It also helps to opt for a wide-angle lens, which makes the dunes appear larger.

Sand is extremely destructive to cameras, so try not to change lenses while taking your shots. Another small problem you are certainly likely to encounter is footprints, because dunes are also popular recreational areas; if necessary these can be dealt with post-camera using the Cloning tool in Photoshop.

ISLANDS

The incidence of islands depends on the nature of the coast and while some will be large, others will be little more than large rocks emerging above the water. Irrespective of their size, a minimalist approach to this subject usually works best, so try

tip

If you can't avoid including footprints in the sand, they can easily be removed with the Cloning tool in Photoshop.

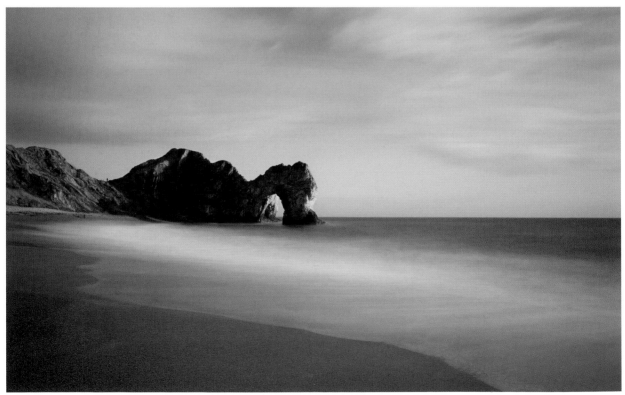

Sand dunes
As there is rarely an obvious viewing point when photographing sand dunes, try to exploit side-lighting in order to accentuate the natural textures. Canon EOS 5D Mark II, 24–105mm lens, 1/80th second at f.16, ISO 400.

using a telephoto lens. Generally the shape determines the mood you should adopt; if it is gentle and rounded, aim to produce an evocative, atmospheric image by emphasizing the subtle tones. Sometimes small islands are shrouded by mist, which greatly enhances this feeling. On the other hand, if the island appears craggy, choose a technique that echoes this. Look for rocks to use in the foreground, or just select a shutter speed that exaggerates the turbulence of the sea.

TIDAL STREAMS

They are often overlooked, but our beaches are peppered with streams and small rivers flowing into the sea. As each tide comes in and then recedes, it has the capacity to redirect the flow of water, which certainly adds interest. If its direction is not ideal on one day, try checking it out on another. Using a wide-angle lens seems to work well with this sort of subject. If the stream is flowing over sand, aim to capture the erosive effects of the water, but if the beach is pebbly, its movement adopts a gentle rhythm, which is best illustrated when using a slow shutter speed.

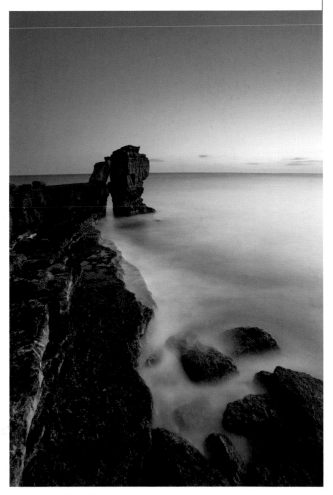

Pulpit Rock
Constructed of stone, most of these natural features are best photographed in the early morning or evening when the low, rich lighting warms up the natural hues of the rock. This had originally been an arch but it collapsed as a result of local quarrying.
Canon EOS 5D Mark II, 17–24mm lens, 18 seconds at f.22, ISO 100.

MAN-MADE FEATURES

PIERS

There are few man-made coastal features quite as charming as piers. They date from a time when the practice of promenading was fashionable and even today they remain popular. These wonderfully ornate structures retain a truly unique and splendid beauty, although, rather sadly, some are now falling into disrepair.

The great advantage of photographing them is that they can be taken in any conditions and from virtually any angle, which is why they are a magnet for all serious landscape photographers. While they suit the quiet light of dawn, they can just as easily be taken during a raging storm. When the tide is in, piers can be photographed from above jutting out to sea, but when it is out, there will be countless small pools, which offer interesting reflections at beach level. Seen from a distance, piers can appear particularly delicate and invite being photographed contre-jour. Conversely, they make excellent subjects when taken close up and are often shot from directly below.

Piers can be photographed at any time of the year, but tend to appear at their most magnificent in the winter months when the lighting is lower and there are fewer people around. There rarely is an obvious shot, which encourages originality.

COASTAL BUILDINGS

Ranging from imposing castles to small fishermen's boat-houses, there are

Pier at night
Piers are easy to photograph as you can use so many different vantage points. In this example I have chosen to photograph it from directly below. Canon EOS 5D Mark II, 24–105mm lens, 214 seconds at f.22, ISO 100.

Silhouetted pier
The delicate structures of piers means that they lend themselves particularly well to contre-jour lighting. If you are able to include some interest in the foreground, it can help the image compositionally. Canon EOS 5D Mark II, 24mm lens, 114 seconds at f.20, ISO 100.

Lighthouse, Torrox
Lighthouses are always best photographed under
dramatic skies as this tends to best highlight their
function. Use a ND grad in order to give the sky
greater emphasis.
Canon EOS 5D Mark II, 17mm lens, 2 seconds at f.22,
ISO 100.

countless buildings along coasts which
make excellent photographic subjects.
Once again, establishing a suitable
angle is the key to success. In order to
maximize the impact of the building in
your photograph, think carefully about the
various compositional strategies you can
use. If the building is the main feature,
consider applying the Golden Section,
and wherever possible try and find a lead-
in line (see the section on composition
[p46]). Lighting is also very important
– find a viewpoint where the angle of the
sun positively enhances the qualities of
the building.

LIGHTHOUSES
Found along coasts throughout the
world, lighthouses tend to be sited on
very prominent locations, be it on a
peninsula, at the end of a causeway or
perhaps on a small rocky outcrop out to
sea. They look quite unspectacular when
seen in the daytime, but if photographed
in the early morning or late evening
when their lights are working, they can
appear transformed.

Lighthouses were constructed to ward
shipping away from potentially hazardous
shores, so aim to include some rocks in
the foreground; if you are also able to
include a raging sea under a stormy sky
even better.

Try experimenting with various
shutter speeds. If the water is particularly
tempestuous, opt to use a fast shutter
speed in order to capture all the detail.
Alternatively, if you choose a much slower
shutter speed that briefly blurs the water,
an entirely different mood will be created.

RESEARCH
Tracking down these magnificent locations
is part of the appeal of this genre of
photography. If you are prepared to pore
over an Ordnance Survey map, it can be
quite amazing what details they reveal.
The Internet is undeniably a wonderful
resource and in particular the various
photo-sharing websites. We all get
inspiration from images we see in books
and magazines, but the real challenge is
to put a fresh spin on the subject. It pays
to walk around and find a personal view.

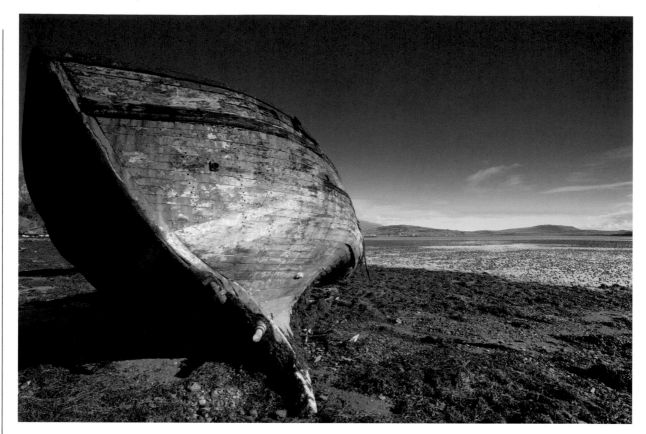

HARBOURS AND ESTUARIES

Where a river flows into the sea, there will certainly be an estuary and very often a harbour as well. A haven for yachts and other sailing craft, while many retain a charm, they are notoriously difficult to photograph, largely because they can appear so cluttered. Moreover, on bright sunny days, the reflective water and the white yachts can create all sorts of contrast problems. Identifying a composition can also prove difficult, but if you are able to concentrate on detail or on just a small group of boats, you will be more successful.

Harbours vary in size and while some are located adjacent to small villages, others are truly substantial developments. The great advantage is that most are crescent shaped, therefore you should be able to establish a good viewing point at virtually any time of the day. If there is higher land nearby, looking down over it can offer an interesting alternative.

COMMERCIAL HARBOURS

While they may lack the charm of their smaller rivals, large commercial harbours are exciting places to explore: not all landscape work needs to conform to the 'chocolate box' stereotype. Many of the

Abandoned boat
One often finds decaying boats abandoned near estuaries and harbours. With their layers of peeling paint, they provide excellent foreground interest.
Canon EOS 5D Mark II, 17mm lens, 1/30th second at f.18, ISO 250.

Commercial harbour
Photographed in the late evening, this otherwise charmless commercial harbour assumes an entirely different character. Not all landscape work needs to conform to the 'chocolate box' stereotype.
Canon EOS 1Ds Mark II, 17–24mm lens, 25 seconds at f.16, ISO 100.

Mont St Michel
The land adjacent to an estuary is invariably flat therefore any large feature can literally be seen for miles. In order to create a greater sense of openness, I have chosen to include a large proportion of sky. Canon EOS 1D Mark II, 200mm lens, 1/30th second at f.22, ISO 100.

larger boats sailing in and out of these complexes, with their layers of peeling colour and their rusting plimsoll line, lack the pristine whiteness of the leisure craft, but they can still prove highly photogenic. Check out the adjoining boatyards where craft that have seen better times have been abandoned. These sorts of places encourage creativity. Try photographing in the late evening when the lights start to appear or alternatively experiment by using a long exposure as an illuminated boat passes by; the results can be strangely enigmatic.

LOW TIDE
Harbours are, of course, tidal, and while they are interesting when the water is in, they are often far more fascinating when it has gone out, as this is when the boats are left marooned in the silt. It is a place full of rotting posts, small piers and random coils of rope, which can serve as possible foreground features, while the patterns created in the sand or mud provide interesting peripheral detail. Occasionally one will also discover the skeletal remains of a half-covered wooden boat, which appears and disappears with each changing of the tide.

COMPOSITION
Aim to make the composition of your photographs as simple as possible and this usually means using either a wide-angle or a telephoto lens. A wide-angle can be used to isolate a single element, which serves as the foreground interest, while dramatically diminishing the background. If you find that you are

unable to use a wide-angle lens, consider isolating your feature by throwing the background out of focus. Alternatively, use a long angle lens to pick out small elements of detail and aim to produce a minimalist effect. Visually, harbours are busy places, but are excellent locations to take photographs.

Harbour wall
Harbours are busy places so aim to make your photographs as simple as possible. While taken in the middle of the afternoon, I have used a neutral density filter to greatly extend the exposure time and thus create a misty effect in the water and sky. Canon EOS 1Ds Mark II, 24–105mm lens, 50 seconds at f.16 ISO 200.

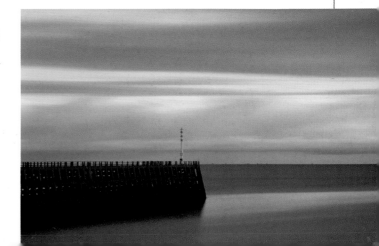

Local Landscapes

I live 30 miles from a National Park, eleven miles from a World Heritage Site stretch of coastline, eight miles from the second largest natural harbour in the world and seven miles from a famous historic monument. I make this point, because while all these locations are relatively close by, I would still need to drive to get to them. While I do regularly travel, I do not feel that you can consider yourself a true landscape photographer unless you are able to explore your own immediate environment with the same level of commitment.

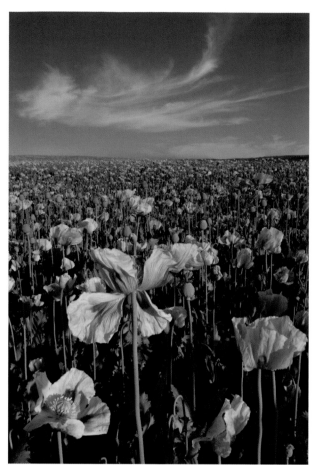

Opium poppies
A rather exotic crop that you imagine could only be grown in distant countries, but because of the potential shortage of morphine in our hospitals, local farmers are being encouraged to grow this unusual produce. Because of the hedgerows, it was impossible to see this from the road, but as I have got into the habit of walking, I am familiar with most of my immediate environment. Canon EOS 5D Mark II, 24–105mm lens, 1/50th second at f.22, ISO 200.

To test out this theory, I decided to dispense with my car and see what could be taken within a three-mile radius; as you might expect, my options were greatly reduced. I live on the edge of a small town surrounded by coniferous forests and farmland and, while it is undoubtedly pleasant, it is not an area that attracts hordes of photographers. But, photographing landscape is largely about capturing mood, therefore I should be able to do this anywhere.

There are several good reasons for why you should get into the habit of photographing your own immediate locality.

- It encourages us to get out and walk, and by investigating what is around us, we become more aware of the changes that occur in the landscape. While the car is a necessity when you want to get to a particular distant location, driving can isolate you from the passing landscape. When you walk, you travel more slowly, which gives you time to assess possible photographic opportunities.

- You can immediately respond to changing weather patterns. You may well be enjoying a leisurely weekend or you may have just returned from work when you notice the wonderfully changing light. By familiarizing yourself with your own

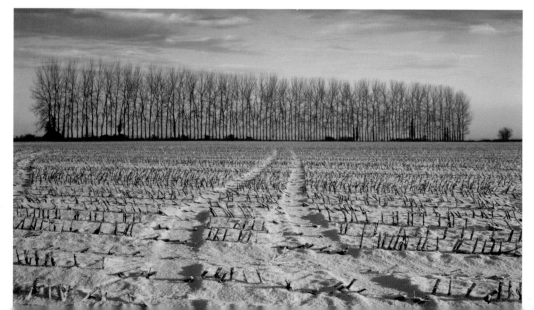

Field in snow
Located just a couple of miles from home, I am very familiar with this field and have rarely considered it a worthwhile subject. However, we are not used to snow in this part of England, and when it does occur it does help you to see your own environment afresh. Canon EOS 5D Mark II, 24–105mm lens, 1/50th second at f.16, ISO 200.

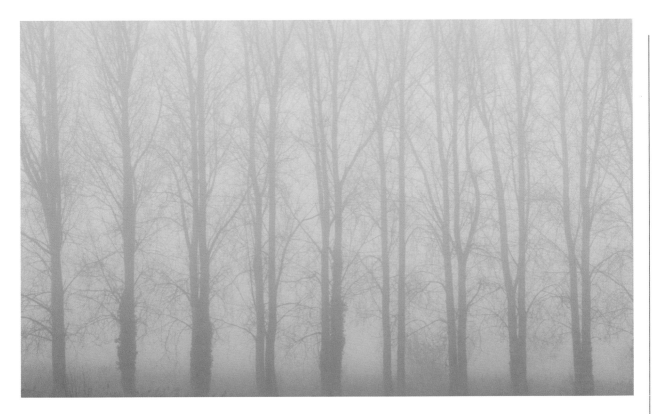

environment, you can immediately respond, knowing precisely where to go. How often have you stared out of the window only to see the start of a dramatic sunset, or watched as an amazing cloud formation starts to fill the sky and wondered where you could possibly go to make good use of it?

- By restricting yourself to your own immediate area you may possibly be the only serious photographer regularly taking images of it. By constantly revisiting certain areas you become aware of the changing moods and seasons, which make you a more confident landscape photographer.
- Like all other activities, photography needs to be practised and if you just rely on long excursions or possible trips abroad you are not necessarily developing important skills. By

regularly photographing your immediate environment, you are developing an awareness and possible techniques which will prove invaluable for those times when you do venture further.

If you live in a large town or city and think that your locality is not a worthy subject, remember the urban landscape offers wonderful photographic opportunities denied to many who live in the country. If that does not whet your appetite, many towns and cities have parks that offer exciting possibilities. While I decided to set myself just a three-mile inclusion zone, yours could be larger to include areas you are comfortable with. Alternatively, there may be an area that you regularly visit, which could easily be adopted as your own, personal, immediate locality.

Line of trees
Located just on the edge of town, it is so easy to ignore this gentle line of trees, but when viewed in winter, particularly in a fog, they assume a strange beauty. Even the very familiar can have worthwhile photographic potential.
Canon EOS 5D Mark II, 24–105mm lens, 1/12th second at f.22, ISO 100.

Poppies
These can be found anywhere and always make excellent photographs. The immediate background was less impressive, so I have concentrated the eye exclusively on the poppies by using a narrow depth of field.
Canon EOS 1Ds Mark II, 24–105mm lens, 1/250th second at f.4.5, ISO 200.

Defining a Landscape

While we all visit famous landscape locations from time to time, it is usually far more satisfying when we are able to photograph in less known places. In the previous section I urged you to familiarize yourself with your own, immediate area. As you know every part intimately, only you can reveal its true character. Paradoxically, the same applies when you visit new areas for the first time. Those living there are so familiar with their surroundings that they become inured to the obvious; as a stranger, you are much more capable of defining a particular landscape.

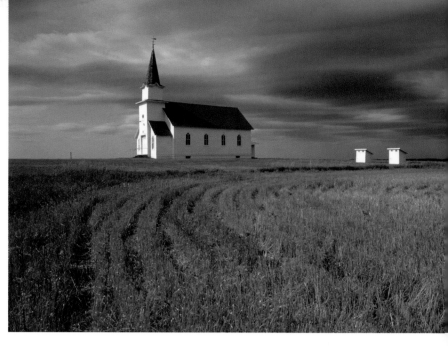

Abandoned church
Having stumbled upon this interesting part of America, I decided to do a little research and quickly found that when the early homesteaders arrived, the first buildings they constructed would be the school and the church, so when you do find examples that have been abandoned, you become acutely aware that the process of depopulation is in full swing. Photograph by Eva Worobiec.
Canon EOS 5D Mark II, 24–105mm lens, 1/80th second at f.11, ISO 250.

As I travel around my own country, I am aware that certain regions have their own unique characteristics that mark them out. It could be the general topography of the land, the inherent vernacular architecture or the prevailing farming patterns. When you visit such areas as a photographer, you are in a particularly strong position as you are able to see everything afresh and photograph without prejudice.

I found this to be the case when visiting a relatively

unremarkable area of America, which has largely remained ignored by other photographers. I stumbled upon the higher plains of America for the first time rather by accident; I was foolish enough to be visiting some of the national parks during the summer when traffic was moving through them, literally, bumper to bumper. As I was travelling with my wife, we looked at the map, identified an area we suspected few visitors were likely to travel to, and headed for eastern Montana.

What we encountered was a revelation. While we had anticipated that the landscape would be much flatter, we had not appreciated how abandoned the entire area had become. While most parts of the US have experienced continuing population expansion, this particular area of the American plains was undergoing quite significant depopulation on an almost unprecedented scale. We came across communities that up to 30 years ago had a thriving populace but in the intervening years many families had left. Scattered throughout the countryside were

Abandoned pick-up
When I first saw these vehicles scattered around the fields, I assumed that it was a worrying indication of the Americans' sense of profligacy, but after doing a bit of reading about the area, I appreciated that many farmers would keep their old vehicles for the spare parts that might be required for their newer vehicles. Living so far from large towns, they became highly self-sufficient.
Canon EOS 5D Mark II, 24–105mm lens, 1/100th second at f.11, ISO 100.

countless abandoned farms and homesteads. Those still living in
the area had become accustomed to seeing all this abandonment,
while few serious photographers bothered to venture into the area.
From my point of view, it was an opportunity too good to miss.

FINDING CHARACTER

There are two aspects to developing our skills as a landscape
photographer. It is of course important that we fully understand
what we can achieve with our cameras and that we can exploit all
the wonderful effects different filters and lenses can provide. But
just as important is the capacity to set ourselves personal projects.
Every landscape has a character which, if viewed sympathetically,
can offer fabulous photographic potential. Analyze what you
are seeing and then consider what photographic technique you
can use that will bring this to the fore. Not all landscape need
necessarily appear showy, and often much quieter images are
capable of communicating the true essence of a place.

Reading up about an area certainly helps as it will provide
you with a fuller understanding of the land and its communities.
Being able to place so many aspects of the landscape into context
gives your photography a sharper focus. By developing a fuller
understanding of a landscape you are in a far better position to
reveal its essential character.

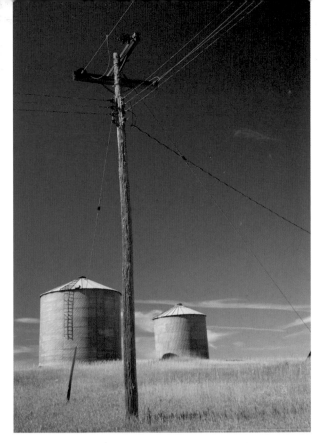

Homestead
Each landscape has its own unique characteristics and what impressed me about
this area was the minimalist landscape and the large open skies; truly not an area
for agoraphobics. Photograph by Eva Worobiec.
Canon EOS 5D Mark II, 24mm lens, 1/100th second at f.11, ISO 100.

Telegraph poles and silos
A landscape dominated by agriculture will invariably appear functional and
utilitarian, but can still offer good opportunities for photography.
Canon EOS 5D Mark II, 24–105mm lens, 1/60th second at f.14, ISO 100.

Acknowledgements.

When producing a book of this nature, I am inevitably indebted to a number of people.
I would particularly like to thank Neil Baber for once again showing faith in me when
commissioning this book, to Sarah Callard for the help and guidance she has offered and
to Cathy Joseph whose editing skills concerning photography are second to none. I am
also grateful to Sarah Clark who truly has fashioned an impressively flowing tome. Thanks
also to Canon UK, Olympus, Paramo and ThinkTank, who have provided me with technical
support, advice and product pictures. I am indebted to Betty and Tony Rackham, whose
knowledge of botany saved me from embarrassment, to Tim Rich who was prepared to
be my model again, and to my very dear friend Peter Baker who kindly reviewed the text
before it was finally submitted.

Shooting the images was unquestionably the part I most enjoyed due in no small
measure to the comradeship I enjoyed from fellow photographers, particularly Tim Green,
Jeremy Guy, Brid Coakley and John Hooton. As I seemed to stumble from one accident-
prone crisis into another I just don't know how they managed to suppress their laughter.
Yet again I must reserve particular thanks for my wonderful wife, Eva. Not only has she
allowed me to completely dominate our travel plans over the past year, but she provided
me with some of the best images in this book. She continues to teach me when to use a
semi colon instead of comma, she calmly remedies problems when the computer goes
wrong, reassures my ego when the photography goes badly and is simply the best friend
anyone could possibly hope for.

About the author.

Tony Worobiec has won numerous awards for photography in the UK and internationally
and has had work exhibited in London's Barbican Gallery, Bradford's National Museum
of Photography and the highly prestigious Fox Talbot Museum, Lacock. He is a founder
member and current chairman of the Arena group of photographers and is a Fellow of the
Royal Photographic Society.

Tony has written numerous articles for many photographic magazines both in the UK
and USA. His expertise in digital imaging embraces both colour and monochrome. This is
his eleventh book.

INDEX